DENYS RIOUT

Yves Klein
Expressing the Immaterial

ÉDITIONS DILECTA

Denys Riout is a professor emeritus of the history of modern and contemporary art at the Université de Paris I–Panthéon-Sorbonne. His works, relating to painting and art criticism, focus on modernity and avant-garde movements.

Also by Denys Riout:
La Peinture monochrome. Histoire et archéologie d'un genre. Nîmes: Jacqueline Chambon, 1996; revised and expanded edition, Paris: Gallimard, 2006.
Qu'est-ce que l'art moderne ?. Paris: Gallimard, 2000; new edition, 2010.
Yves Klein : manifester l'immatériel. Paris: Gallimard, 2004.
Yves Klein. L'aventure monochrome. Paris: Gallimard, 2006.
Vers l'immatériel / Towards the Immaterial. Paris: Éditions Dilecta, 2006.

ST. HELENS COLLEGE

709.2
RIO

128190

Aug 2017

LIBRARY

CONTENTS

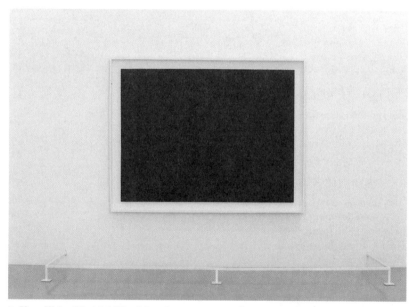

1. Yves Klein, *Untitled Blue Monochrome*, private collection, on loan to the Musée d'Art Moderne et d'Art Contemporain de Nice.

Foreword

For all arts, no matter which ones, language is,
after all, the universal organ of communication; or,
to retain Waller's comparison, the common currency
wherein all spiritual goods can be exchanged. Hence one
must talk and communicate, communicate![1]

Yves Klein's monochromes are famous. His *Anthropometries* were much commented upon and his *Exposition du vide*, which opened on April 28, 1958, marked a milestone. The presentation to the public of a completely empty space, in which no tangible work was present, remains a memorable event whose meaning, however, seems obscure and whose interest, beyond the daringness of the gesture, uncertain. And so the detractors of contemporary art found it easy to criticize this feat, to draw attention to it as exemplary of the tricks that proliferated in twentieth-century art. After the vernissage of the exhibition, the artist received a sheet of *NRF* letterhead on which was written, "With the void, full powers" **(fig. 2)**. The person who wrote this somewhat sardonic sentence, Albert Camus, did not make clear if the void granted full powers to the artists, to the specialists, to the public, or—without distinction or privilege—to all the players of the art world.

Critics and historians have made good use of the powers that have been bestowed upon them, often exercising their sagacity in inventing interpretations without giving any thought to the explicit intentions of the artist. For some, the gallery walls, painted white, should be considered monochromes. Others use Klein's long stay in Japan as an excuse to bring up Zen philosophy. More generally, the avatars

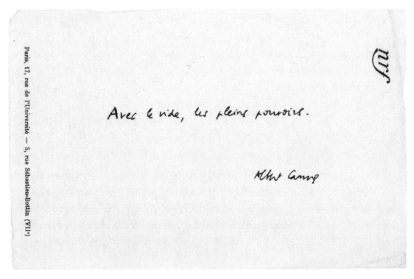

Paris, 17, rue de l'Université — 5, rue Sébastien-Bottin (VIIe)

Avec le vide, les pleins pouvoirs.

Albert Camus

2. Albert Camus, "With the void, full powers," 1958, sheet of *NRF* letterhead (*Nouvelle Revue française*, Éditions Gallimard).

of a multifaceted spirituality justify the wildest reflections. The artist explained his project on many occasions: to present directly, without recourse to the visible, the "pictorial sensibility", that is, the best of painting in its essence. The declared artistic ambition challenged the aesthetic conceptualizations likely to form the basis for a judgment in a way that was difficult to take up, because the disappearance of the painting dismissed all possibility of formal analysis.

Klein deserved all the more credit for developing his explanations as he was making a breach in an era that was still entirely devoted to the cult of visibility. That is why his writings must be read and reread: they contain the hermeneutical keys essential to the understanding of his artistic intentions. Today, a good half-century later, it is hard to imagine how daring and difficult to support this endeavor was because we have at our disposal a perspective that fails the artist. In 1958 Maurice Merleau-Ponty was no doubt already thinking of a great work that would analyze the dialectic between the visible and

the invisible, but although he began to write the manuscript in 1959, his text—unfinished—was published in 1964, after his death and that of Klein. Since then, conceptual art, which made its appearance in the late 1960s, taught some art lovers to accept the idea that the fine arts could, in order to develop, escape the traditional limits of the visual arts. The concept of *dematerialization*, promoted by Lucy R. Lippard in the early 1970s, familiarized them with works whose visibility is ephemeral, limited, or absent. More recently, artists readily turn to the written word, not to comment on their works, but as part of their oeuvre. The fictions proposed by Patrick Corillon and Sophie Calle, the maxims disseminated by Jenny Holzer, and many other recent, language-based works blur the boundaries between literature and the visual arts.

In the 1950s, the context was very different. The partisans of figuration still railed against abstract art, itself divided between proponents of cold geometry and supporters of gestural vehemence. The revival of religious art, initiated by Père Couturier with the help of Matisse, Léger, Bazaine, and a few others, scandalized the traditionalists. It drew attention to a spirituality of art as such. However, the visual means used by these artists did not in the least prepare the way for the astounding daring of the painter who chose to present simply the immaterialization of blue and who succeeded in selling, during "relinquishments" governed by "ritual rules," "zones of immaterial pictorial sensibility."

This series of invisible works, conceived and executed between 1957 and 1962, has never been the subject of a specific study. Moreover, the works are often interpreted in relation to later developments in Western art. I would like to replace this "downstream" reading with an "upstream" reading, the only one capable of giving an account of what was at stake at the time, both for the artist and for his public. It is thus a matter of examining in detail what Klein did and what he said and wrote, with his weaknesses as well as with the resources of his imagination, cunning, and conviction. Deeply devoted to Saint Rita, the patron saint of lost causes, Klein, a profoundly Catholic artist, often cited Delacroix, sometimes referred to Van Gogh, battled Mathieu, endeavored to set himself apart from Malevich and Strzeminski,

made use of Bachelard, and invoked Artaud. Both of his parents were painters, and early on he acquired a very good knowledge of the artistic milieu and its debates in the postwar years. But his culture was still that of an autodidact: hungry for knowledge, grazing here and there, quick to seize elements capable of backing up his intuitions, of supporting his arguments.

Klein wrote prolifically in an idiosyncratic style, which sometimes did not conform to academic norms, yet was always comprehensible. He was often provocative, extreme, as he admitted in 1962: "Of course, I had no doubts about anything when writing *Le Dépassement de la problématique de l'art*: the exaggerations in that little book now annoy even me!"[2] It is thus a question of finding in his writings the explanations capable of throwing light on his quest. He wrote, of course, so his works would be understood, as well as—and perhaps even more—to think, to imagine, to propose, to test new solutions likely to help a project, whose coherence appeared in retrospect, evolve. On the way, we will see that the study of immaterial works leads us to perceive differently his "visible and tangible" creations henceforth caught up in a dialectic that contributes to the clarifying and enriching of their meaning. The artist said that after each of his exhibitions or events he was "bombarded by the question: 'And what will you do next? It would be impossible to take it any further.'" The evolution of his work refuted the avant-gardist view underpinning this question. If it was possible for him to go still further, it was to increase the depth of meaning of his work in the course of a journey that was the opposite of a headlong rush, a journey that allowed him to articulate the visible and the invisible, the purity of the monochrome and the flesh, all under the auspices of the Christic Incarnation.

The reading of Klein's texts and the analysis of his creations suggest parallels that he himself had not thought of, although his thought horizon implied them. No one ever speaks alone, and positive knowledge does not constitute the whole of "culture." The soft knowledge of a diffuse culture provides food for thought and stimulates the daring of artists as much, if not more, than the scholarly exegeses of specialists in the face of which they remain, allowing for exceptions, powerless. The "learned painters" of the Renaissance were neither humanists nor

theologians, and yet their works should be considered in relation to humanism and theology if one would like to understand the paintings, sculpture, and architecture they have produced. Klein had probably not read Plato, much less Plotinus, the Fathers of the Church, or the debates about image that tore apart Christianity on many occasions. But these great moments in Western thought form the backdrop for his most vivid intuitions. It seems useful to mention it because this "backdrop", evanescent here, constituted the base on which the artist's daring was able to develop and the art lover's reception base itself: all share, with varying degrees of competence, this frame of thought, an interweaving of philosophy and theology. The ever-changing interpretation of these canonical references, as I propose it here, should not be considered proof of the interest or the profundity of Klein's works, but as a condition of possibility of their emergence and an available framework for their reception.

Before getting to the heart of the matter, I would like to draw attention to the profoundly "literary" dimension of Klein's oeuvre. This characteristic is not a result of the presence of text—there have always been texts related to visual works, and often in abundance. Paintings are artifacts, subject to a formal analysis. Surrounded by comments, every painting is an *icono-verbal* entity. To perishable paintings, Klein, anxious to go beyond the problematic of art, added the immaterial and its legend, borne by the Word, much more enduring. That is why one must agree to reverse the polarity: his oeuvre seems less *icono-verbal* than *textual-iconic*. It is truly epic.[3] The artist narrates the trials and tribulations of sensibility in a world of objects. This legend is constructed like a myth: it brings together different materials and links them in an organic whole, in order to presentify that which can only be said between the lines, between the objects, the events, and the narratives. The meaning is not in the words or the paintings or the events. It lies in the richly colored, watered effect created by these disparate elements. It is, moreover, for this reason that—all having already been said—the task of elucidation and appropriation must be unceasingly carried out: the myth remains alive as long as storytellers perpetuate its memory—in other words, as long as they continue to interpret it.

Visibility and Presence

Painting only serves to prolong, for others, the abstract pictorial 'moment' in a tangible and visible manner.[4]

Beneath a willingly provocative exterior and despite the apparent disparity of his oeuvre or his preoccupations, Yves Klein developed a way of thinking about painting whose coherence is still exemplary. One of the questions that he recurrently asked himself haunts aesthetics and art criticism: What connections can be established between what we see and our appreciation of it? Eugène Delacroix, one of Klein's main references, observed: "The art of the painter is all the nearer to man's heart because it *seems to be* more material. In painting, as in external nature, proper justice is done to what is finite and to what is infinite, in other words, to what the soul finds inwardly moving in objects that are known through the senses alone."[5] These attractive assertions do not really explain how the artist imparts on the materials he works with an emotional and significative power whose, presence and mode of action no formal, iconological, or other type of analysis succeeds in fully legitimizing.

Not in the least a philosopher, Klein thought like an artist[6] when he took up in turn the dichotomies evoked by his predecessor. Like Delacroix, he wrote to confirm his intuitions, and elaborate and clarify the conceptual bases of the metamorphoses of his work. The films—silent, but sometimes in color—and photographs that he had produced were intended for the public in particular. While these documents enabled him to leave his mark, they above all were part of a didactic objective that facilitated the media coverage of the finished

work. These perennial "supplements" tacked on to the exhibitions, ephemeral by nature, provided an explanatory framework that helps us understand why the painter devoted to the monochrome was led to consider his paintings the "ashes" of his art, and to leap into the void or, more exactly, to embrace the immaterial.

Perceiving the Invisible

Klein's dazzling adventure was that of a sedimentation, of an agreed spareness in order to bring up to date the essentials, the artistic—and not pictorial[7]—essence of the painting. The painter clearly did not immediately envisage the potential developments implied by his decisions. The unifying theme of his most significant works is the result of a continuous creative process whose structure should be deduced a posteriori.[8] Imaginative and endowed with admirable logician daring, Klein implicitly adapts to his own use the principles of the experimental method developed by Claude Bernard: he proceeded by trials and successive rectifications. For him, each of his exhibitions was the occasion to record and analyze the reactions of critics and art lovers. This is how he conceived a series of events that led him from the monochrome painting to an "immaterialization" of color, intended to liberate, with no intermediary, in the state the most in keeping with its truth, the radiance of the pure pictorial sensibility.

In 1955, during his first real exhibition (Club des Solitaires, Paris, **fig. 3**), and especially on the occasion of a debate organized in the context of his second solo exhibition (Galerie Colette Allendy, Paris, February–March 1956), Klein noted that the public confronted with a series of monochromes in various colors "reassembled them as components of a decorative polychromy."[9] This is not what he had hoped. To avoid such an interpretation developing, he decided to present, during his exhibition at the Galleria Apollinaire in Milan (January 1957, **fig. 4**), a room exclusively devoted to ultramarine. The eleven paintings chosen, hung eight inches from the wall without frames and all the same size, looked interchangeable. However, explained the artist, observant art lovers were able to distinguish, beyond appearances,

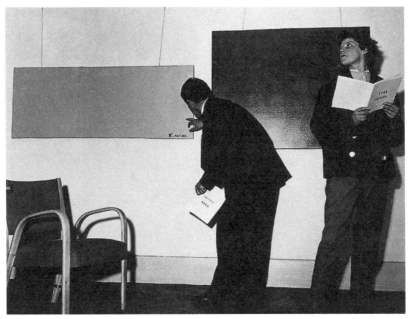

3. View of the exhibition *Yves Peintures*, Club des Solitaires, Paris, October 1955.

the distinctive character of each of these "monochrome propositions." These art lovers are even said to have agreed to pay different prices to acquire one or other of these works. Klein was delighted:

> This shows, on the one hand, that the pictorial quality of each painting was perceptible by something other than the material and physical appearance and, on the other, that those who were choosing could obviously recognize the state of things I call "Pictorial Sensibility."[10]

The concept of the introjected sensibility of the subject in the work has gotten a lot of bad press: indeterminable, not to mention ineffable, it is, possibly, experienced, but never reveals itself. That is why it allows

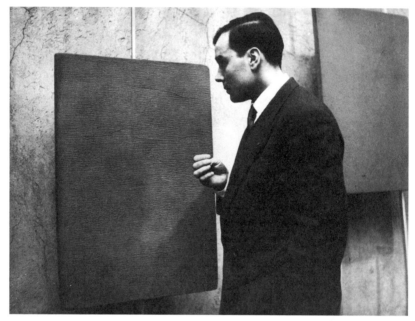

4. Yves Klein at his exhibition *Proposte monocrome, epoca blu,* Galleria Apollinaire, Milan, January 1957.

all experiments and authorizes the deployment of discourse that is all the more frenzied given the fact that it does not have to justify its assertions. Nothing says, however, that the judgment of taste is not based—beyond the analyses that rationalize as much as they can—on the absolute conviction that the art lover's sensibility was touched by a diffuse *je ne sais quoi* that emanates from the work. Understood at this fundamental level, art is a mystery. It is no longer an object of discussion but of faith.

Can the invisible be *perceived?* The answer, no, seems to go without saying. On the other hand, we all know from experience that invisible forces can act and that they thus demonstrate their positive existence—who would cast doubt upon the reality of electromagnetic fields or the force of gravity? With his words, with the notions or

concepts he had at his disposal, Klein sought to define and name the active presence that distinguishes the work from all others when it is endowed with it. He distrusted the term "soul," used by Delacroix, but which has since become devalued or tired. That is why he wished to replace it with "much less compromised words, such as human or cosmic 'sensibility,' or even 'pure energy.'"[11] Klein went deeper into his thinking when he noted:

> So, I am in search of the real value of the painting, the one that makes two paintings that are absolutely identical in all visible and legible effects, such as lines, colors, drawing, forms, size, thickness of paint, and technique in general, but the one is painted by a "painter" and the other by a skilled "technician," a "craftsman," despite the fact that both are officially recognized as "painters" by the public. This invisible real value means that one of these objects is a "painting" and the other is not (Vermeer, Van Meegeren).[12]

If the point seems to be poorly supported by the example of Van Meegeren's forgeries, of which the least that can be said it that they scarcely resemble Vermeer's paintings, Klein's questioning nevertheless has strong philosophical overtones.

Jorge Luis Borges may have hinted at this in his short story, "Pierre Menard, Author of the *Quixote*."[13] This story presents the great work—unfortunately lost—of the writer Pierre Menard. Menard devoted part of his energy not to copying Cervantes's book, but to writing, in the twentieth century, a few chapters whose pages "coincided—word for word and line for line—with those of Miguel de Cervantes." Pierre Menard never thinks of copying a passage by his predecessor. No, what he wants is to produce anew a text that is identical to that of his great work, but identical in appearance only. Thus, when one uses the language of his time, his successor used an archaistic style. The former sets his story entirely in the Spain he knows, the latter chooses this country but prohibits the literary recreation of local color. When one

writes "*à la diable*," the other recreates spontaneousness. At the end of a mischievous display, Borges convinces us that if the two texts are indeed "verbally identical," that of Menard, radically different in fact, is "almost infinitely richer."

This edifying fable is food for thought about the limits of a strictly formal analysis of a work.[14] It is prolonged by Arthur Danto when he imagines, in an attempt to define the essence of art, a series of paintings that are very dissimilar although their differences are absolutely invisible. In *The Transfiguration of the Commonplace*, the American critic and philosopher describes a (fictitious) exhibition of red monochromes. All appear identical. No visual element allows them to be told apart, and yet each of them acquires a unique identity, different from all the others, if one agrees to consider their respective content, presumed or evident, here known by the historical context that saw its birth, revealed by their titles, incredibly varied, or by the statements and texts by the artists eager to make their intentions clear. These "confusable counterparts belonging to distinct ontological orders"[15] sweep, not without humor, the captivated reader along into abyssal thinking about the essence of art and, correlatively, about the limits of an exclusively perceptual approach to the works. Danto reminds us that "pure visuality" is a myth because our perception remains in all circumstances and in spite of our efforts to attain an original "naïveté," loaded with theories, crammed with knowledge and prejudices.[16]

Unlike Danto's imaginary monochromes and Borges's story, real forgeries and, even more so, changes in attribution make us grasp fully the reality of the contamination of the seen by the known. Rembrandt's painting is exemplary in this respect. It moves us through the subdued vividness of the pictorial paste in which the profoundest mysteries of the psyche seem to be lodged. How can one deny that in his most deeply moving works the spiritualization of the matter allows us to see all that is tragic in the human condition? It is just a matter of looking. However, as soon as we learn that one of his paintings was not by him, that it was in fact patiently produced to mimic the effects that moved us deeply, a strange feeling of turmoil overcomes us. So, how should we think about *The Man in the Golden Helmet* (**fig. 5**)—long attributed to Rembrandt—when we know that a skillful practitioner imitated

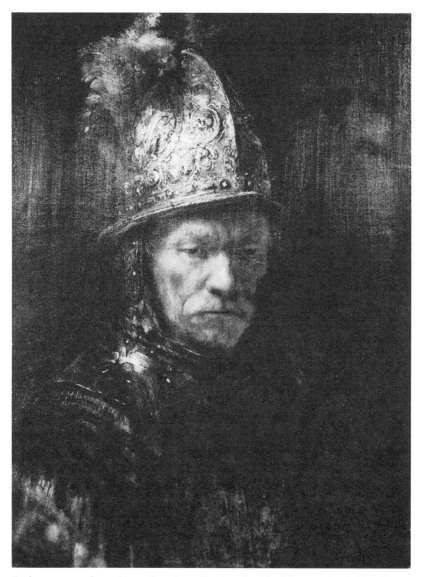

5. Anonymous, formerly attributed to Rembrandt, *The Man in the Golden Helmet*, Gemäldegalerie, Berlin.

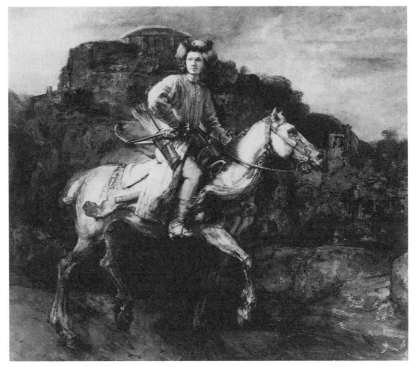

6. Rembrandt, *The Polish Rider*, c. 1655, Frick Collection, New York.

the master's style to produce, with no intention of deceiving whomso-ever, a perfectly convincing artifact?

When they were looking for striking examples, likely to convince their readers, Danto, and Klein before him, chose Rembrandt—the emblematic figure of an ability to endow pictorial matter with myste-rious but manifest emotional powers. Fond of meaningful fictions, Danto established a parallel between *The Polish Rider* (c. 1655, **fig. 6**), a touching painting "in which an isolated mounted figure is shown midjourney to an uncertain destiny,"[17] and its indiscernible replica, "the result of someone's having dumped lots of paint in a centrifuge, giving the contrivance of a spin, and having the result splat onto

canvas, 'just to see what would happen'"[18] and that would feature all the aspects of the Rembrandt painting in the Frick Collection, New York—the chance of this happening is statistically minimal but perhaps not nil. The hypothetical cases of paintings with indiscernible differences imagined by Danto allowed him to ask a crucial question in the philosophy of art: "whether an unnoticed, and let us even suppose an *unnoticeable*, difference can make an aesthetic difference."[19] The answer elaborated by Danto obliges us to decenter our attention. To understand what differentiates works that are apparently similar, one must stop goggling, stop exclusively trusting in the eyes, and pay more attention to the intentional structures and the categorial registers than to the formal characteristics, the only ones perceptible.[20]

Thirty years previously, Yves Klein was already confronting such issues with conceptual tools that were infinitely cruder and from a viewpoint that was more creative than analytical. The painter, who did not want his oeuvre to be confined in the narrow circle of only the "retinal" register—which, however, he perfectly mastered—attempted to demonstrate that two blue monochromes, identical in appearance, could have an aesthetic value, and thus also a market value, that was different. Preoccupied with backing up his convictions, Klein turned to businessmen and alchemists who, like good artists, have the "extraordinary power" to transmute the most ordinary, and even the basest, materials:

> The gold of the ancient alchemists can actually be extracted from everything. But what is difficult is to discover the gift that is the philosopher's stone and that exists in each of us.[21]

Great manipulators, miracle workers, painters acted in a comparable way when all is said and done, and Rembrandt was, in this respect a particularly illuminating example because he was often criticized by his contemporaries for using too many disreputable effects in a far too trivial manner.[22] Klein thus pursued his alchemical comparison, but took advantage to introduce another metaphorical reference, in a register markedly less suspected of charlatanism, photography:

It is the same for the greatest and most classical painters, like Rembrandt, for example. He knew that, in full view of everyone, he had to paint and depict figures, objects, and landscapes as he knew the people of his era saw them, or saw themselves, in order to have himself allowed into the community-society in which was living, but in actual fact, the painting was alchemical and from a different era. It depicted nothing realistic, it was a pictorial presence created by the painter, who knew how to specialize a surface to make it into a sort of highly sensitive *photographic plate* intended not to photograph like a machine but to be a present witness of the poetic pictorial moment; the inspiration, state of communion, and enlightenment of the artist in the presence of everything.[23]

Isolating the aesthetic qualities of the painting, supposed to be independent of its contingent representative function, although deeply anchored in a tradition based on mimesis, is a topos constantly used by the early champions of abstraction. The assertion of such a division is, however, much earlier to the appearance of non-figurative paintings, and Klein could have once again laid claim to the legacy of his master Delacroix when he evoked the "music of the painting." It is the result of "a certain arrangement of colors, light, shade, etc.": if you find yourself too far from the painting to know what it represents, wrote Delacroix, "you are struck by its magical harmony."[24] Klein substituted alchemy, the matrix of modern physics, for the "magic," but he wanted above all to explain the mechanism of the phenomenon whose effects we feel. How does an emotional and poetic charge incorporate itself into colored matter to become an undisputed "pictorial presence"? The painter set out to understand the mysteries of artistic creation using a recent but already commonplace model, known to all, at least its basic aspects, as a starting point: the photographic process. This conception—which seems to be metaphorical but perhaps allows itself a bold

generalization based on analogical reasoning, of the processes required by Niépce's invention—should be closely examined.

The Photographic Process

Klein's thinking remained substantialist. Just as he believed in the positive existence of color, an entity with which we make contact,[25] he thought of "pictorial sensibility" not as a quality of the perceiving subject but as an individual reality within the work itself. Consistent with his presuppositions, he devoted himself to justifying the presence of this sensibility in the material texture of the painting. The naïveté of the premises does not matter here—if we see a blue surface, it is because it *is* blue, if we feel the presence of a spiritual energy "animating" the painting, it is because it lies within it. Klein did not seek to rival cognitive science specialists. When he made public his convictions, the artist led his readers[26] into the meanders of his theoretico-poetic fictions. They could thus share with him the charms of an adventure with many twists and turns made possible, in fact, by the unbridled vigor of the logical support that consolidated his intuitions.[27]

Klein's coup, when he advanced a procedural explanation of the photographic type to explain the timeless emotional power of Rembrandt's works, consisted in repudiating representation at the very moment it invoked photography. From its very beginnings, photography was considered, to praise it or to reprimand it—it does not matter here—a means of capturing down to the tiniest details an image of the real present in front of the lens of the camera obscura. A few months before Niépce and Daguerre's process was unveiled in front of the Académie des Sciences and the Académie des Beaux-Arts meeting in a plenary session for the occasion (August 19, 1839), Jules Janin wrote in *The artist* that the daguerreotype was "the most delicate, the finest, and the most complete reproduction to which the works of God and those of man can aspire."[28] One of the favorite games of the early aficionados, confronted with these images drawn by light and fixed thanks to the wiles of chemistry, consisted in using a magnifying

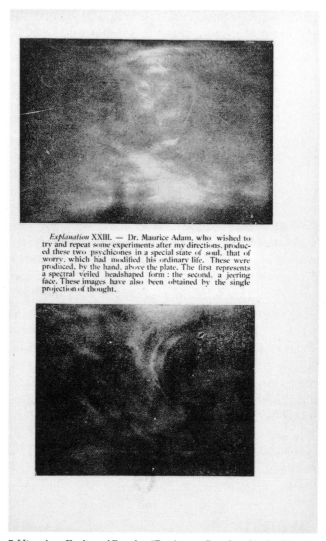

Explanation XXIII. — Dr. Maurice Adam, who wished to try and repeat some experiments after my directions, produced these two psychicones in a special state of soul, that of worry, which had modified his ordinary life. These were produced, by the hand, above the plate. The first represents a spectral veiled headshaped form : the second, a jeering face. These images have also been obtained by the single projection of thought.

7. Hippolyte-Ferdinand Baraduc, "Psychicones" produced by Dr. Maurice Adam, *The Human Soul: Its Movements, Its Lights and the Iconography of the Fluidic Invisible* (Paris: G.-A. Mann, 1913), pl. XXIII; Bibliothèque Nationale de France, Paris.

glass to lose oneself in the maze of details invisible to the naked eye and yet part of the image.

Photography has many links to the non-visible, the unseen, or the invisible. Many experiments have been carried out to increase the field of visualizable reality. All shared the same desire: to go beyond what is directly perceived by the human eye, an organ that is both remarkable and mediocre. In the early 1840s, one of the inventors of photography, William Henry Fox Talbot, created a device intended to show that this process did not content itself with reproducing what we see.[29] He proposed to shut several people in a room with no light and shot through with invisible radiation. A device capable of recording this radiation would allow the poses of each person to be captured, even though none of them was able to see themselves or their companions. This reverie was concerned with the non-visible, but it is revealing of a desire to dissociate the photographic image from that which is perceived by natural vision.

In the 1890s, there was a proliferation of attempts to fix, on a sensitive plate, a reality that evaded direct vision or which was super-natural.[30] Spirit photography recorded apparitions, captured specters, fixed with the purpose—with a hint of proselytism—of revealing the forms adopted by spirits and ectoplasms. It aimed to confirm the existence of a fluidic radiation, unseen most of the time and in which miscreants did not believe. Motivated by more scientific motives, Dr. Baraduc, a psychiatrist at the Salpêtrière hospital, wanted to capture the "emanations of the [human] soul." His "psychicones," produced in the dark without a camera, captured "luminous and vivid images of the thoughts"[31] **(fig. 7)** of subjects in front of whom he placed a photo-graphic plate. It sufficed to develop and fix it to perpetuate the image of an invisible "aura." August Strindberg placed his sensitive plates on windowsills or the floor, sometimes already immersed in the developer, so that they could capture the actions of the moon or stars. A writer, playwright, and painter, Strindberg was suspicious of the distortions induced by cameras, lenses, and our natural perception: obstacles to an objective vision. He wanted to know "how the world would look emancipated from [its] deceptive eye."[32] His "celestographs" **(fig. 8),** a cloudy mix of spots and patches were, according to Strindberg, a

truth of the world whose "virtual" image should be captured beyond the visible.

Röntgen's discovery (1895) arrived just at the right moment to confirm the ravings of all the conjurers, be they sincere or charlatans, of this other world. X-rays enabled "photographs of the invisible,"[33] which were scientifically unassailable and did away with the boundaries between the invisible and photography, to be taken. While spirit experiments continued, in the early twentieth century, against a background of passionate discussions and sometimes lawsuits, other approaches developed. Thus, Professor Charles Richet, member of the Académie de Médecine and founder of the Institut Métapsychique International, wanted to study thoroughly all the "invisible emanations inaccessible to the common herd, capable of stirring the organisms of oversensitive subjects and to reveal to them, in rapid flashes, a few fragments of the reality surrounding us."[34] Metapsychic photographs were part of this exploration when they revealed and recorded, it was believed, the effects of invisible vibrations emitted by cerebral activity.

Anton Giulio Bragaglia had hoped to have the Futurists support not only a method of recording movement, "photodynamism," but also special effects intended to produce images of the "astral body" or other spectral manifestations. These photographs dragged photography, usually devoted to strictly objective reporting, from its ancillary tasks to place it in the service of an ancestral imagination.[35] In 1913 Bragaglia published two articles, "I fantasmi dei vivi e dei morti" and "La fotografia dell'invisibile," in which he advocated inventiveness in order to explore a world beyond the visible, which never ceased to fascinate. Since then, the advances in science have offered ever more amazing photographs to the gaze of scholars and the curious. Stemming from the world of scientific research, they periodically gave rise to publications aimed at the general public who also appreciated the aesthetic of these images, their ability to fire the imagination.[36]

Evidence of a collective fantasy, deliberate hoaxes, or revelations of supernatural realities, the photographs which aspired to record messages from another world, beyond the visible, answered the imperious call of a scopic impulse. All wished to make visible that which is not, or is barely, visible. They were part of a general movement to which many artists,

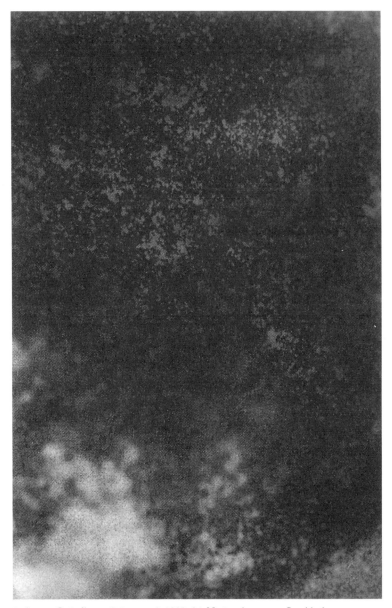

8. August Strindberg, *Celestograph*, 1893–94, Nationalmuseum, Stockholm.

who were the contemporaries of these experiments, also subscribed. Thus, Odilon Redon wanted to put, as far as possible, "the logic of the visible at the service of the invisible,"[37] and Paul Klee stated: "Art does not reproduce the visible but makes visible."[38]

The photographs of the invisible perhaps reveal to us the existence of other worlds, but undoubtedly invite us to contemplate a truth of photography[39]. They favored the recording of a trace over the production of a mimetic image. Imprints fixed in the sensitive matter, they in no way represent the forms of the invisible of which they give an account, as a realist painter or draftsman would, subjected to the presence of the referent of which he produces a lifelike icon.[40]

Many studies have shown that photography, in its operating process, perpetuates indicial signs. All are based on the semiotics of Charles S. Peirce, who distinguished between the icon, particularly subject to the system of likeness, and the index, "a sign which refers to the object that it denotes by virtue of being really affected by the object"[41] The trace of a footstep on the ground is an index, not as long as it has some "similarity or analogy" with the object signified, but because it maintains a dynamic relationship with it as with "the senses or memory of the person for whom it serves as a sign."[42]

Regarding photographs, Peirce remarked that confusion remains possible because "they are in certain respects exactly like the objects they represent."[43] But this likeness, he added, should not mislead us because it is a result of the conditions that prevailed when the photograph was taken. In other words, it arises not from the physicochemical essence of the process, but from the use of the camera obscura, of the darkroom in which a lifelike imaged formed, an image recorded by the photosensitive plate placed in such a fashion so as to receive it without distortion. These photographs were thus produced "under such circumstances that they were physically forced to correspond point by point to nature." That is why they belong to "the second class of signs, those by physical connection,"[44] in other words, using Peirce's terminology, "indexes." From this point of view, the photographs of the invisible are particularly interesting because they claim to record the phenomena that by definition escape all visual perception and are not, strictly speaking, subject to any representation based on likeness.

Received, like all photographs, as images, they were first and foremost traces that attested to an alteration of the sensitive material affected by the flow of a radiation (luminous for "ordinary" photographs). The photograph that fixes, thanks to chemical manipulations, the trace of these alterations, bears witness to their reality—determining the nature of this causal reality would be, of course, another question altogether.

A painter, that is to say, a practitioner, Klein was interested in processes. When he wondered about the magic of Rembrandt's works, as we have seen, he downplayed the role given to representation and emphasized a "pictorial presence" imprinted in the material. Indeed its recording indeed functions on the photographic model, which uses a "very sensitive" plate destined to, since it was a witness to the "pictorial moment, collect the poetic energy that was deployed at the time and preserve it, forever active. Klein quite rightly made a distinction between this fundamental principle of photography and the accessory conditions that make it produce images: it is not a matter of "photographing like a machine," like an ordinary camera would. Dr. Baraduc and August Strindberg did not react differently when they devoted themselves to capturing the essential—they willingly did without the optical "machine." Klein's extolling of Rembrandt's merits was an exercise in self-justification. The photographic process he developed while he was considering the works of the Dutch master was also his own:

> The painting is only the witness, the sensitive plate that has seen what has happened. Color, in the chemical form in which all painters use it, is the medium best suited to the event. Therefore I can say: My pictures represent poetic events or, rather, they are immobile, silent, and static witnesses to the very essence of movement and life in freedom, which is the flame of poetry in the pictorial moment![45]

At no time did Yves Klein make clear how the surface of the painting and the color covering it turn into a sensitive plate capable of both recording and fixing the "poetic events" of which they are the witnesses. The attempt to support the hypothesis of a similarity

between pictorial creation and photographic processes comes to an abrupt end if one does not consider the strictly technical explanations. One had to demonstrate which spells enabled color to retain the trace of psychic events. Klein let the mystery remain. We will never know how reality illuminated matter.[46] The intuition or certainty that such a marvel could be possible was, however, shared by more than one artist. A thurifer of the invisible, Odilon Redon believed that the success of a charcoal drawing is linked to "the fullness of the physical strength" of the draftsman. The quality of the black draws "its exaltation and vitality . . . from the deep and secret sources of health."[47] The inert matter handled by a weary man "transmits nothing . . . whereas the happy hour of the propitious effervescence and strength, it is the very vitality of a being that bursts forth, his energy, his spirit, something of his soul, the reflection of the sensibility, a residue of his substance, as it were."[48] Delacroix used other words to say much the same thing. Klein is part of the same conceptual and ideological tradition. While he went a step further by proposing the photographic model, he had to appeal to an unwavering adherence—an act of faith—to convince us to accept the new definition of pictorial work that he was proposing, very logically given its premises:

> The painter is the one who knows how to specialize this real value, this sensibility born of belief and of his knowledge of poetry, if matter is indeed concentrated energy, as science has concluded in the final analysis.[49]

Aware of the danger, despite his appeal to the discoveries of modern science, Klein distanced himself from magic and occultism: "Magic, like occultism—from the point of view of art—is illicit, unhealthy, in bad taste, and untimely."[50] His speculative horizon, like that of many artists, was both pragmatic—he endeavored to make his art evolve—and critical—he positioned himself with or against his colleagues. Abstract expressionism, which was the star of the show in Paris under the names of lyrical abstraction, Tachism, or Art Informel, raised his ire: "I despise artists who empty themselves out on their

paintings, as is often the case today. How morbid! Instead of thinking about the beautiful, the good, and the true, they vomit, they ejaculate, they spit out all their horrible, rotten, and infectious complexity on to their paintings as if to relieve themselves and burden 'the others,' the 'viewers' of their works, with their losers' remorse."[51] That is why he contrasted the *expression* with the *impression*, "the illumination of matter" that enabled him to substitute for psychological excesses the presence of a "boundless cosmic sensibility,"[52] pacified and better able to open up to the universal:

> The essential of painting is that 'something,' that etheric glue, that intermediary product which the artist exudes with all his creative being and which he has the power to place, to inlay, to impregnate in the pictorial matter of the painting.[53]

The photographic metaphor, particularly striking, confirms in a nearly rational way his own concept of the link between the artist and his work, a more profound, more substantial link than the one that prevailed, according to him, among the abstract expressionists. But Klein went even further. Not only did he do without the chemical tricks of photography, he also recorded the invisible without inscribing it into the field of the visible. A double postulate characterized his explanations of the eleven blue paintings shown in Milan in 1957. All alike, "in appearance," these monochrome propositions were, however, "recognized as being different from one another by the public."[54] The explanation, simple, and in keeping with the logic put in place by the artist, lay in the fact that "each blue world of each painting, although the same blue and treated in the same way, presents a completely different essence and atmosphere; none resembled any other, no more than pictorial moments or poetic moments resemble each other."[55]

Closing One's Eyes

Does there exist a mode of vision that would be able to perceive that which we cannot directly show to the other, to the one looking in

the same direction as us? It would be an eminently subjective vision, without proof, almost without consciousness of itself at the precise moment when the act of perception takes place, an act that it accompanies or replaces. This manner of seeing called for the suspension of the ordinary way of looking so that a faculty of which Plotinus said that "everyone possesses, but few people ever use"[56] can develop. Only this "inner vision" would be capable of capturing, beyond or on this side of the visible, the "poetic moments" to which Klein referred. Photography, reputed to be so implacably descriptive, suggested to Roland Barthes a meditation that posed this question from a subjective viewpoint ready to entrench itself, to see better, in the intimacy of the being, eyelids lowered. We remember that he contrasted the *studium* with the *punctum*, a detail—"sting, speck, cut, little hole"[57]— that cuts it to the quick, takes it by surprise, unsettles it, wounds it, grabs hold of it. Whether it is noticed or not, the *punctum* enjoys a paradoxical status. An effect of reception, it has a tangible existence or, more precisely, an attributable cause: "it is an addition: it is what I add to the photograph and *what is nonetheless already there*."[58]

If one wants suddenly to make appear this "addition" taken from within the visible, one must turn one's back on the objective study of the analyst whose mastery, which is, moreover, indispensable, tests its limits here. Barthes went even further: "Ultimately . . . in order to see a photograph well, it is best to look away or close your eyes."[59] The explanation given for this surprising precept is perfectly rational: "Absolute subjectivity is achieved only in a state, an effort, of silence (shutting your eyes is to make the image speak in silence). The photograph touches me if I withdraw it from its usual blah-blah: 'Technique,' 'Reality,' 'Reportage,' 'Art,' etc.: to say nothing, to shut my eyes, to allow the detail to rise of its own accord into affective consciousness."[60]

Barthes gives various examples of *punctum*. He invites us to remember with him what afflicts it, to relive this private experience in his shoes. But when it is a question of his privacy, of the "The Winter Garden Photograph" in which he finally finds his recently deceased mother, Barthes did not reproduce it in the book. The main thing was not a question of visual communication, which clearly does not mean to say the experience of the eyes did not take place. No more than the retreat

into a contemplation with closed eyes excludes observation, and even the attentive observation of the *studium*. One should instead consider the modality of attention that gives the *punctum* a chance to happen, as if cloven, divided in two phases: see, then look away to better let the power of a visible unseen take its course in oneself—the addition "already present" and yet unnoticed as long as the eyes focus on it.

In Western culture, this binary structure has had a long history. It contrasts or links the eyes with the body and the eyes with the soul—also named the mind's eye. According to the period and school of thought, this tradition was dominant or vilified. But it is still present, at least as a cultural remanence, and it is on it that Klein, whose convictions were confirmed by his reading of Delacroix, based himself. Of course, Delacroix thought that "The first quality in a picture is to be a delight for the eyes."[61] But the colorist did not forget that this "first quality" would not suffice to fulfill spiritual aspirations. That is why he also noted: "The art of the painter is all the nearer to man's heart because it *seems to be* more material. In painting, as in external nature, proper justice is done to what is finite and to what is infinite, in other words, to what the soul finds inwardly moving in objects that are known through the senses alone."[62]

Several times, Klein invoked the notion of "indefinable" that he had borrowed from Delacroix.[63] The passage in Delacroix's journal where he had found it is particularly interesting because he explicitly mentions the "eyes of the body" to regret their simplistic nature when they are the sole ruler of aesthetic perception:

> You think that painting is a material art because it is only with the *eyes of the body* that you see those lines, those figures, those colors. Woe betide he who sees only a precise idea in a fine painting, and woe to the painting that shows nothing more than its finish to a man endowed with imagination. The merit of painting is the indefinable: it is exactly that which escapes precision—in a word, it is what the soul has added to the colors and lines to get to the soul. Line and color, in their exact meaning, are the

> coarse words on a coarse canvas, such as the Italians write to embroider their music on it. Painting is unquestionably, of all the arts, the one in which the impression is the most material in the hands of an ordinary artist, and I maintain that it is the one which a great artist takes the furthest toward the obscure sources of our most sublime emotions, and the one from which we receive those mysterious shocks that our soul, freed, so to speak, from terrestrial bonds and *withdrawn into what is most immaterial about it*, receives almost unconsciously.[64]

The philosophical roots of the link between what we see and what touches the soul go back to Plato who, already, contrasted the organs of the body and the eye of the soul, the only one capable of perceiving the truth, especially if it is aided by the dialectical method that "gently draws it forth and leads it up" from "the barbaric slough."[65] The development of what remains inaccessible to the eyes of the body has found a particularly effective intermediary in the Christian tradition. One of its interests, from our viewpoint here, is that it explores the question of art. When one wonders how to make the invisible seen, if it is licit to represent it, of what nature it must be in order not to betray its mission, one must go deeper into reflection about the links forming, in the visible image and through the manner in which the devout viewer comprehends it, between the material object revealed and the supra-perceptible contemplation that allows access to its ultimate truth.

The multiple debates, particularly about icons and the way they are considered, attest to a vitality, over the centuries, of the question of a possible link between the visible and more substantial realities. Mystics contributed to these arguments and one of them, Maximus the Confessor, suggested an intrication that no doubt would have appealed to Klein:

> And if we perceive what does not appear by means of what does, as the Scripture has it, then much more will visible things be understood by means of

invisible, by those who advance in spiritual contemplation. Indeed, the symbolic contemplation of intelligible things by means of visible realities is spiritual knowledge and understanding of visible things through the visible. For it is necessary that things which manifest each other bear a mutual reflection in an altogether true and clear manner and keep their relationship intact.[66]

André Grabar annotated this text, and willingly or unwillingly gives a splendid justification, if one enters into the logic of Maximus the Confessor, of Klein's prognostications: "This passage . . . declares that the knowledge of the divine background reveals the *spiritual meaning*, that is, the supra-perceptible contained—but not visible—*in visible things*."[67] If one replaces "divine background" with "pictorial sensibility," one understands that, contained in the blue monochrome, it is well and truly present without being visible. This—real—presence can have an effect on the art lover provided that he shows himself to be receptive enough to give it a chance to express itself. That is why, although they all looked the same, the eleven monochromes shown at the Galleria Apollinaire in 1957 could indeed reveal to viewers differences that were as intimate as they were decisive.

A Daring *Ellipsis*

In retrospect, the Milanese exhibition appears to have been the trigger for another conception of the oeuvre, a conception that led the artist to do without the painting, that is, the physical support of the "pictorial sensibility," an entity whose essence is not in any way material. Klein generalized the lesson of his "blue period" when he stated: "The blue period was the initiation of both the public and myself."[68] From then on, he was ready to embark on a "race toward the blue immaterial," a race "toward the invisible reality, toward the non-visual of [his] painting, toward total pictorial reality."[69] The chronology and his own explanations show that, shortly after having

observed the reactions of the art lovers in Milan, Klein drew decisive conclusions from them:

> So I thought the next stage after the blue period [read: as it was presented at the Galleria Apollinaire] would be the presentation to the public of this pictorial sensibility, of this "poetic energy," of this matter intangible liberty in a concentrated, not contracted, state.
>
> It would be a truly informal painting, as it is and should be. So, in my double exhibition in Paris, at Iris Clert's and Colette Allendy's in 1957, I presented, in one room of the second floor at Colette Allendy's a series of surfaces of pictorial sensibility invisible to the naked eye, of course, yet well and truly present.[70]

The first attempt—still rough—that did not resort to the painting to present the "pictorial sensibility" did take place at Colette Allendy's, during the exhibition, which opened on May 14, 1957, the second part of a double exhibition by Klein known under the generic title *Propositions monochromes*. This title, which did not figure on the invitation card, comes from the words of Pierre Restany's text: "Yves Klein's monochrome proposals today define the destiny of pure pigment. This great history of the blue period will be told simultaneously on the picture rails of Colette Allendy and Iris Clert." A compelling document carries us along in the artist's wake in this double exhibition: the film he had made. In color, it opens with the doorway of the Galerie Colette Allendy where we accompany, following the example of the subjective camera, Klein for a guided visit. That is how we attentively examine the panels of a large blue partition that enabled one to be surrounded by color,[71] a monochrome painting whose matter we scrutinize, a rectangle of blue pigments laid down on the floor, a round blue painting (a plate). Then, a wand held by an invisible hand goes through the two groups of four blue volumes arranged perpendicular to the wall from which they project, etc.

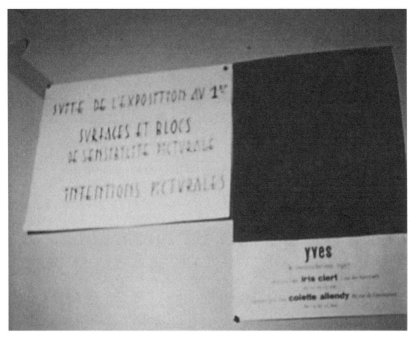

9. "Surfaces and Blocks of Pictorial Sensibility. Pictorial Intentions," poster displayed opposite the stairs, Galerie Colette Allendy, Paris, May 1957.

An effect of the editing leads to a transition with what follows, which is entirely different. At that moment, the reportage style gives way to a short dream sequence, a cut designed to take us into another world. First of all, a white veil[72] with large folds fills the whole screen. In front of this veil, the hanging wands of *Blue Rain*, swaying slowly, help unrealize this brief transition. Then the camera moves down. It makes a young woman appear; she seems to loom up from the lower edge of the frame, a reassuring presence before the leap into the unknown. The visit continues with a static shot that allows us to read a poster displayed near the stairs: "The exhibition continues on the second floor: Surfaces and Blocks of Pictorial Sensibility. Pictorial Intentions" **(fig. 9)**. The appetite thus whetted, the decisive shock was prepared by these signs intended to guide our intellection.

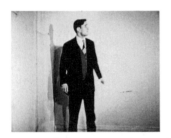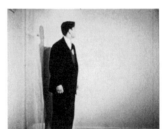

10. Yves Klein presenting a "pictorial intention" in the room reserved for "surfaces and blocks of pictorial sensibility," Galerie Colette Allendy, Paris, May 1957. Stills from the film devoted to Klein's double exhibition at the galleries of Iris Clert and Colette Allendy, *Monochrome Propositions*.

The images of the film then lead us into the room situated on the upper floor. After a close-up on the radiator and its top, Klein enters into shot and stands in front of a blank white wall. There, he mimes for us the presentation of a painting (missing, of course). As if he was going to grab hold of it, a hand on its side, the other supporting it, the artist looks at us, examines his work, inviting us to "see" it as well **(fig. 10)**—this pose echoes the one he had adopted to present his orange monochrome, rejected by the Salon des Réalitiés Nouvelles in 1955, and this characteristic gesture also features in one of the photographs of the taking down of the works exhibited at the Salon Violet in 1962 **(fig. 11, 59)**. Klein then moves toward another wall, white and blank, apparently, and adopts a pose typical of the art lover. He moves closer, steps back, concentrates his gaze, and scrutinizes the invisible presence. Finally, after having sat on top of the radiator, he gazes at the room and his eyes focus on a point, another, to the right, to the left, no doubt captivated buy the "surfaces and blocks of pictorial sensibility" that he has just invited us to perceive. When he gets up, the radiator shelf sways: Klein turns around, carefully *steadies* it so that in no longer perturbs the atmosphere of the room.

The visit continues in the garden, then at Iris Clert's. But the essentials have been put forward, thanks to the presence of the artist and his mimed demonstration. He shows us, using methods inspired by mime, that the apparently empty room is inhabited by "surfaces"

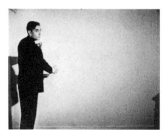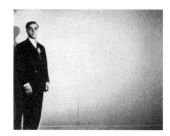

and "blocks" of a "pictorial sensibility" that does not really need the artifices of painting or sculpture to extend into space and affirm its presence. The founding intuition is there: we can have access to this presence without the aid of the painted surface. The eyes, summoned once again, guide us toward another, inner contemplation.

In the educational filmed version, conceived by the artist, the traditional form of the painting, a dematerialized shadow, acted as a switch for a presentification for its essential qualities. Klein transposed a rhetorical figure, *ellipsis*, into the language of gestures. Fontanier points out that it "consists of deleting the words that would be necessary to the plenitude of the construction, but in which those words that are expressed make it well enough understood so there remains neither obscurity nor uncertainty."[73] It's all there: the title given by the generic "label" thumbtacked to the wall at the bottom of the stairs, the artist, his gestures and gaze turned towards his works, the public to which these works are addressed, everything except the material paintings, removed without, however, any obscurity or uncertainty in the act of communication. In an earlier text, Klein, always concerned about explaining and persuading, evoked an experiment that everyone can experience. In its way, its sheds light on the filmed sequence:

> One can carry out the experiment of removing a
> painting, a "real one," from a room where it has

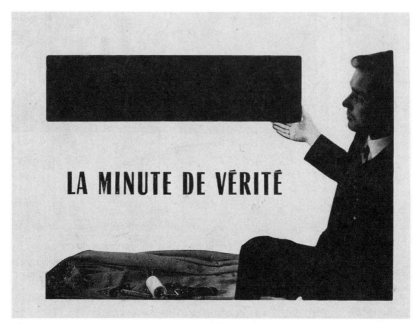

11. Yves Klein presenting an orange monochrome painting, photograph illustrating an article by Pierre Restany, "La minute de vérité," *Couleurs* 18 (December 1956): 10.

stayed long enough to specialize the atmosphere surrounding it; one quickly notices that it is missing because its actual presence was too strong, through the psychological effect of the material support that it represents, to safely lean over the full void of pictorial sensibility.[74]

Several twentieth-century works feature gestures similar to those used by Klein to show absence. Kazimir Malevich, for example, painted a self-portrait[75] signed in the lower right-hand corner with a small image of his *Black Square* in 1933. Seen in a close-medium shot, the artist seems to hold a precious, but absent, object. Even more evident, his head-and-shoulder portrait of a woman worker **(fig. 12)** was painted during the same period. She adopts the position of the

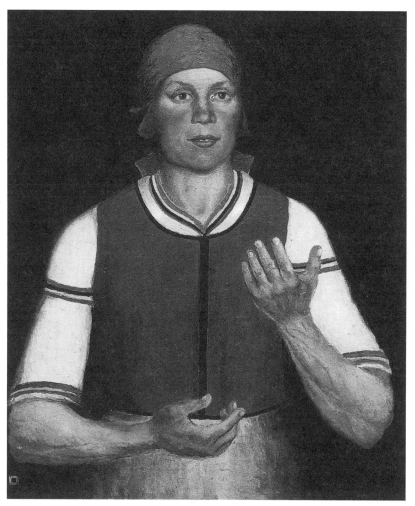

12. Kazimir Malevich, *The Woman Worker*, 1933, Russian Museum, Saint Petersburg.

13. Alberto Giacometti, *The Invisible Object*, 1934, bronze, Fondation Maeght, Saint-Paul-de-Vence.

arms and hands characteristic of a mother holding a newborn and supports his head with a tender gesture. However, the child—memory or hope?—is missing. The work that is closest, at least in terms of its title, to Klein's gestures in his film, is no doubt Giacometti's famous sculpture, *The Invisible Object* **(fig. 13)**. Yves Bonnefoy saw in it a "Madonna without Child."[76] This female figure, which looks like a large pagan idol, seems to protect a precious object between its two hands that is, again, absent. The variations drawn or engraved by the sculptor have another title, *Hands Holding the Void*, a title that resonates with the name given to one of Klein's major creations, the exhibition of the "Void."

Other characteristics of the first presentation of "pictorial sensibility" freed from its material moorings should be taken into consideration. First of all, the presence of the artist, figure of the intercessor watching us, invites us to enter the contemplation of the invisible with him. According to Sidra Stich, the floor was closed more often than not and the existence of the invisible work was only revealed to a small number of friends, always led into the empty room by Klein himself.[77] Pierre Restany, a special witness, confirmed that the artist was keen on accompanying the invisible with his physical presence. In an account of the vernissage of the exhibition, he wrote: "After concentrating, alone, in the room, [Klein] presents it to the public as is, sensitized by his presence. The monochrome painter had just defined his first zone of immaterial pictorial sensibility."[78] The critic later gave another account of the episode, more private, more secret. In this version, after having lit the Bengal lights attached to the *One-Minute Painting*, in front of the public gathered in the gallery garden on the evening of the vernissage, the artist invited his mentor to "remain alone and in silence, with him,"[79] in the second-floor room whose door he closes on the way out. Klein himself goes back over this episode to remind us that this presentation of immaterialized works had not been announced on the invitations and was [reserved] for "some friends," although it was opened to "those who just happened to think about investigating whether there was something else 'to see' upstairs."[80]

The presence of Klein, the corporal incarnation erected opposite the immateriality of the painting, constituted a salutary counterweight to

14. Yves Klein, *Tactile Sculpture*, undated, private collection.

its dematerialization. The artist constantly brought antagonistic polarities into play, establishing between them a relationship that appeared dualistic, but that it would be more accurate to place under the aegis of antonymic logic. That is how he had envisaged presenting at Colette Allendy's—at the same time, therefore, as his invisible "Surfaces and Blocks of Pictorial Sensibility"— one or more tactile sculptures, a project that he was unable to realize on that occasion. They were boxes pierced with holes equipped with muffs through which one would have placed one's hands in order to "feel," without seeing them, the smooth and harmonious figures of naked young women, living sculptures which would have been inside the volumes. Klein, deciding that it would be "a little premature,"[81] preferred to postpone the realization of this idea of which he would later give a toned-down version **(fig. 14)**. But it still reflected the need to establish a carnal counterpoint to the invisible works, which were, strictly speaking, impalpable.

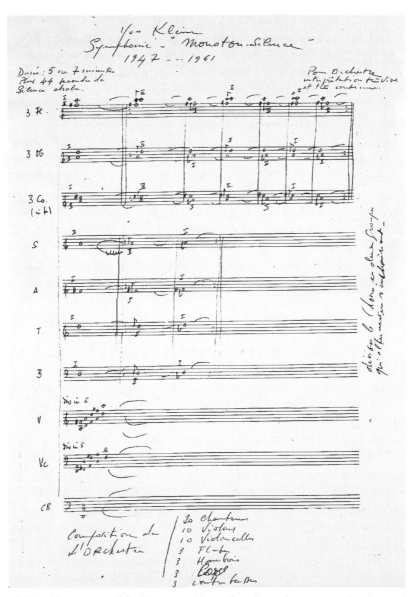

15. Yves Klein, score of The Monotone-Silence Symphony, short version, for choir and orchestra, 1961.

This desire for incarnation, for physical presence, which accompanied the process of dematerialization of the painting, refers to the principal model of Christian thought. A Catholic, Klein was, as noted above, deeply devoted to Saint Rita. He was, of course, aware that the mystery of the Incarnation is the fundamental dogma, the one that enables the advent of Christianity. Jesus Christ was both fully a man and fully God as he will remain for eternity one of the three hypostases of the Holy Trinity, the Christian configuration of the one God—another founding mystery. The Incarnation, moreover, played a considerable role in the recurrent debates on the licitness of the images of an invisible, incorporeal God and the nature of the way in which they should be worshipped, the manner in which they should be considered. The essential point here—Klein was not in the least a theologian—is the dual structure toward which the artist strived. It was at the very moment when he was experimenting for the first time with a presentation of invisible works, that he decided to become "Yves le Monochrome" in the eyes of everyone. Until then, he had been a painter, like his parents. From then on, with the title he had assumed, he incorporated monochromy, proclaimed that he incarnated it.

According to several sources, a version of The Monotone-Silence Symphony **(fig. 15)** was played in the Galerie Iris Clert, on May 10, 1957, during the vernissage of the first part of Klein's double exhibition.[82] The information now seems difficult to verify but the musical work was certainly recorded, at least partially, before 1959, since Klein played a brief extract during his lecture at the Sorbonne on June 3, 1959. In addition to its own qualities, the symphony is emblematic of the general organization of an oeuvre galvanized by the invisible. It remains one of the essential components of a vast artistic and media project whose exhibited structural redundancies affirmed a coherence. What is essential is that this musical work was presented in diptych form. During the first twenty minutes, a single, undifferentiated sound—the sonic equivalent of the monochrome painting—invaded the space, catching the attention of the audience. The following twenty minutes were devoted to silence—the sonic equivalent, if I may say so, of the *ellipsis* of the painting, which had become invisible.

This bipartite structure offers a limpid hermeneutic key to the link constantly reiterated by Klein between the visible and the invisible, the eyes of the body and the eyes of the soul, positive perception and affective reception. To give it its full measure, one must consider it in both senses. The invisible succeeds the visible, and that is the price to pay for the communicational constraints. But running counter to this, the presentation of invisibility sheds a singular light on the monochrome propositions that, while they conform to the enchanting splendors of color, are also devoted to the invisible. Like Christian icons, they invite us to encounter, beyond the visible, the presence of a reality that no line could circumscribe, that no human eye could perceive—here, for Klein, the "invisible pictorial sensibility." His conviction was firmly established then:

> In music, the art does not express itself solely through the sense of hearing or, in painting and sculpture, by the sense of sight. The senses are the tactile organs of our body or physical vehicle intended to enable us to move [around] in the physical world of matter. Nature is more than just physical and material, far from it, far from it! ... If nature, in artistic creations, was only what was perceived by our five senses, we would be rather wretched creatures on earth and in the universe, and rather limited.[83]

It is difficult to say whether the signification of The Monotone-Silence Symphony would have been perceptible in the hubbub of a society party. On the other hand, another element of the vernissage was certainly late to express itself. Klein, or his gallery owner,[84] thought of launching blue helium balloons. On May 10, several bunches of balloons were tied together in front of Galerie Iris Clert on rue des Beaux-Arts **(fig. 16)**. From there, Klein, his friends, and a small crowd of art lovers or passersby went to the nearby place Saint-Germain-des-Prés to carry out the launch. The memory of this spectacular and playful event was refined by the artist who later made it part of his oeuvre as the first *Aerostatic Sculpture*. The idea to indicate the number

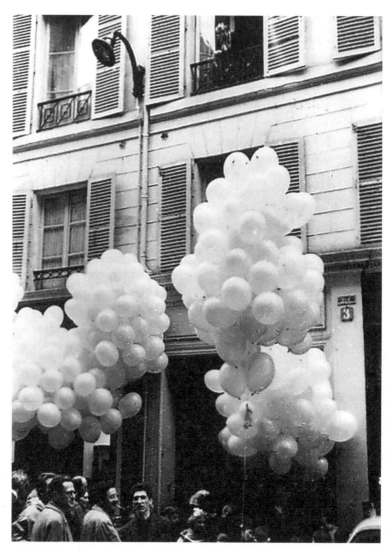

16. The blue balloons of the *Aerostatic Sculpture* in front of the Galerie Iris Clert on May 10, 1957, the evening of the vernissage of Yves Klein's exhibition, before they were brought to the church of Saint-Germain-des-Prés and launched into the sky.

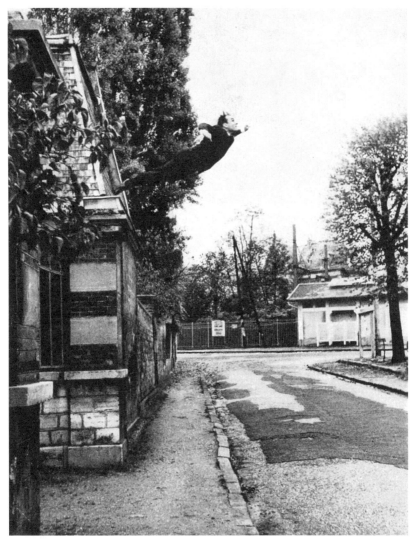

17. Yves Klein, *The Leap into the Void*, 5, rue Gentil-Bernard, Fontenay-aux-Roses, October 1960. Another version of this photograph (with a cyclist in the background) was published by Klein on the front page of his newspaper *Dimanche* (November 27, 1960) with the headline: "Un homme dans l'espace! Le peintre de l'espace se jette dans le vide!" ("A Man in Space! The Painter of Space Leaps into the Void!"). See page 69.

of balloons, 1,001, also came to him afterward.[85] It associated this gesture to the fantastic element through the transparent reference to the tales of *The Thousand and One Nights*. The spoken word is the means by which the seduction is brought about.

Pursuing the reinterpretations initiated by the artist, we can consider the balloon launch a secular Ascension. Without visible help, the balloons rose in the sky where they were destined to disappear. Thus, the invisible paintings of the second part of the double exhibition, at Colette Allendy's, and there, in front of the church of Saint-Germain-des-Prés, the blue attaining invisibility, a lovely extended metaphor of the immaterialization of the monochrome propositions presented in rue des Beaux-Arts. *The Leap into the Void* of 1960 **(fig. 17)** brought the process to completion. The photograph of this action, published in *Dimanche. Le journal d'un seul jour* ("Sunday: Newspaper for a Single Day"—November 27, 1960) is accompanied with a comment by the artist pointing out, notably: "He claims to be able to catch up with his favorite work: an aerostatic sculpture made up of One Thousand and One Blue Balloons, which, in 1957, flew away from his exhibition into the sky of Saint-Germain-des Prés, never to return!"

One final characteristic of the presentation of "Surfaces and Blocks of Pictorial Sensibility" is essential to the comprehension of the process of immaterialization. The visitor who went to the gallery, assuming that he had access to the continuation of the exhibition, or the spectator who visited the exhibition filmed under the direction of the artist, was supposed to have seen various blue works before going upstairs, going up toward the sky where the physical presence of the paintings was no longer required, to feel the effects of a pictorial sensibility purged of matter. The relationship between the visible—below—and the invisible—higher up—is one of the fundamental requirements for the success of this rash endeavor: a fleshly being endowed with corporeal senses, the spectator must rely on the reality of his existential condition if he wants the chance to escape it. What's more, the presence of the invisible should be designated, not to say interpreted, through language, an excellent link between a sensorial reception and an ideal comprehension. In the Galerie Colette Allendy, the poster pointing out the continuation of the exhibition unequivo-

cally indicated the presence of an invisible sensibility. A wise precaution: to believe, one must know to what it would be proper to attach faith.

Semi-private, this endeavor was barely mentioned in the press[86] (fig. 18) or elsewhere and should be considered a trial, designed by Klein to test the validity of his intuition. This trial must have seemed sufficiently conclusive for him to decide to make it as glamorous as it was daring. While he was getting ready to produce a spectacular presentation of the pictorial sensibility, the artist wrote a text for the first issue of the magazine *Zero*, in which he discussed his approach and explained his intentions:

> Thus I have pondered whether even color [line, drawing, has long been the object of a sentence without appeal], in its physical aspect, has become finally for me also a limit and a hindrance to my effort to create perceptible pictorial states.
>
> In order to reach Delacroix's "indéfinissable," the very essence of painting, I have embarked on the "specialization" of space, which is my ultimate way of treating color. It is no longer a matter of seeing color but of perceiving it.
>
> My recent work with color has led me progressively and unwillingly to search for the realization of matter with some assistance (of the observer, of the translator), and I have decided to end the battle. My paintings are now invisible and these I would like to show in my next Parisian exhibit at Iris Clert's, in a clear and positive manner.[87]

The exhibition he was preparing when he wrote this text was supposed to open on April 28, 1958, his birthday. Yves Klein was thirty years old and the vernissage organized that day was a considerable success. The exhibition itself quickly became a legend. It is still considered one of the seminal events[88] in twentieth-century art.

Yves

L'expérience tentée par Yves fait apparaître certain paradoxe dans l'opinion. Elle fait apparaître la profonde antipathie entre couleur et peinture. Ce n'est qu'à ce prix qu'on peut refuser la légitimité de l'entreprise. Mais on peut essayer de le suivre.

Tout dans cette affaire a été mis à contribution pour créer cette évasion et plus encore peut-être cette détente dans un bain de couleur. Surface et perspective, pigment et reflet, physique et mental, présence et mémoire.

Une seule couleur étendue indistinctement sur des toiles ou des sculptures réalisent cet enveloppement de bleu, ce bleu par pénétration et par saturation. C'est à la première phase, la phase, si l'on veut, picturale. Mieux encore, le moment de la contagion, celui où se se donne libre cours le charme de l'individualité du bleu, l'instant de sa liberté.

Ensuite isolement, murs blancs, chambre claire sans aucun tableau. Seul demeure le reflet, les murs réceptifs à l'envoûtement révèlent la présence du bleu sans aucun support. Que s'est-il passé? On hésite : surface neutre ou blancheur contrariante? S'agit-il d'une persistance rétinienne et physique ou d'une persévération de l'esprit alourdi de sa drogue?

L'expérience d'Yves prouve l'extraordinaire puissance de la persuasion. Rien n'est là, tout est là.

Les goûts et les couleurs n'existent pas. Il n'y a que des habitudes sans valeur. C'est sur les amours contrariées de deux ou trois anthropoïdes complexés (moins bêtes que les autres, plus doués en tout cas) qu'on a bâti la légende amoureuse de l'humanité. De même pour la couleur. Sans grands rapports avec les yeux, elle doit tout aux fortes têtes.

L'incident clos n'est pas clos. C'est un dossier ouvert et signalé. (Galeries Allendy et Iris Clert.) J. A.

18. This article, "Yves", by J. A. (Julien Alvard), *Cimaise* (July–August 1957): 34, features on a page in one of Yves Klein's press books.

Celestial Eclipse

Painting no longer appeared to me to be
functionally related to the eye.[89]

Yves Klein had meticulously prepared the exhibition that went down in history as the "Exhibition of the Void." This description, immediately comprehensible beneath its provocative appearance, has the merit of being clear but it glosses over the essentials, what the artist attempted to have the public experience. Since then, interpretations do not take into account at all the explanations given on various occasions by Klein are eternally repeated. Incomplete, they contribute to the persistence of a misunderstanding. That is why, and although this exhibition was apparently very well-known, it is vital to give a precise account of the elements of the exhibition, entirely organized around the relationship between blue, on the outside, and the invisible pictorial sensibility, in the heart of the gallery, again comprising a diptych with undeniable didactic virtues.

This exhibition, which immediately became famous, dramatically confirms the conviction expressed by the artist: "The paintings are but the ashes of my art."[90] It remains to explain why—not without excellent reasons—Klein did not stop painting, developing the way of the Incarnation at the very moment he was conceiving his "Relinquishments of the Zones of Immaterial Pictorial Sensibility."

The Immaterialization of Blue

In the early evening of April 28, 1958, two republican guards in their ceremonial uniforms were on sentry duty in front of the building

Iris Clert vous convie à honorer, de toute votre présence affective, l'avènement lucide et positif d'un certain règne du sensible. Cette manifestation de synthèse perceptive sanctionne chez Yves Klein la quête picturale d'une émotion extatique et immédiatement communicable. (vernissage, 3, rue des beaux-arts, le lundi 28 avril de 21 h. à 24 heures). Pierre Restany

19. Invitation to the vernissage of the exhibition, later known as that of the "Void," on April 28, 1958, Galerie Iris Clert, Paris.

20. Yves Klein, *Exasperations 1958*, project for an envelope written and drawn in blue pencil.

housing the Galerie Iris Clert. The artist had wanted them to be there to impart upon the vernissage of his exhibition the dignity befitting major events. The art lovers invited knew Klein as one of the most radical representatives of the pictorial avant-garde. Undoubtedly rare were those who knew what was waiting for them in the gallery when they arrived at rue des Beaux-Arts. They had all received invitation

iris clert 3, rue des beaux-arts - paris - dan 44-76

exaspérations monochromes

de Yves KLEIN

l'air et l'eau

sculptures de KRICKE

21. Advertisement for Yves Klein's exhibition at the Galerie Iris Clert, published in *L'Oeil* (May 1958).

iris clert

3, rue des Bœux-Arts, Dan 44 - 76

PARIS 6e

Jusqu'au 5 mai

YVES le monochrome 1958

à partir du 20 mai

les Olympiens peintures d'ARMAN

22. Advertisement for the exhibition *Yves le mono-chrome* at the Galerie Iris Clert, published in *Art international* (May–June 1958).

cards printed in blue italic longhand **(fig. 19)**—"for the solemnity"—and above all in embossed letters "so that the blind may read it (and they are all blind!)."[91]

The event was not called "Exposition du vide" ("Exhibition of the Void"), and Klein had not yet provided the first title that he had publicly used for it, the following year: *La Spécialisation de la sensibilité à l'état matière première en sensibilité picturale stabilisée* (*Pictorial Sensibility in Raw Material State, Specialized as Stabilized Pictorial Sensibility*[92]). While he was preparing this exhibition, the artist most probably intended to use another title, less technical and more evocative: *Exaspérations monochromes.* There is a project for an envelope **(fig. 20)**, written and drawn by the artist exclusively in blue colored pencil, in the Yves Klein Archives. In addition to the address and blue stamp, it features this inscription, which was probably printed in "italic longhand" near the upper edge of the envelopes meant to contain the invitation card, *Yves Le Monochrome, Exaspérations 1958*. An advertisement published in *Cimaise* (March–April 1958) took up this wording: "'Monochrome Exasperation' by Yves Klein from April 28." Another advertisement, published in *L'Oeil* (May 1958), stipulates: "*Monochrome Exasperations* by Yves Klein") **(fig. 21)**. In the singular or in the plural, it is the title chosen when Iris Clert took out these advertisements.[93] In a magazine that was published a little later, the exhibition, which had already opened, was announced quite differently: "To May 5, YVES the monochrome 1958" (*Art International*, May–June 1958) **(fig. 22)**. The invitation card for the vernissage of, "this event of perceptive synthesis" did not mention a title, neither on the back, left blank, nor on the front, on which were printed practical information and a text by Pierre Restany:

> Iris Clert invites you to honor, with all your affective presence, the lucid and positive advent of a certain reign of the perceptible. This demonstration of perceptive synthesis marks the successful conclusion of Yves Klein's pictorial quest for an ecstatic and immediately communicable emotion.

This invitation, 3,500 copies of which were sent out, was slipped into an envelope and stamped with the blue stamp that Klein had already used to mail the invitation to his double Paris exhibition the previous year **(fig. 23)**. Before being confronted with the apparently bare walls and empty space, the art lovers thus saw an evocation, in miniature, of the blue monochrome paintings that they had had the opportunity to view at Iris Clert's or Colette Allendy's. There were other reminders. The window of the small gallery and the windows of the front door of the premises were painted blue up to a certain height, so that from the street, no one could see what was exhibited inside. The door itself was blocked up. The visitors had to go through the main door of the building to get into the gallery from the lobby. This main door was swathed in blue drapery **(fig. 24)**. After having bumped into the blue opacity covering the window, one had to cross this blue dais and break through to the other side of color to reach the unknown.

Before they went inside the gallery, the visitors were invited to partake of a blue cocktail (gin, Cointreau, and methylene blue). Inscribed in the memory, reactivated by its peripheral presence, blue was also incorporated. Invisible, it lodged itself within the body of every one of those who were about to become eye witnesses of its immaterialization. This preparatory communion with the emblematic color of the artist, himself the living incarnation of monochromy, constituted the last element of the preparatory measures. Klein unequivocally stated:

> In this way, tangible and visible Blue will be outside,
> on the exterior, in the street, and, inside, there will
> be the dematerialization of Blue.[94]

The ultramarine blue present in rue des Beaux-Arts should have also shone in the Paris sky. Klein had obtained authorization to illuminate the obelisk in place de la Concorde in blue. During the trials a few days earlier, Iris Klein and the artist were in raptures at this "enormous unpunctuated vertical exclamation mark,"[95] which seemed to levitate in the night sky **(fig. 25)**. The origins of the obelisks are uncertain, but Egyptologists all agree that the monoliths erected

23. Envelope with blue stamp containing the invitation to the vernissage of the exhibition, later known as that of the "Void," on April 28, 1958 (Galerie Iris Clert, Paris), addressed to Yves Klein by himself.

24. View of the Galerie Iris Clert, window painted blue, and the entrance to the building, draped in blue, for Yves Klein's exhibition, April 28–May 12, 1958.

in front of temples—the place de la Concorde obelisk rose in front of the entrance of the Temple of Amon, built during the reign of Ramses II—were linked to the cult of the sun, whose radiance they perhaps symbolized. We now know that the tops of the obelisks—the pyramidions at least—were covered in gold. Klein was likely enchanted by this additional complicity between the blue of the sky and the gold of the sun's rays symbolized by the obelisk. Rising in the azure sky, they expressed in the clearest way possible the relationship, placed under the sign of the fire that burns inside this star, between the color surrounding the immaterial work and the gold—gold that would serve, we will see, as a trading currency with the "immaterial pictorial sensibility." Unfortunately, the authorization initially granted was cancelled at the last minute by the police.[96] This regrettable decision did not in any way mar the intelligibility of the project, which was diffuse enough to preserve its efficacy. The fundamental link between "material and physical Blue, waste and coagulated blood, born of the raw material sensibility of space"[97] and the "immaterial pictorial sensibility" was so clearly inscribed in the project conceived by the artist that it would be difficult to be unaware of it.[98]

The evening of the vernissage, young judokas, Klein's students, led the guests through the hall—a sort of narthex—in groups of ten, toward the inside of the gallery where Klein, in evening dress, was waiting for them. Accustomed as they were to the surprises organized by avant-garde artists, the art lovers present were no doubt stunned: the gallery appeared absolutely empty. No paintings were hung on the white walls; in the space or on the floor, there were no sculptures or other constructions that could pass for a work of art (fig. 26). At the time, no one thought to consider the group of elements that made up the event, from the invitation to the blue cocktail, including the blue dais, etc., as an interdependent whole, a parergon incorporated into the work like the frame when, painted by the artist, cannot be replaced without damage to the integrity of the work with which it is interdependent.

A color film allows us—today still—to cover the stages of the itinerary conceived by Klein that were part of his exhibition for the same reasons as the "empty" room to which he leads us. First of all, the

25. Yves Klein, illumination in blue of the obelisk in place de la Concorde, Paris, "Conceptual work produced by the Musée National d'Art Moderne in association with the City of Paris on March 1, 1983, to mark the inauguration of the retrospective exhibition of the artist's work at the Centre Pompidou," postcard published by the Amis du Musée d'Art Moderne de la Ville de Paris.

camera shows the street (the secular environment), shot from below. The emphasis is on the sky. Then successively appear the window partially covered with blue, the dais surrounding the main door of the building, the hall, a blue curtain that one must pull apart to enter the gallery interior, and the *cella* whose door is draped in white here. The camera goes around it, lingering on the immaculate, white walls, presented in close-up. But the film is silent. Therefore, the curious viewer, left wanting more after having watched this visual demonstration, should obtain further information by listening to the artist himself giving further explanations to his audience on June 3, 1959, during the lecture "The Evolution of Art Toward the Immaterial," whose invitation card employed typography used for the "Void" exhibition invitation **(fig. 27)**:

26. Interior view of the Galerie Iris Clert, bare walls, empty display case, and entrance draped in white, during Yves Klein's exhibition, April 28–May 12, 1958.

With this attempt I set out to create, establish, and present to the public a pictorial sensible state within the confines of an exhibition gallery of ordinary painting. In other words, to create an ambience, a pictorial climate that is invisible but present in the spirit of what Delacroix in his journal called "the indefinable," which he considered to be the very essence of painting.

This pictorial state, invisible within the gallery space, should in every aspect be the best definition of painting yet given, that is to say: radiance. Invisible and intangible, this immaterialization

of the painting should act, if the creative process is successful, upon the vehicles or sensible bodies of visitors to the exhibition much more effectively than visible, ordinary representative paintings, whether they be figurative, non-figurative, or even monochromes.[99]

One will have understood, despite the absence of visible works, the gallery was not in the least empty. Its space was, on the contrary, saturated with what constituted the intrinsic quality of every good painting: the pictorial sensibility. It was even more present as there was nothing else in this space at the time.

Here, we are in a position to understand better the surprising status given to his paintings by the artist himself: "I don't really believe in painting-painting: for me, it is only, at the most, an exercise. My monochrome paintings are not my definitive works, but the preparation for my works. They are leftovers from the creative processes, the ashes."[100] Ash is comparable, from a semiotic point of view, to smoke. While smoke is the sign of an active fire, ash is the sign of a spent one. Like ash, the paintings testify for posterity. But they testify to an aim that denies the aesthetic gaze. The beauty of the sign must not make us forget the other side of the sign, here what the artist calls "the immaterial pictorial sensibility," a sensibility that concerns the "aura," if one believes in the intuition expressed by Klein in these terms: "My art is not behind 'the ashes' that are my works, but inside and around, like an aura of these ashes."[101] Thus, the materiality of the paintings, the variety of their appearance is secondary, or even insignificant. The variety of the texture of the monochromes could mislead us if we understand it as an exploration of facture (tactile handling)—giving the concept, *faktura*, the meaning that the Russian constructivists ascribed to it. The appearance of the monochromes has to be captivating enough to give rise to an attentive and benevolent gaze, but a gaze intended to transform itself into inner contemplation. The fact that these works are striking matters, and at the same time counts for little, since it is a question of seeing something else, and seeing it differently.

*Le Conseiller Culturel
près l'Ambassade de la République Fédérale d'Allemagne
Bernard von Tieschowitz
vous prie d'honorer de votre présence les deux communications faites
sur le thème de "L'Evolution de l'Art vers l'Immatériel"
par M.M. Yves Klein
et Werner Ruhnau, architecte
Le Mercredi 3 Juin à 21 heures précises
et le Vendredi 5 Juin à 21 heures avec projections
à la Sorbonne, Amphithéâtre Turgot 17, rue de la Sorbonne.
Invitation valable pour deux personnes dans la limite des places disponibles.*

27. Invitation to the lecture given at the Sorbonne by Yves Klein on June 3, 1959: "L'évolution de l'art vers l'immatériel" ("The Evolution of Art toward the Immaterial").

To present an "invisible pictorial state within the gallery space," Klein had painted the walls white. It seemed necessary to him to clear the atmosphere of the "impregnations of previous exhibitions," and he hoped to appropriate the space in order to make it his "space for work and creation," his studio:

> In order to specialize the ambiance of this gallery, its pictorial sensibility in the raw material state, into an individual and specific, autonomous and stabilized pictorial climate, I must, on one hand, whiten it so as to wash away the impregnations of the many previous expositions. Through the act of painting the walls white, I desire, by this act, not only to purify the setting, but also, and above all, by this action and gesture, momentarily to make it into my space for

work and creation—in a word, my studio. . . . In not playing the role of a house painter, which is to say, by giving free rein to my own facture, to my painterly gesture, free and perhaps a little distorted by my sensual nature, I believe that the pictorial space that I have previously managed to stabilize in front of and around my monochrome paintings will henceforth be well established in the space of the Gallery.[102]

Confronted with an event in which the only painting present—but not presented—was that of the freshly painted walls, critics, when they did not content themselves with scoffing at the exhibition, stressed the only concrete element likely to hold their attention: the white walls, perceived as *monochromes*.[103] These critics thus showed themselves to be reliant on a restrictive conception of the exhibition, limited to what happened in the gallery when it should not have been separated from its visual and discursive surroundings. If one takes into account the whole of the exhibition, it is problematic to consider the walls white monochrome frescoes. Klein thought it was indispensible to spirit away the paintings better to affirm that which comprises their real value, the power of their radiance. Thus, and despite appearances, the gallery that hosted this "immaterial pictorial radiance"[104] could not be empty, since it was entirely filled, saturated. Getting back to his intentions once more, the artist stated to the audience in a Sorbonne lecture hall:

A sensible density that is abstract yet real will exist and will live by and for itself in places that are *empty in appearance only*.[105]

The artist invited the visitors to follow the progression of the visible blue becoming invisible,[106] to accompany it on its "race toward the blue immaterial . . . toward the invisible reality, toward the non-visual of [his] painting, toward the total pictorial reality."[107] If he did manage to pull it off, it was indeed the "immaterial blue color"[108] that was presented in April 1958. It goes without saying that this "authorized

account" has no more hermeneutic legitimacy than the interpretations produced since then by commentators, but also no less. It is always useful to consider what artists wanted to realize, be it to observe that they have failed or have succeeded in doing something else.

However, while Klein gave perfectly clear explanations, he sometimes helped cloud the issue. Thus, giving the name "pneumatic period" to the phase following his "blue period," which saw the continent of an invisible reality open up, did little to facilitate comprehension. The locution refers to a mundane reality for those who were unaware of the philosophical or religious meaning of pneuma—"breath" in Greek. Very few of the visitors to his exhibition knew that the notion of pneuma, a spiritual principle mentioned by the Stoics, had also existed in the early days of Christianity, when the Gnostics affirmed the existence of a "pneumatic" world opposed to that of the Hylics, men whose focus was on material realities. For that matter, Klein never really explained this reference to pneuma.

Furthermore, the titles proposed by the artist in 1959 for his April 1958 exhibition at Iris Clert's were not only more or less incomprehensible, but also difficult to remember (*Pictorial Sensibility in Raw Material State, Specialized as Stabilized Pictorial Sensibility*, then *The Specialization of Sensibility in Raw Material State into Stabilized Pictorial Sensibility*). Faced with the absence of paintings or any other visible work in the gallery, the critics did not fail to mention "the Void." Klein and Restany quickly adopted the term, usually between quotation marks in their writing and often with a capital V. It was likely to stimulate the imaginations of their contemporaries. A fairly widespread knowledge of Zen Buddhism, at least by hearsay, and more generally of Far Eastern thought, makes us hopeful that the void might not always be as empty or futile as it seems. This way of concept from another civilization fascinated many Westerners. In 1959, for example, Jean Grenier gives the example of a hypothetical Chinese custom to expound his thought. The chapter he dedicates to "the poetry of space" opens with this anecdote:

> Apparently in China, concerts reserved for very close friends or very enlightened amateurs are

sometimes organized. If a European manages to become part of this select audience, he is dumb-founded: all the musicians are in their places and playing their instruments, but in such a way as to produce no sound; the flute is very near the mouth and the drum is very near the drumstick. But all contact is studiously avoided. Which does not prevent the orchestra from mimicking the gestures made by other orchestras. The audience . . . experiences pure pleasure at the progression of notes that it *could* hear but . . . no longer needs to. . . . In other words: an actual performance would make him feel very ill at ease.[109]

The success of the exhibition organized in "response" to Klein's by his friend Arman in the same gallery led to the replacement of the titles the artist proposed in 1959 for his April 1958 exhibition with another title—much clearer, but also perfectly misleading—and which people began using right away. Arman filled the space, from the walls to the ceiling, with garbage so that no one was able to enter it **(fig. 28)**. Inaugurated on October 23, 1960, *Le Plein* ("The Full"), formed an antithetic couple with "Le Vide" ("The Void"), and was immediately proclaimed as such by Restany, who wrote for the invitation card of this event: "Up to now, no gesture of appropriation at the antipode of the Void had ever so closely defined the authentic organicity of contingent reality."[110] Shortly afterwards, Klein, who had left Iris Clert's gallery to join that of Jean Larcade, leaped into the void in front of obliging photographers. *A Man in Space*, the famous photograph—in actual fact, a photomontage—of the event, which he published in *Dimanche. Le journal d'un seul jour* **(fig. 29)**, is commented on in an article, "Le peintre de l'espace se jette dans le vide!" ("The Painter of Space Leaps into the Void!"). The four pages of this publication explore the theme of the void. It includes articles entitled "Théâtre du vide" ("Theatre of the Void"), "Capture du vide" ("Capturing the Void"), and "Viens avec moi dans le vide" ("Come with Me into the Void"). The front page features a box stipulating that "La Révolution bleue continue" ("The

28. Arman preparing his exhibition *Le Plein*, Galerie Iris Clert, Paris, October 1960.

Blue Revolution Continues"), but the damage was already done. The void imposed itself. While it is easy to understand how the immaterialization of blue led to the "void" (visible), it is much more difficult, indeed impossible, to infer this immaterialization from the encounter with the bare and silent void.

In a text published in the magazine *Zero* in July 1961, Klein mentions his "first presentation of the 'VOID' at Colette Allendy's in 1957" and also proposes a fable as an explanation of his approach:

Today I feel—thinking of everything that has happened—like the worm in the Swiss cheese of the history of science, which eats its way forward, making holes. It creates an empty space around itself and moves on . . . From time to time, it meets a hole, which it must circle around in order to move forward, in order to live, to have something to eat! One day there is no more cheese, because it has eaten the whole thing; there is nothing but emptiness, an enormous emptiness. Then it hovers in space, free and happy . . .[111]

This fable, like Klein's other explanations, did not really manage to explain the need for an initial material presence. And yet it was essential to the fulfillment of his intention: to go back from the visible to the invisible, to bring out the real qualities of the painting—previously prisoners of matter—to succeed in presenting, at the end of the itinerary, of the story, the "immaterial pictorial sensibility" directly. The attractive power of the void is such that it has nevertheless imposed itself, driving into oblivion the process of the immaterialization of blue that, like the cheese eaten by the mouse, ends up disappearing. Klein's great strength lay, on this occasion, in having built a narrative that, from step to step, from presentation to presentation, was supposed to lead us to understand his intentions, to experience his own adventure in his shoes.

Klein demonstrated, in this case, a remarkable artistic competence by inventing formal means capable of inscribing his intentions in reality. Before him, other artists were confronted with the tricky problem of making the invisible perceptible by relying on the visible. Byzantine painters could not content themselves with hoping that believers would look at their works with the eyes of the spirit as much as with the eyes of the body. André Grabar evoked the problem raised by their paradoxical situation, since they should have, in a manner of speaking, "made the invisible visible," and he lists the various formal responses developed then:

29. Yves Klein, *Dimanche. Le journal d'un seul jour*, November 27, 1960, front page.

To guide the viewer, some special signs were invented, such as, for example, the disk of light surrounding the theophanic visions. But it was also thought that by reducing in the extreme the points of contact between figuration and material nature, the supra-sensible could be better evoked. Therefore, volume, space, weight, the usual variety of movements, shapes, and colors were eliminated. 'Dematerialized' in this way, figuration seemed truer to the Intelligible.[112]

Byzantine artists worked in a world entirely permeated by religious faith. In such a context, no one called into question the legitimacy of the problem they faced, not even the Iconoclasts whose radical solutions consisted of renouncing images, even images meant to lead believers to regions where no representation could have currency. Klein lived in a secularized world still tinged with positivism, where the fantastic element, fable, and the mysteries found refuge in a few oases reserved for their frequentation. One of these oases, art, called for, if not faith, at least the lifting of its ban. Art lovers were often *believers* and the museums where they carried out their devotions were, to begin with, considered "temples." Experts in religious practices like their forbears, they gathered near their idols, organized pilgrimages to touch the eyes of the most venerable relics, split into intolerant cliques, and excommunicated those who celebrated false gods.

In actual fact, it is not really essential to be a believer to be interested in art, but one must at least like to be confronted with stories, tales, and fables, the stories—some prefer to say "logic"—that underlie each of the remarkable creations left for us to judge. A single essential requirement remained, beyond the infinite diversity of the things said, of the explicit or underlying intentions: that form acquire the plenitude conferred by coherence.

The formal means employed by Klein were equal to his intentions, whatever we might think of those intentions. Born after the upheaval that was abstract art, he succeeded in reconciling, in the same movement, the efficient memory of the painting and the iconoclasm

of its renunciation. Here, the intensity of the radiance of his blue monochromes serves as a guarantee. The artist used this guarantee of quality as a base to promote a speculative construction that articulated in a poetic gesture the visible, the blue, and the invisible, the presence of its radiance then promised only to the eyes of the spirit. Stéphane Mallarmé scattered black words on the white page. Klein took another throw of the dice. Blue was expelled beyond the walls, but still resonated in the white space. In both cases, as Mallarmé writes, "Nothing will have taken place but the place, except perhaps a constellation."

To measure the formal success of Klein's 1958 undertaking, it would probably be useful to compare it with Frantisek Kupka's vague project or the semi-failure of Warhol's *Invisible Sculpture*. Kupka evoked the possibility of doing without the support in a visible form, but never attempted to carry out such a project, probably since he could not conceive of *how* to do it. Thus his intuition pertained to the domain of scientifico-artistic reverie based on many short-lived parapsychological utopias:

> In light of the progress being made just about everywhere, one would have grounds for believing in the possibility of new means of communication, as yet unknown, say, of more direct communication that would take the path of the magnetic waves used by hypnotists. In this respect, the future holds surprises for us. One could expect the invention of an X-ray capable of revealing the subtlest events, at present invisible or badly lit, both from the outside world and the soul of the artist. By improving more and more the technical means at their disposal, perhaps artists will one day succeed in making the viewer a witness to the very rich life of their subjective world without being obliged to carry out the arduous task that today comprises the making of a painting or sculpture.[113]

Much later, Andy Warhol reduced his "arduous task" so much that his *Invisible Sculpture* almost sank into oblivion. In a New York nightclub in 1985, he stood in front of a label put up on the wall behind him for a moment: "Andy Warhol, USA, *Invisible Sculpture*, mixed media, 1985" **(fig. 30)**. A photographer captured the scene. Warhol was interested in the void. A few terse statements testify to this: "*I really believe in empty spaces*, although, as an artist, I make a lot of junk. Empty space is never-wasted space. Wasted space is any space that has art in it."[114] Also: "My favorite piece of sculpture is a solid wall with a hole in it to frame the space on the other side."[115] But when he put this into action, after Klein, after the conceptual artists and Robert Barry in particular[116]—fascinated for a while by the void and the immaterial—after the publication of Lucy R. Lippard's book, *Six Years: the Dematerialization of the Art Object from 1966 to 1972*, Warhol this work aside. For want of surroundings, for want of articulations thought of when setting it up or incorporated later, it remains uninterpretable, literally unfathomable. For want of an elaborate presentification, in the absence of any later echo in the oeuvre of the artist (who died in 1987), it was transformed into, at best, a devalued sign of the invisible, a mere symptom of trivialization.

Faced with this crude bareness—a striking counterexample—the merits of the endeavor presented with such care and brilliance by Klein at Iris Clert's come vividly to light, despite the later faux pas relating to its naming, the only poorly handled element. If one believes the artist, the reception of this work partially shielded from the vagaries of the visible, was a success **(fig. 31)**. During his Sorbonne lecture, Klein declared:

> It was a complete success and the press was forced to note this phenomenon and acknowledge that it had observed 40% of the contacted public in this apparently empty room captivated by something that is certainly highly effective, for many people who entered in a state of fury emerged satisfied [*laughter*], commenting upon and discussing in a

30. Andy Warhol in front of the label for his *Invisible Sculpture*, The Area, New York, 1985.

serious and positive manner the real possibilities of such a demonstration.

I think I should also say that I even saw numerous individuals enter and, after several seconds, burst into tears for no apparent reason, or begin to tremble or sit themselves on the floor and remain there for whole hours without moving or speaking. . . . All this greatly astonished me and, I must acknowledge, still greatly astonishes me today.[117]

MANIFESTATION D'AVANT-GARDE

A LA GALERIE IRIS CLERT

EN dehors de tout un côté tapageur et qui déplait, il ne saurait être question de ne pas situer cette manifestation.

Yves Klein dont nous connaissons les recherches sur la valeur de la couleur pure, essaie ici d'aborder la synthèse de la lumière elle-même et cela sans intellectualisme et sans jeu de l'esprit. Ce n'est donc pas un canular mais la reconnaissance d'un pouvoir, d'une magie de la couleur. Le verbe s'incarnant fut pour l'homme le début du temps de la confusion, la séparation de sa vie spirituelle et de sa vie biologique. La magie ici est certaine. On ressent tout d'abord une sensation physique. C'est la rupture avec un humanisme conventionnel, c'est l'annonce d'une nouvelle démarche.

Le visiteur sent qu'il lui est difficile de se contenter des dimensions fragmentaires qui jouent alternativement, le laissant le plus souvent sur sa soif. La galerie apparaît alors comme une antichambre où le temps est dépassé et où le passé et l'avenir n'ont plus de raisons d'être. Bien plus encore l'abstraction s'avère inutile puisque nous sommes devant une concrétisation de toutes possibilités, de toutes puissances. Il nous est difficile de ne point songer alors à la vanité des choses humaines, car l'être humain prend sa vraie valeur c'est-à-dire devient membre d'un monde cosmique et non plus le seigneur présidant à toutes choses.

Le peintre Wilfredo Lam qui est présent re-

garde de toute sa chair et exprime son ravissement devant cette nouvelle virginité recréée où l'espoir est non seulement permis mais est tout puissant. Pour lui c'est encore une synthèse totémique, une invocation permanente de tout ce qui fait la joie. C'est aussi autre chose, la rencontre avec la loi des nombres. En effet, le visiteur se mouvant dans la galerie peut sentir les axes différents et variables, sous lesquels il discerne de nombreuses magies et d'incalculables pouvoirs donnés par l'unique couleur.

Yves Klein se propulse avec tout son instinct et la monochromie chez lui est une valeur essentielle. La densité de la couleur qu'il choisit refuse toujours tout assemblage avec les autres couleurs car il la fait, il la rend possessive et exclusive. Cette démarche prend donc la valeur d'un « commencement d'autre chose », d'un autre règne. La défense du blanc est encore plus virulente car le bleu choisi pour l'extérieur de la Galerie devient comme un no man's land, s'offrant entre la tradition accoutumée, la routine désuète et appauvrissante et ce qu'Yves Klein nous propose comme

« le vierge, le vivace, le bel aujourd'hui ».

Le public réagit d'une manière asez étonnante et l'on peut affirmer que 40 p. 100 des visiteurs restent là, pénétrés de la magie de la couleur se demandant avec intérêt quelle aventure se déroulera après l'audace de ce vivant recommencement.

31. This article, "Manifestation d'avant-garde à la Galerie Iris Clert," by C. R. (Claude Rivière), *Combat* (May 5, 1958): 7, features on a page in one of Yves Klein's press books.

The end of this sentence is punctuated with peals of the audience's laughter. Daring and precise when it came to his work, Klein sometimes defused the seriousness of his undertakings with manifestly excessive comments that would not be disavowed by a hostile critic inclined to mock an audience whose reactions were unauthentic. Much later, one of them attacked a Robert Ryman exhibition: "In any case, it's white, white, white. And that, exactly, is what is interesting, etc. I saw a young man sitting on one of the benches, deep in thought in front of a white

canvas. One realizes that there is a madness that is truly of our century in what has been presented to us as modern art."[118]

Be that as it may, the critic was not as understanding as the public described by the artist. A column in *Le Monde* sums up press reaction:

> "Revolution through the Void" (*Arts*); "Exhibition of White" (*La Croix*); "Long live nothing!" (*Noir et blanc*): this is how the press saw Yves Klein's latest exhibition. . . . "Where are the paintings?" asks the visitor who has ventured into this tabernacle; Klein's response goes further, when all is said and done, than his joke: "In his journal, Delacroix set great store by the concept of the indefinable. I make it my essential material, systematically using it: the painting, by dint of being indefinable, makes itself absence."[119]

The Krefeld *Cella*

Before turning to another aspect of an overall project that was more homogeneous than it appeared—the emphasis placed on the body in its living, active, and sensual concreteness—let us make a digression in the thread of the chronology in order to stress the possibility of a perpetuation of a dazzling but ephemeral event.

Since 1954, the Kaiser Wilhelm Museum in Krefeld has had a villa, built by Mies van der Rohe in the 1920s, at its disposal. Its owner, Ulrich Lange, placed it at the disposal of the museum for exhibitions of contemporary art.[120] Invited to present a retrospective of his work there, Klein replied immediately to Paul Weber, the director of the museum: "I am very enthusiastic about being contained in the beautiful building by Mies van der Rohe." In this letter, the artist indicated what he would be "able to furnish for the exhibition." As well as the presentation of existing works, Klein suggested the materialization of projects that meant a lot to him on the theme of fire. Moreover, he wanted to revive his 1958 exhibition:

An empty room should be reserved for the speciali-
zation and the Stabilization in the atmosphere of
my "Void" volume of the *immaterial pictorial sensi-
bility*. Pneumatic period.—Then for my very latest
initiative of today (even though it is a very old
problem for me, taken up once again today), "the
Anthropometries of the blue period."[121]

In this first formulation, the invisible and the body remained
directly connected. The artist also asked his correspondent to send
him a plan of the rooms that would be reserved for him, as well as of
the garden, in order to be "even more precise."

In November, Klein drew a rough plan[122] of the hanging and posi-
tioning of his works in the space of the Museum Haus Lange. In the
center of the villa, a very small room was devoted to the "Void." The
visitor reached it after having seen several large blue monochromes, a
blue *Sponge Relief*, and three groups of small *Spring Showers*. A second
door allowed the visitor to leave the space and reach the *Tomb of Pure
Blue Pigment*, accompanied by "pink rain." Another, more complete
plan **(fig. 32)**, features modifications, but the "Void" remains in the
center of the layout, which was where it was presented during the
actual exhibition.

The space used by Klein was not part of the building designed by
Mies van der Rohe. Located between a vast hall, the gentleman's study,
and the living room, the small space intended for a concert organ
was enlarged[123] at the very beginning of the 1950s. This is the state
in which Klein found it. For his exhibition, the room (14½ x 5¼ x
9½ feet), entirely painted white, including the floor, was harshly lit by
two "neon" tubes hanging from the ceiling **(fig. 33)**. The film made by
Yvan Butler to document the Krefeld exhibition captured a state of
the work. Once again, the editing reflects a desire to articulate blue,
the presence of the artist, the invisible, and corporality.

After having shown us the street, the building, the exhibi-
tion poster, and the arrival of a white Citroën DS, the film takes
us into the rooms of the Museum Haus Lange. The camera lingers
on the blue monochromes, presents a sculpture and *Rains*. Several

32. Yves Klein, plan produced in 1960 for his exhibition *Monochrome und Feuer* at the Museum Haus Lange, Krefeld, 1961.

close-ups of various sponges invite us to think about the process of impregnation. After the material of a pink monochrome had taken up the entire screen, a black changeover introduced an appearance by Klein against a pink background. Another black changeover, and the material of a monochrome glows before the presentation of the space inhabited by the "immaterial pictorial sensibility," a space so flooded with light that the room seems to have vanished. Immediately after this sequence, the *Great Blue Anthropophagy: Homage to Tennessee Williams*, (1960, 108¾ x 164½ in.) opens the continuation of the visit. It is unlikely that this perfectly illustrative montage was the fruit of chance.

Two photographs taken in this room prove how much the artist took care to guide the interpretations of his gestures thanks to the documents that he hoped to distribute. Through these documents, he organized visual parallels and suggested the establishment of links between these works. In one of these photographs, we see Klein walking

33. Recent interior view of the "empty" room dedicated to the "immaterial pictorial sensibility," Museum Haus Lange, Krefeld.

toward us in the immaculate space **(fig. 34)**. No shadow disturbs the dematerialized whiteness of the space. The second photograph shows him from the back, disappearing into the "Void" **(fig. 35)**. Both echo the *Leap into the Void* photograph, a reproduction of which appears in the Krefeld exhibition catalog **(fig. 17)**.

One recalls that the artist had already published, with the title "A Man in Space", a photograph of this event (*Dimanche*, November 27, 1960). Nan Rosenthal made a particularly illuminating comment about this image: "It depicts what millennia of ancient Western art and Christian art have also depicted: the human image in ascension.

34. Yves Klein in the "empty" room dedicated to the "immaterial pictorial sensibility," Museum Haus Lange, Krefeld, during his exhibition *Monochrome und Feuer*, January 14–February 26, 1961.

However, the artist has shown himself—not a Winged Victory, nor a member of the Holy Trinity, nor Superman—doing the ascending, a vision that reminds us that is artists, not gods, who often people modern myths."[124] In this image, Klein seems to be flying toward heaven, thus demonstrating the pertinence of his statement: "Let's be honest, to paint space, it is my duty to go there, into space itself."[125]

The 1960 photograph teems with urban details—disorderly sidewalk, badly maintained street, suburban house, train station, telephone poles and wires, trees, and, in the newspaper photograph, a cyclist riding away. Only the sky, gray in this black-and-white photograph, is empty—no cloud or bird disturbs its tranquillity. It is toward the sky that the artist makes his way, leaping into the void with all the

35. Yves Klein in the "empty" room dedicated to the "immaterial pictorial sensibility," Museum Haus Lange, Krefeld, during his exhibition *Monochrome und Feuer*, January 14–February 26, 1961.

force of his dynamic energy. In Krefeld, the solution is infinitely more serene, but fulfills an identical aspiration. The relaxed painter of space walks resolutely into the space of an "immaterial pictorial sensibility" that he has "stabilized." Even better, his artistic efforts were rewarded: he was able to make us enjoy it, his creation allowing us to experience the experiment in his wake, if we so desired.

The room dedicated to the "Void" in the Haus Lange Museum has been there since its creation in 1961. To visit it today, one must be aware of its existence because no indication signals its presence.[126] On the other hand, if an art lover asks a museum guard where it is and says he would like to visit it, he will be taken to see it without hesitation. Beforehand, the guard must get the key from reception: after reaching the small room, the visitor observes that the door is not fitted with a latch, but has a keyhole. This detail contributes to

the fact that the door goes unnoticed. No label appears on the wall
(fig. 36). When the door is open, the guard steps aside to let the
visitor in and lets him know that he will be closing the door. And
when the visitor wants to leave, he only has to use the latch—the
inside of the door is fitted with one—to leave the room and shut the
door behind him.

The visitor is now isolated in an immaculate room, a long, narrow
space with a relatively high ceiling. The door is located at the end of one
of the longest walls. The light is almost blinding, all the more so since
the white walls reflect it without any loss. Only the floor, also white,
bears traces—discreet stains—of the passage of the art lovers who had
entered this secret space before him over the years. Opposite the entry
door is another, identical door. But this door, sealed up, cannot be
opened. Curious visitors, who would like to verify what is what after
having returned to the "public" rooms of the Haus Lange, will observe
that the wall in this place does not betray the slightest trace of a door.
A final detail might attract the attention of painting aficionados: the
walls are not entirely smooth. Here and there, the texture of a material
lights up a surface whose whiteness is dazzling.

Shut up in the heart of the "Void," what does the visitor feel? It
is an experience that is too personal, too private for us to be able to
speculate about the possible reception of this work—as mentioned, the
encounter is not experienced under the gaze of others. A single fact
is certain: the art lover is not there by accident; having come specially
to Haus Lange, perhaps at the end of a trip to Krefeld undertaken
precisely for that reason, he knows more or less what to expect and he
knew in particular that the sharpness of the gaze would not be of great
help here. A genuine place of artistic pilgrimage, the Krefeld room is
reminiscent of—following the secularized example of a version that is
more cultural than religious—the structure of ancient pagan temples.
Their architecture, often spectacular, was merely the magnificent and
protective cladding of a secret place to which only initiates had access,
the *cella* inhabited by dangerous gods whose effigies were not to be
carelessly revealed to the human gaze.[127]

In the absence of a ritualized devotion governed by the organiza-
tion of a cult with well-established rules, the art lover is attracted

36. Exterior view of the door to the "empty" room dedicated to the "immaterial pictorial sensibility," Museum Haus Lange, Krefeld (summer 2002).

by the visible. The *cella* has obviously been repainted. After making inquiries,[128] I learned that the room was repainted on the occasion of a Lucio Fontana-Yves Klein exhibition, *Im weißen Raum*, in 1994. The appreciation of its authenticity—a crucial consideration for the nature or value of the lived experience—depends on the status granted to this intervention on the room left behind by Klein. In other words, does the visitor who now enters this space, repainted exactly as it was, enter the artist's work, or is he invited to appreciate a remake of it, a sort of ersatz, a devaluated substitute?

Various examples enable us, by way of comparison, to form an opinion. First of all, the fact that we can enter the room itself—and not a reconstruction, as is the case in Lascaux—should be taken into account. Moreover, let us consider the "restoration" of Barnett Newman's painting, *Who's Afraid of Red, Yellow, and Blue III* (1967–68). Slashed in 1986, the painting was entrusted to an American specialist. After his intervention, when the painting was back on display at the Stedelijk Museum in Amsterdam, a fierce controversy flared up because the painting seemed to have been entirely repainted. After the many debates provoked by this affair, a clear consensus emerged: a painting thus "restored" could not longer be considered the artist's work. That is why it is essential to come back to the role assigned by Klein to the white paint applied to the walls **(fig. 37)**. His explanations are very clear in this respect, since he unambiguously distinguishes between the function of the paint—a precondition intended to remove the residual emanations with which the space is laden as a result of the uses to which it has been previously put—from the founding operation itself, invisible (and unverifiable)—"specializing" and "stabilizing" in space that the immaterial pictorial sensibility appropriated. Of course, only the artist himself can carry out this operation. When he envisaged the creation of immaterial "decorations" in the new buildings, Klein once again insisted on the need for its presence:

> A painter, collaborating with an architect on the decoration of a new construction, for example, will no longer paint abstract, figurative, or monochrome decorations on the walls, but will simply—through his presence in his collaboration with the architect—give a sensibility, a sensible life, a warmth, to the construction of the edifice that it would have acquired in collaboration with its inhabitants, but over a much longer time, and certainly not in the conditions of sweetness, gentleness, uncanniness, extraordinariness, and marvellousness that the painter of the future will be able to provide *solely by*

37. Yves Klein painting the space of the "empty" room white for his exhibition *Monochrome und Feuer*, Museum Haus Lange, Krefeld, 1961.

his effective presence in the edifice from time to time during its construction.[129]

Klein's "Void" did not pertain to either conceptual art or the category of "works with scores," exemplified by Sol LeWitt's *Wall Drawings*, which advocated the separation of program and execution. The impregnation of a space by a specific charge of "immaterial pictorial sensibility" was not an idea, a project that everyone could take hold of to embody it or update it here or there, as he or she pleased. Klein's way of working was too reliant, as we will see, on a way of thinking inspired by the Incarnation for it to be conceivable

to recreate his works in his absence, even though it might appear easy to do so.

The significance of the Krefeld *cella* lies in its permanence. It is an archaeological site, that is, an authentic site that a string of happy coincidences has preserved in its fundamental integrity. That is why the work does not have to be "updated."[130] On the other hand, it should certainly be "revived," in other words, restored to remove obstacles to enjoying it under the right conditions. The paintings are cleaned to restore the vividness of their colors. Here, it was simply a matter of working on the "frame"—the frames were also restored, especially when they are the originals—that is, the walls of the space endowed with a "sensible life" by the artist himself in the past. It remains to be seen if the "immaterial pictorial sensibility" is a reality or a fiction and, in the first hypothesis, what its degree of volatility is. The answer to these questions cannot be demonstrated in a truly rational manner because this is all a question of personal conviction.

The Monochrome and the Flesh

Just when Klein was presenting to the public an exhibition in which the painting was freed from the shackles of matter, he was venturing into an opposing—or, more exactly, symmetrical—path. Aware of the dangers inherent in all dematerialization, Klein felt the need to light a backfire to protect himself from his own daring innovations. He never stopped painting pictures, monochromes. The artist said that he found himself in an empty studio and that his "activity of immaterial pictorial states was coming along wonderfully" when he made the decision to hire models to work with so that their radiant presence would be passed on to the color. These models, intended to create a "sensitive atmosphere inside the studio," which would allow him to "stabilize the pictorial material," laughed a lot, he said, to see "magnificent solid blue monochromes executed using them!"[131] According to one of the accounts given by Klein to explain how the collaboration with the young women came about, the young

women, increasingly "attracted by the blue," allegedly decided to help him, to throw themselves into the color in order to paint his mono-chromes for him with their bodies. He had previously said that the collaboration was his idea:

> One day, I realized that my hands, my tools for handling color, were not enough. It was the model herself that I needed to paint the monochrome canvas. No, it was not an erotic folly![132]

Regardless of the probable denial, regardless of the variations in the narratives, the main thing is that less than two months after the closing of the "Void" exhibition, the artist was organizing a semi-private demonstration of this spectacular approach. The session took place on June 5, 1958, in the home of one of Klein's friends, Robert Godet, who had invited a few special guests. After the dinner, a naked model started to crawl on a sheet of paper placed on the floor (**fig. 38**). Following the artist's instructions, the young woman spread with her body and hands the blue paint, which was soon everywhere, trans-forming the white support into a perfect blue monochrome (see the frontispiece, **fig. 1**).[133]

The direct contact between the body and the color exempli-fies a topos of discourse on painting, the affirmation of complicity between the color and the flesh, and female flesh in particular. Since Plato, color, whose charms no one disputed, was condemned or, at least, vassalized. The philosophical arguments mixed with moralizing motifs to denounce its dangers. The virtues of drawing—renounced by Klein—reputed to be more intellectual, more reasonable, were held up in contrast with it. The dispute kept being revived and, in the seven-teenth century, Charles Le Brun defended an increasingly contested position when he vaunted, in front of the members of the Académie Royale de Peinture et de Sculpture, the merits of drawing, "the pole and compass" of painting, a pole whose mastery saved painters and art lovers from "drowning in the ocean of color, where many go under believing they are safe."[134]

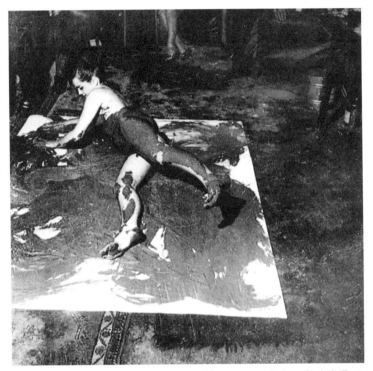

38. First public presentation of a "living brush" in action, at Robert Godet's, Paris, June 5, 1958.

The fact that the colorist excels in the expression of the flesh is not, of course, impervious to opprobrium, or at least to mistrust, on account of which it suffers, despite the pleas of its advocates. Denis Diderot, for example, remarked:

> It is said that the most beautiful color in the world was that delightful red that innocence, youth, health, self-effacement, and modesty imprinted upon the cheeks of a girl; and something was said that was not only fine, touching, and delicate, but

true; for flesh is indeed difficult to render; it is this unctuous white, even without being pale or mat; it is this mixture of red and blue that imperceptibly perspires; this is blood, the life that is the colorist's despair. He who has acquired a feeling for flesh has taken a large step; the rest is nothing in comparison. Thousands of painters have died without having experience this feeling; thousands of others will die without feeling it.[135]

All the same, the mistrust of the body, and of color, would persist much longer. A few years after the death of Delacroix, Charles Blanc published a book that was immensely successful. His condemnation of color—irrevocable—was based on an association with the corrupting influence of femininity: "Drawing is the masculine sex of art, and color the feminine."[136] Subjected to drawing like emotion should be subjected to reason, it adds charm, expressivity, and grace. But if this order, which is reputed to be "natural," found itself turned upside down, painting would be heading for ruin. It would be "ruined by color, as humanity was ruined by Eve."[137]

The flesh, as fascinating as it can be, initially appeared to be the antithesis of spirituality. It was to be its negation in a Manichaean vision of the world, of man, and of God. Christianity contributed to the renouncing of this vision, or at least to qualifying it, to offering the prospect of surpassing the frontal opposition between body and mind, flesh and soul. Since God became man, we can hope that the sacred inhabits corporeal reality. This participation of the—invisible—sacred sanctifies matter—of which we can never rid ourselves here below. It is on it, that is, our mundane reality, that we must lean if we want to attain more spiritual regions. An excellent teacher, Saint John of Damascus explained it in these terms:

For since we are twofold, fashioned of soul and body, and our soul is not naked but, as it were, covered by a mantle, it is impossible for us to reach what is intelligible apart from what is bodily. Just as therefore

> through words perceived by the senses we hear with
> bodily ears and understand what is spiritual, so
> through bodily vision we come to spiritual contem-
> plation. For this reason Christ assumed body and
> soul, since human kind consists of body and soul;
> therefore also baptism is twofold, of water and
> the Spirit; as well as communion and prayer and
> psalmody, all of them twofold, bodily and spiritual,
> and offerings of light and incense.[138]

A way of accessing immaterial realties, the epiphany of the flesh,
of the faceless body, arouses a double desire. Earthly love mingles with
divine love: the sensuality refined by blue awakens an appetite for
things of superior essence. To perceive the glorious, transfigured face
of these corporeal depositions in which the flesh is done away with, it
is advisable to turn to the radiance of the color without drawing. If one
would like to feel all its power, one must agree to let oneself be carried
away beyond the visible. A "beyond" that calls for the visible, the body,
and the flesh so that the dynamic of an intrication rendered think-
able—that is, possible—by the cultural heritage to which it belongs
establishes itself.

A few months after the presentation at his friend Godet's home of
the rather remarkable use he made of the body, Klein went to Antwerp
where he gave new impetus to the immaterial instance. One year later,
when the development of the immaterial works had attained a certain
ritual perfection, he organized a public anthropometries session, which
placed corporality in the spotlight (we will return to this). The bipo-
larity of his fundamental "problematic" was then brought to its acme.

The Immaterial, Words, and Gold

Even before the vernissage of the exhibition known as that of the
"Void," Klein contemplated commercializing the "invisible pictorial
sensibility." A card enclosed with the invitation featured this comment:
"for all persons not provided with this card the price of admission

will be 1,500 francs"[139] **(fig. 39)**. Self-righteous souls did not fail to take umbrage at such a venal attitude, but the artist could have had other reasons for placing his creation in the world of trade, that is, as it happens, on the art market. A work that is sold, a work that is stolen, a work that is copied or plagiarized, acquired ipso facto a sort of legitimacy—that is conferred by the artistic status. Every genuine creation can be acquired in return for payment.

Klein continued the implicit demonstration when he said that he had "sold two immaterial paintings at this [exhibition]."[140] This claim could not be verified, but it is most likely untrue as, in April 1958, the artist had not developed a mode for the transfer of his immaterial creations, although he later claimed that all the pictorial "sensitivity" exhibited was "for sale, in strips or in a whole bloc."[141] The entrance fee for his exhibition thus enabled him to overcome a difficulty, the possibility "to take from it, by impregnation, whether consciously or not, some degree of intensity."[142] In the event of a theft of sensibility, the artist would not have been completely swindled: "And that, that above all, must be paid for. It's not really that expensive, after all, 1,500 francs." [143]

M ..

..

invitation pour
DEUX PERSONNES
du 28 avril au 5 mai

pour toute personne non munie de cette carte
le prix d'entrée est de 1500 frs

39. Yves Klein, "Ticket good for free admission," included with the invitation card to the vernissage of his exhibition at the Galerie Iris Clert on April 28, 1958.

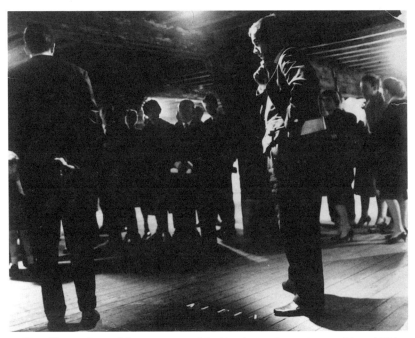

40. Yves Klein in front of the space reserved for him during the vernissage of the exhibition *Vision in Motion—Motion in Vision*, Hessenhuis, Antwerp, March 17, 1959. Photograph by Charles Wilp, with a caption by the artist on the back: "Yves Klein presents the immaterial."

Klein was perfectly aware that this thorny problem, the placing of his invisible works on the art market, the modes of their transfer, should have found a solution, and a solution adapted to their singularity. Invited to take part in a group exhibition, *Vision in Motion— Motion in Vision* (Hessenhuis, Antwerp), he seized the opportunity to state the price of immaterialized blue. The evening of the vernissage, March 17, 1959—even though he had sent nothing tangible for the exhibition—he made an appearance **(fig. 40)** in order to make the work appear out of speech and make clear to everyone the fundamental principle of the exchange he wanted to propose to art lovers.

Two months later, he gave an account of the event to the audience of his Sorbonne lecture:

> Invited to exhibit with a group of artists comprising Bury, Tinguely, Roth, Breer, Mack, Munari, Spoerri, Piene, and Soto, I traveled to Antwerp and on the occasion of the opening, instead of installing a painting or whatever tangible and visible object in the space that had been reserved for me in the Hessenhuis exhibition hall, I loudly pronounced to the public these words borrowed from Gaston Bachelard: "First there is nothing, then there is a deep nothing, then there is a blue depth."
> The Belgian organizer of this exhibition then asked me where my work might be. I replied, "There, there where I am speaking at this moment."
> "And what is the price of this work?"
> "A kilo of gold, a kilo ingot of pure gold will suffice."[144]

This was the first public expression of the concept of exchanging the immaterial for gold. It goes without saying that the artist did not improvise his speech or responses. Between the first attempts to immaterialize blue and this proclamation to which many witnesses can testify, Klein had found the solution to his problem. It would have been mundane to sell these exceptional works for vulgar paper money. It had to be gold because it has two virtues that, in this case, complemented one another. First, it is a metal reputed to be stable, a quality that it has in common with truly immaterial works—unlike the Krefeld *cella*, they would never require the services of restorers. Second, and even more importantly, gold was long used as a standard for national currencies. Their value was defined in terms of gold. It did not matter that, in terms of economic reality, this was no longer true in 1958. In the Western imagination, gold was still an absolute reference, like the "immaterial pictorial sensibility" was, in a manner of speaking,

the supreme artistic value, the reference value of the paintings whose job was to express it by giving it substance.

Since the success of Marcel Duchamp's ready-mades, everybody knew that every object could potentially be transformed into a work of art through the addition of a verbal utterance. Klein used this modus operandi—"In the beginning, there was nothing," except that in the end no object was "transfigured."[145] During his lecture, Klein would nevertheless suggest a further radicalization of the relationship between its presence, its concrete intervention, and the establishment of the work:

> I aimed to reduce my pictorial action for that exhi-
> bition to its extreme limits. I could have made
> symbolic gestures, such as sweeping clean the exhi-
> bition space that had been reserved for me in that
> hall; I could even have painted the walls with a dry
> brush, without color. No! Those few words that I
> pronounced, that was already too much. I should
> not have come at all, nor should my name have
> featured in the catalogue.[146]

Such a radicalization would, of course, be doomed to fail: if Klein had attempted the experiment, no one would have known about the existence of the work. Even if it does not go through the medium of the visible, the artist's intention should be communicated, in one way or another, to its recipient, the public. The mode of existence of the invisible works required a peripheral understanding. It was made possible by a system of designations: places of inscription, images of absence, declarations, and texts that express the existence of the gesture and thinking underpinning them. Here, Klein, moreover, based himself on the memory of a personal journey, punctuated with exhibitions that—at breakneck speed, but even so—stepafter step outlined—and clarified the project. In Antwerp, Klein no longer showed anything, no painting bound the invisible to a perception.

The articulation, still as fundamental to the success of the operation, had changed register. It was based on the sequence of a story in install-

ments: first, the paintings with the invisible "Pictorial Intentions," then the blue presence of their evocation opposite the immaterialized blue, and finally the only memory of the journey completed. If one agrees to consider the logic of this shaping of the project that led Klein to hope to disappear better to promote his invisible, immaterial works, it must be acknowledged that these works were less a sudden appearance than a patient elaboration. They were dependent on a story, a narrative that the artist had meticulously unfolded. In his will to efface himself, he came up against the necessity of organizing their traces.

Beyond the Sky, Eden

The true painter of the future will be a mute poet who will write nothing, but will recount an immense, limitless painting, without articulating, in silence.[147]

"Take flight" every day! At least for a moment, which may be brief, as long as it is intense![148]

To understand better the narrative of the "transfers of immaterial pictorial sensibility," it might be worth recalling an ancient legend, the tale that Plato transcribed in a text dedicated to "the beauty of souls." A summary of it follows. During his dialogue with Phaedrus, Socrates imagines the tribulations of souls, winged and free, or wingless and, in this instance, bound to a body. It is difficult for them to accompany the gods in heaven. Thus, many of them fall back down to earth without having enjoyed the "happy visions" that motivate them. During their temporary escapades "upward to the top of the vault of heaven," our immortal souls can, nevertheless, succeed in doing so. There, after great effort, they "pass outside and take their place on the outer surface of the heaven, and when they have taken their stand, the revolution carries them round and they behold the things outside of the heaven." They then have access to wisdom, justice, and knowledge, and then, after "passing down again within the heaven," go home. Since "the region above the heaven was never worthily sung by any earthly poet," before him, Socrates reveals its nature:

It is, however, as I shall tell; for I must dare to speak the truth, especially as truth is my theme. For the colorless, formless, and intangible truly existing essence, with which all true knowledge is concerned, holds this region and is visible only to the mind, the pilot of the soul.[149]

Klein placed this founding act at the beginning of his epic: lying on the beach in Nice, he did not sign the sky like a traditional artist would have done had he been an enthusiast of the ready-made, who affixes his name to the work. No, the young man immediately flew to the underside of the sky:

Just an adolescent in 1946, I went to sign my name *on the underside of the sky* during a fantastic "realisti-co-imaginary" journey.[150]

Beyond the problematic of art, beyond the sky, the transfers of *Zones of Immaterial Pictorial Sensibility* put the finishing touches to the immaterialization of the painting. To make this achievement part of human reality—built up of exchanges—Klein imagined modes and conceived a "ritual." It is most likely on this occasion that appeared with the greatest clarity the ties that bound him to a philosophical and religious tradition on which the entirety of Western art is reliant—even when it renounces it. Believers, agnostics, or non-believers, steeped in philosophy or not, we are immersed in this inherited culture. In this case, for Klein—a Catholic believer—it was not just a backdrop or a magnificent but useless setting. It was a narrative framework necessary for both the elaboration and the understanding of the artistic or spec-ulative adventures of the artist grappling with the invisible.

"Checkbooks" and Receipts

The proclamation of an equivalent in gold for the *Immaterial* presented in Antwerp marked a beginning. Thus, the invisible oeuvre

left the realm of daydreams, or that of the simple petitio principii, to enter the world of art, a world in which only the constituted fictions, given shape, stood a chance of being recognized. For this reason, the announced work could legitimately be said to be worth a price dependent on the real existence of a "pictorial sensibility" freed from any material support. After the Antwerp experiment, Klein, encouraged by Iris Clert, endeavored to resolve the problem of the sale of his invisible works with no concrete existence. There would be an exchange for gold, but the terms remained to be defined and the document that would authenticate the deed of transfer to be designed.

In September 1959, Iris Clert thanked Peppino Palazzoli, the first buyer of a "zone of immaterial pictorial sensibility," and told him, to reassure him, that Klein was designing a receipt.[151] The artist drew several sketches of a "Certificate" before coming up with the definitive form of the "Receipts"—he had never spoken of "checks" or "checkbooks," terms widely used in catalogs and books about his work. The recurrent error—one is tempted to call it a Freudian slip—is not without interest. This incorrect wording draws attention to the economic nature of the document and of the transaction, as if to include the transfers in the chorus of ordinary artworks, those lodged in artifacts and subject to the laws of the art market. Furthermore, the term "check" implies that one must have confidence in the system, and particularly in the authorities standing surety—here, the Galerie Iris Clert—because, if a "receipt" does not foresee in any way the value at stake, a check should be able to be cashed. It also entails the risk of "bouncing."

A model for a counterfoil book and two drafts for "Certificates" have been preserved. These three sketches show an evolution in the formal design and the wording of the document. Klein initially envisaged referring to the series using letters before numbering them. The wording varies in these projects: the "Synallagmatic Relinquishment of a Transferable Zone of Immaterial Pictorial Sensibility"[152] **(fig. 41)** was followed by the "Relinquishment of a Transferable Zone of Immaterial Pictorial Sensibility"[153] **(fig. 42)**. The initial price was then set at twenty-five grams of fine gold for Series A. The draft of a receipt in the Musée National d'Art Moderne, Paris, and the one in the model

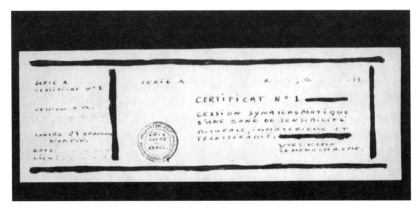

41. Yves Klein, draft of a "certificate" for the "synallagmatic relinquishment of a transferable zone of immaterial pictorial sensibility," 1959, pink ink and gold paint on paper mounted on a blue background, private collection.

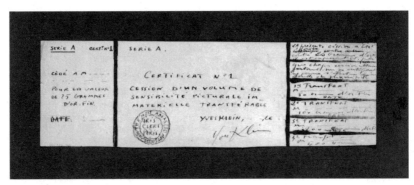

42. Yves Klein, draft of a "certificate" for the "relinquishment of a transferable zone of immaterial pictorial sensibility," 1959, ink and gold paint on paper mounted on a blue background, Musée National d'Art Moderne, Centre Pompidou, Paris.

for the counterfoil book have blanks for the names of the successive buyers of the same zone **(fig. 43)**. The price indicated doubled with each register transfer and the former owner was supposed to countersign the document when he sold the work.

43. Yves Klein, model for a counterfoil book for the relinquishments of volumes of "transferable immaterial pictorial sensibility," 1959, back of the receipt, ink, ballpoint pen, and gold paint on paper, IKB blue paper, Musée National d'Art Moderne, Centre Pompidou, Paris.

44. Yves Klein, model for a counterfoil book for the relinquishments of volumes of "transferable immaterial pictorial sensibility," 1959, front of the receipt, ink and gold paint on paper, blue paper, Musée National d'Art Moderne, Centre Pompidou, Paris.

On the complete model of the counterfoil book **(fig. 44)**, the text written in red/pink, the divider lines, the gold rules, and the blue cover allude to Klein's emblematic trilogy of colors. The receipt in this book was produced by pasting two sheets of paper together. On the back of the sheet on which the recto is drawn, two hurried sketches, visible against the light, clearly express the intention to have a watermark appear in the paper. The meaning of these rather crude brush drawings

is difficult to decipher, but the lines around the two figures mentioned unambiguously convey the idea of radiance. The fletching—perfectly recognizable—indicates that the figure on the left might well be the effigy of Saint Sebastian. As for the figure on the right, more legible on the draft of the standalone receipt in the Musée National d'Art Moderne, Paris, which also features two designs on its back, it suggests the presence of a bust with a halo—Saint Rita?

In mid-November, Klein finalized the form of the "ritual" and had all the receipt books, which were slightly differently from the first sketches, printed. Iris Clert could then send Peppino Palazzoli the promised document. She wrote to him on November 18, 1959:

> Here at last is the long-awaited <u>receipt for sensi-bility</u>. (sent under separate cover by registered mail)
> Everything was finalized as quickly as possible
> If you sell it, you must have the next owner sign the back and so on.[154]

The documents that were printed in the end were simpler **(fig. 45)**. The text simply indicates: "Received: twenty grams of fine gold in exchange for one zone of immaterial pictorial sensibility." The "Seal of Guarantee"[155] was henceforth affixed above the text. The blanks left

45. Receipt book for the *Zones of Immaterial Pictorial Sensibility*, Series No. 5, 1959, printed paper, private collection.

for the date of the transfer and for the required signature of the artist were to be filled during the transfer. Instead of the watermark, the letters "IKB," printed tone on tone, occupy the entire width of the receipt. The back was left blank, but the information initially planned to be placed there was replaced with a box printed on the front. The box text sets out the rules applicable to the possible transfer of a zone by its buyer. This is accompanied by a warning:

> This transferable zone may only be sold by its owner
> for double its initial purchase price.
> (Signatures and dates of transfers on the back)
> The transgressor incurs the total annihilation of his
> own sensibility.

Six or seven—plus one—"Receipt Books" were produced by Iris Clert's printer.[156] All in the same size, the fact that they are distinctly larger (3½ x 11½ in.) than an ordinary checkbook confers on them the solemnity of an artwork in its own right. For each of them, the IKB blue upper cover is lighter and more flexible than the cardboard that serves as a base, which is also blue but stiff, to ensure that the receipt book is durable. The choice of blue was eminently symbolic: placed on the exterior, it evokes the organization adopted for the 1958 exhibition. Like at Iris Clert's, blue, the material and visible evocation of painting that had become unnecessary, is peripheral here, whereas the "immaterial pictorial sensibility"—the receipts referring to it—is at the heart of the matter. Once again, the immaterial, the genuine product of an analytical sedimentation, articulates the visible and the invisible to offer us a chance to grasp the essence on the basis of existence.

The first seven receipt books, each containing ten receipts for ten zones, display a price following a geometric progression with a common ratio of two, starting with twenty grams of fine gold, double the price of the following series. The zones of Series No. 7 were thus transferable for 1,280 grams of gold. Most of the receipt books have been preserved. However, the receipt books planned for Series No. 3 (exhibited in Leverkusen in 1960) and Series No. 7 have not yet

46. Receipt book for the *Zones of Immaterial Pictorial Sensibility*, Series No. 0, 1959, printed paper, private collection (the visible counterfoil attests to the agreed transfer to the Museum Haus Lange).

been found.[157] It is not certain whether the seventh receipt book was actually produced. On the other hand, an eighth receipt book **(fig. 46)**, slightly different from the previous ones, was printed: Series No. 0 has no indication of the price or the equivalent in fine gold. The "zones of immaterial pictorial sensibility" in this series, reserved for the elect, for close relations, while the others were intended for the art market, therefore seemed to be less "transferred" than given, the price of the exchange being left open. Another notable difference: this receipt book contains not ten, but thirty-one receipts. None is numbered. The box with its "warning" to transgressors does not feature on these "blank checks" either. These absences[158] display a tasteful simplicity and, above all, they indicate an unfailing trust in the beneficiaries of these non-standard "zones": Klein did not think that they would give away or resell their receipts.

While he was designing the model "Receipts," or a little later, Klein thought about the practical details of the exchange, to which had to be given all the prestige called for by its exceptional nature. After he worked out the details, the artist put down in writing the "Rules of the ritual for the relinquishment of the zones of immaterial pictorial sensitivity". They stipulate:

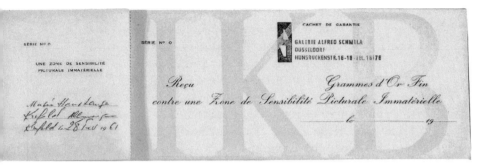

The immaterial pictorial sensitivity zones of Yves KLEIN the Monochrome are relinquished against a certain weight of fine gold. Seven series of these pictural immaterial zones all numbered exist already. For each zone relinquished, a receipt is given. This receipt indicates the exact weight of pure gold which is the material value correspondent to the immaterial acquired.

The zones are transferable by their owner. (See rules on each receipt).

Every possible buyer of an immaterial pictorial sensitivity zone must realize that the fact that he accepts a receipt for the price which he has [paid] takes away all authentic immaterial value from the work, although it is in his possession.

In order that the fundamental immaterial value of the zone belongs to him and becomes a part of him, he must solemnly burn his receipt, after his first and last name, his address and the date of the purchase have been written on the stub of the receipt book.

In case the buyer wishes this act of integration of the work of art with himself to take place, Yves Klein must, in the presence of an Art Museum Director, or an Art Gallery Expert, or an Art Critic, plus two witnesses, throw half of the gold received in [the] ocean, into a river or in some place in nature where this gold cannot be retrieved by any one.

From this moment on, the immaterial pictorial sensitivity zone belongs to the buyer absolutely and intrinsically.

The zone[s] having been relinquished in this way are then not any more transferable by their owner.[159]

The buyer thus had the choice between two options. He either remained attached to tangible traces and kept his "Receipt," but did not still really possess the "authentic immaterial value" of the work, or played the game and thus denied himself the only concrete trace of the transaction in his possession. But his name figured on the stub in the counterfoil book, conferring upon his purchase—in the expert hands of the artist—the prestige attached to the purest and most just gestures. The absence of an object, the absence of proof to hand down or resell, expresses his complicity with the artist and demonstrates his deep understanding of the work. The collective memory is thus the only reality of his purchase. Of course, this memory is sustained by a set of enduring traces, recorded during or on the occasion of the "ritual": besides the receipt stubs, there are photographs, testimonies, and sometimes also published accounts and reactions in the press. In the artist's wake, the buyer goes down in history, in art history legend.

Selling the Immaterial

Klein sold seven "zones of immaterial pictorial sensibility": six from Series No. 1, the least expensive, and one from Series No. 4. We have already mentioned the first buyer, Peppino Palazzoli (**fig. 47**). That

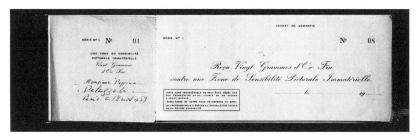

47. Receipt book for the *Zones of Immaterial Pictorial Sensibility*, Series No. 1, 1959, printed paper, private collection (the visible counterfoil attests to the sale to Peppino Palazzoli of Zone No. 1).

same year, three other art lovers took the plunge.[160] Jacques Kugel and Paride Accetti respectively received zones 2 and 3 of Series No. 1 on December 7, 1959. The next day, Alain Lemée received the following zone, no. 4 **(figs. 48, 49, 50)**. None of these four buyers burned his receipt. The receipts are sometimes exhibited **(figs. 51, 52)**[161]. The receipts of Jacques Kugel (Series No. 1, Zone No. 2) and Alain Lemée (Series No. 1, Zone No. 4) were mounted on a leaf-gilded ground, a reminder of the terms of the exchange as well as a prestigious means of display **(fig. 53)**. Its status is thus ambiguous: the barely informed visitors could imagine that it was a work in its own right, whereas the receipt is only its sign, but a sign authenticated by the artist and, as a result, destined to become a relic.

Everyone could imaginarily appropriate the "zone of immaterial pictorial sensibility" mentioned as no name appeared on the document. Moreover, the "zone" did not substantially belong to its buyer since he had not burned his receipt. When the receipt, an item for sale, changed hands, it goes without saying that the "zone" in no way belonged to the owner of the exhibit, an occasional owner whose name does not appear in the artist's counterfoil book. On the other hand, if we consider it an icon—and the gold ground invites us to do so—we can go from the sign, not mimetic, but linguistic in this case, to what it evokes or designates. That is exactly what the theology of the icon invites us to do, not without many shades of meaning,

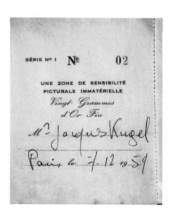

48. Receipt book stub for the sale to Jacques Kugel of the *Zone of Immaterial Pictorial Sensibility*, No. 2, Series No. 1, on December 7, 1959.

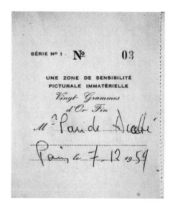

49. Receipt book stub for the sale to Paride Accetti of the *Zone of Immaterial Pictorial Sensibility*, No. 3, Series No. 1, on December 7, 1959.

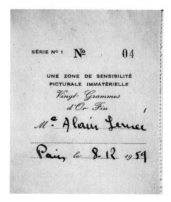

50. Receipt book stub for the sale to Alain Lemée of the *Zone of Immaterial Pictorial Sensibility*, No. 4, Series No. 1, on December 8, 1959.

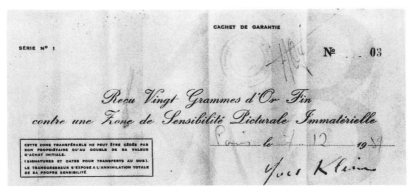

51. Yves Klein, receipt given to Paride Accetti for the purchase of *Zone of Immaterial Pictorial Sensibility*, No. 3, Series No. 1 (December 7, 1959), private collection.

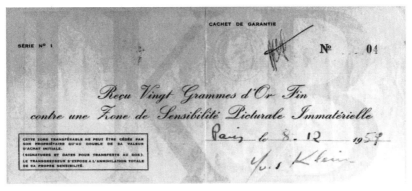

52. Yves Klein, receipt given to Alain Lemée for the purchase of *Zone of Immaterial Pictorial Sensibility*, No. 4, Series No. 1 (December 8, 1959), private collection.

the subjects of subtle debates on the links that unite and separate the representation of the represented,[162] God or the divine mysteries, that is, an infigurable "represented" whose real existence many disputed—his conceptual existence is clearly not in doubt.

Three complete transfers, with the destruction of the receipt by fire, were the objects of a photographic report, a genuine recording in

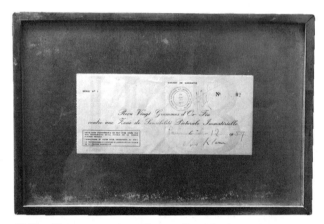

53. Yves Klein, receipt given to Jacques Kugel for the purchase of *Zone of Immaterial Pictorial Sensibility*, No. 2, Series No. 1, mounted on a gold background (December 7, 1959), private collection.

images designed to bear witness to the "ritual" performed. Thus, we can see Dino Buzzati burning his receipt,[163] in order to appropriate fully the "immaterial pictorial sensibility" while the artist throws into the Seine half the gold leaf received in payment for the work **(fig. 54)** on January 26, 1962 (*Zone of Immaterial Pictorial Sensibility*, No. 5, Series No. 1). One of the photographs taken on February 4, 1962, during the transfer of the following zone (No. 6, Series No. 1) to Claude Pascal, betrays the presence of the second photographer working that day **(fig. 55)**. This sensible precaution—doubling the chances of obtaining good photographs at the risk of, as is the case here, revealing the process—shows the extent to which Klein was keen on having lively images of his artistic doings. The last of these transactions in the presence of witnesses, the sale of *Zone of Immaterial Pictorial Sensibility*, No. 1, Series No. 4 to Michael Blankfort on February 10, 1962, was the most spectacular because of the personality of the witnesses and the number of people involved. On that occasion as well, two photographers recorded the main scenes of the transfer.

For these three transfers, Klein produced a photo album with captions and notes. It is a large notebook of thick aquarel paper.[164]

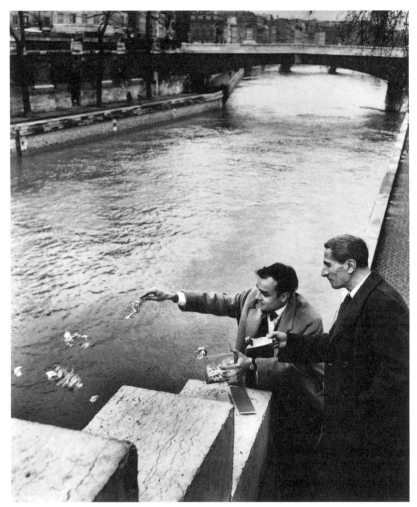

54. Yves Klein, transfer to Dino Buzzati of *Zone of Immaterial Pictorial Sensibility*, No. 5, Series No. 1, Pont-au-Double, January 26, 1962 (photo Harry Shunk).

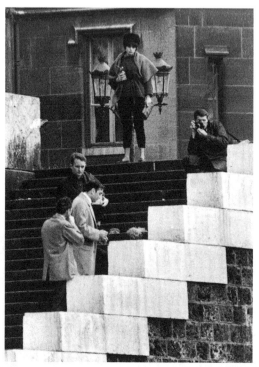

55. Yves Klein, transfer to Claude Pascal of *Zone of Immaterial Pictorial Sensibility*, No. 6, Series No. 1, Pont-au-Double, February 4, 1962 (photograph Gian Carlo Botti).

On the back of the—untitled—front cover are pasted the rules for the ritual in English, then, on the first page, the French version. The photographs of the transfers to Buzzati, Pascal, and Blankfort follow. After the four photographs of Dino Buzzati, the article by the writer published in *Corriere della Sera* ("Sortilegio a Notre-Dame," February 4, 1962) is pasted to a sheet of paper. Eight photographs give an account of the transfer to Claude Pascal: the last image shows the gold leaf thrown into the river drifting along before being swallowed up.[165]

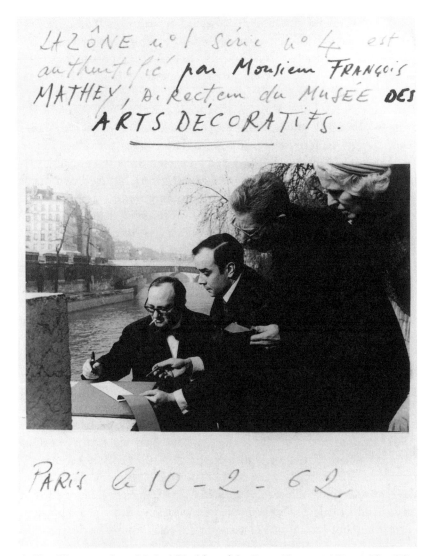

56. Yves Klein, transfer to Michael Blankfort of the *Zone of Immaterial Pictorial Sensibility*, No. 1, Series No. 4, Pont-au-Double, February 10, 1962, page from the "Spiral Notebook" put together by the artist (authentication of the zone transferred by François Mathey).

Only the pages of the album dedicated to Michael Blankfort were published in part.[166] They open with a portrait of the artist and then present, on five double-page spreads, nine photographs of the course of the operation in the presence of the witnesses: Madame Bordeaux-Lepecq, president of the Salon Comparaisons; Jeanine de Goldschmidt, Parisian gallery owner; Virginia Kondratieff of the Dwan Gallery, Los Angeles; François Mathey, director of the Musée des Arts Décoratifs; Jean Larcade, gallery owner; and Pierre Descargues, art critic.

François Mathey, the "official" representative responsible for authenticating the object of the transfer **(fig. 56)**, received two ingots in exchange for his participation and signature on the receipt and the stub.[167] The fourteen remaining ingots were divided into two equal groups. Klein kept seven and threw the seven others into the river. In order for the zone to fully belong to its buyer, he had to burn his receipt, which he did. Pierre Descargues and other photographers (Gian Carlo Botti and his assistant) took shots of the main phases of this transfer. The witnesses present are joined by all those who watch through these enduring images, irreplaceable documents that bear witness to the ephemeral event inspired by the invisible work.

After the last photograph of the Blankfort transfer had been pasted into the album, three articles were published in *Arts* (anonymous), *La Tribune de Lausanne* (not signed, but by Pierre Descargues), and *Il Giorno* (anonymous).[168] The last two articles were illustrated with beautiful images that made the event seem more spectacular. Thus, Klein began to put together the elements of the critical fortune of these "rituals," a critical fortune whose existence is all the more essential as no concrete trace of these works has survived—with the exception of the burnt sacrifice of a receipt stub. The artist, moreover, added to the information made available to future historians with the annotations correcting the "errors" made, according to him, by the writers of the two articles published in French. The lasting quality could only be ensured by documentation including testimonial evidence. This documentation focuses on the void left by the absence of a tangible object, not to fill it, but to draw attention to it, to inscribe forever in the collective memory: "this-took-place."

The ritual of these three transfers took place in Paris on the banks of the Seine, on the steps leading to the embankment from the Pont-au-Double. Klein had, of course, not chosen at random this place whose name, gift from the gods, evoked the geometric progression of the prices for the various series of "zones of immaterial pictorial sensibility." But even more important was the site of the bridge, a location that very few photographs document.[169] It leads, from the Left Bank of the river, to the Île de la Cité and, more precisely, the parvis of Notre-Dame Cathedral. The entire artistic ceremony thus took place at the foot of one of major centers of Christianity, a discreet tutelary power. Relatively brief, the encounter during which the ritual took place resembled—in terms of its social form—the civil wedding, the signing of a notarial deed,[170] or the inaugural ceremony. After the signing, after the exchange, and as is the custom in many social circumstances, a lunch[171] marked the importance of the moment spent together and concluded the temporal bubble in which it took place. Normal life could then resume.

The complicity of the witnesses, provided for by the "ritual," was essential. They represented the art world as a whole: critics, galleries, salons, and museums. The fact that they agreed to take part in the ceremony was no indicator of its quality. Their presence only guaranteed its admissibility as an artistic endeavor, an endeavor that critics could judge as they pleased. By agreeing to stand surety for the artist in full view of everyone, the witnesses paved the way for galleries and salons likely to exhibit "zones of immaterial pictorial sensibility," "zones" that could later be acquired by museums to preserve them forever. The effectiveness of such support—that of the art world—has been proven. In the case of Yves Klein's immaterial works, it played a role, but it alone could not decide the fate reserved for what it supported. At the most, it can be said that the artist had taken no chances, not neglecting to work on either the form of his works nor on the way in which they were exhibited or promoted, in order to make them part of the world they aspired to enter. Like his predecessor, Nicolas Poussin, Klein, who thought he was a "classic,"[172] could have said: "I have neglected nothing."[173]

The role played by the buyers is also worth mentioning. The personality of the buyers and witnesses was not inconsequential. Thus, for example, François Mathey was not afraid of compromising—in the name of art—an institutional reputation from which Klein could immediately benefit. The businessman Peppino Palazzoli was so impressed by the "blue period" exhibition at the Galleria Apollinaire that he opened his own gallery in Milan, the Galliera Blu. Because of him, art dealers and collectors could be reassured about the validity of a rather strange transaction. Dino Buzzati had written about the Klein exhibition at the Galleria Apollinaire in 1957. By buying an immaterial work from Klein, Buzzati was giving the artist the support of a renowned writer. As for Michael Blankfort, a writer and scriptwriter, he represented Hollywood, and all it stood for.

The determination of the witnesses and, even more, of the buyers was essential because, without them, the "ritual" would have remained at the project stage, one of the many abandoned synopses. Without these objective allies, there would have been no photographs, no account of the events, and no reviews to attract the public's attention, like the article entitled "Klein Sells Wind!"[174] The buyers were also supporters. They did not content themselves with subsidizing[175] the artist, who had, strictly speaking, "nothing" to sell them, except for a sensibility whose existence was very uncertain and, in the best-case scenario, the opportunity to take part in something that associated their names with his work.[176] They had the generosity to enable the "ritual" to take place and the daring to stand surety for the artist by leaving him a deposit on what would become, if everything went well, a work of art in the full sense of the word, but a rather paradoxical work whose mode of existence defied all the laws of the genre insofar as it did not conform to the minimum requirement: embodying in an artifact or at least in a ready-made object (it should be recalled that conceptual art did not exist in those days).

We have already mentioned that Klein claimed to have sold "two immaterial paintings"[177] during his exhibition of the "Void" in 1958. He also mentioned transfers of the immaterial that took place in "the most absolute anonymity." The factual veracity of these assertions is of little importance as not one of these potential buyers has made himself

known. Had they remained secret or lackluster, the transfers—simple projects or, at best, edifying fictions—would not have gone down in history. The "zones of immaterial pictorial sensibility" will always lack the base of a taking root in the artwork, in its market, and in its history. That is what the "collaboration" of the buyers contributed.

And yet, Klein transferred or gave away two other zones in the greatest discretion. After returning from Cascia, Klein carried out an exchange with Museum Haus Lange in Krefeld, represented by its director, Paul Wember. The transfer of the first zone of Series no. 0 took place in the room dedicated to the immaterial on February 28, 1961, just after the exhibition of the artist's work closed its doors to the public. This gesture, known about for several years, received no publicity, and its existence could be verified only recently, when the counterfoil book for this series was made available for consultation. The first stub comprises the following information written in pink ink in a firm hand: "Museum Haus Lange / Krefeld Germany / Krefeld Feb. 28, 1961" (see **fig. 46**). Edward Kienholz was the beneficiary of the second transfer of this series. It was granted to him in Los Angeles on June 14, 1961 (**fig. 57**). After Klein's death, his widow, accompanied by Arman, threw the gold that Kienholz had not given at the time of the transfer into the Mediterranean from a boat.[178] This gesture completed the ritual: the zone henceforth belonged to the artist by rights and he could then do what he liked with it. The receipts of these private transfers have never reappeared.

Klein's immaterial works still resist classification. Although they were based on declarations, these "Oral Paintings"[179] were not linguistic in nature. The use of discourse by the artist could not be descriptive, strictly speaking, and performative even less. Its development rests on a postulate—that is, an utterance without proof: "Universal sensuality exists and I specialize in it. I thus hope to be an authentic realist of the beautiful today."[180] The artist became the officiant of a ritual that required membership and presupposed that ordinary rationality is put to one side to allow declarations, narratives, explanations, glosses, images, and other peripheral shocks, the time to bring out the fantastic element. In 1959, before having finalized the complete ritual for the transfers, Klein attempted to define this collaboration—placed

57. Receipt book stub for the transfer of a *Zone of Immaterial Pictorial Sensibility*, Series No. 0, to Edward Kienholz, June 14, 1961.

under the patronage of nature—between the work, the artist and his "readers":

> My zones of immaterial pictorial sensibility, stabilized, detachable, and expansible beyond the infinite, were created through a dynamic contemplation, filled with wonder, of nature in all its aspects and moments.
>
> For me, it is no longer about painting canvases, but rather about establishing in a permanent and lasting manner between me and this nature, with which I am at one, the NEO-FIGURATIVE canvas that is both the most real and the most immaterial that exists and that gives readers or, better, 'EXPERIENCERS' of such events or pictorial climates through pure performances, a spectacle,

more precisely a 'STATE' of the quality, perma-
nence, and transparency of what the Vermeers, the
Rembrandts, the Giottos, the Michelangelos gave
to their eras![181]

One must believe, at least a little, to agree not to see or touch. On
the other hand, art lovers who question the reality of the "immate-
rial pictorial sensibility" and refuse to give any credit to its stabiliza-
tion by its prophet, Yves le Monochrome, would find it difficult to
deny the quality of the system imagined and actualized by the artist.
Its principal merit, in this case, was not envisaging from the mono-
chrome and the pictorial tradition, the extraction of a reified and yet
always invisible "sensibility." Its merit lies entirely in the coherence of
its logical extrapolations and in the economy of the shaping of their
practical consequences, a form that was evocative enough to remain
inscribed in the collective memory.

This form revived an anthropological heritage, that of rituals of
all kinds that never ceased to proliferate, and is part of a historical
tradition, Christianity. It is from this double root that it draws its
efficacy. The artist and the art lover shared an implicit meme that did
not need to be specified in order to act, on the contrary. It was more
of a diffuse, possibly vague, knowledge, than a precise reference. This
backdrop, common to all, modeled both the horizon of expectation of
the viewers or "readers" and the base on which the creation took place.
Klein gave private signs of his attachment to Catholic beliefs and
devotions. The most noteworthy indirectly combined the transfer ritual
with the artist's ardor for the patron saint of lost causes, Saint Rita,
whose cult became widespread in southeastern France and northern
Italy in particular. During the exhibition of his work at Museum Haus
Lange in Krefeld, Klein went to the monastery dedicated to the saint,
and where her remains are kept, in Cascia. He anonymously left an
ex-voto (fig. 58), which was discovered in 1979, there. The transparent
plastic box divided into five compartments contains blue pigment,
pink pigment, gold leaf, a prayer addressed to the saint and, on a bed
of blue pigment, three ingots of fine gold that were, according to the

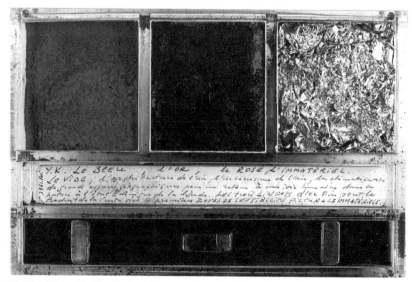

58. Yves Klein, *Ex-Voto Dedicated to Saint Rita*, 1961, pure pigments, gold leaf, gold ingots, and manuscript in a Plexiglas box, collection of the Monastero di Santa Rita, Cascia, Italy.

prayer, "the product of the sale of the first four zones of immaterial pictorial sensibility."

In February 1961, Klein had sold four zones; Iris Clert indicated that that they had been sold for "10,000 francs apiece."[182] Does this mean that this amount corresponded to the exchange value of the twenty grams of gold, or had Klein himself converted the fiduciary currency? What was important was that the ritual was—one way or another—respected and that the artist expressed in the clearest way possible, albeit in secret, the links being forged between his oeuvre and his attachment to a religious culture and practice.

Exhibiting the Immaterial

While waiting for Yves Klein to arrive in Los Angeles, Iris Clert dreamed of a spectacular action to present the "immaterial pictorial

sensibility." To meet the artist at the airport, she wanted to rent one of those armored trucks used to transport funds: "On this truck, a huge banner would say PURE SENSIBILITY. This completely empty armored truck would be escorted by motorcyclists; the press and television would be present to cover the event." Clert had to give up this "coup"—her own word—which she would have had no problem setting up. She seemed to regret it: "But unfortunately, it was only a fantasy."[183] This anecdote shows, conversely, how very keen Klein was to respect the lofty fragility of his invisible works when he had to confront the aporia of their public presentation.

The transfers assumed a confidential character. The ritual was ephemeral by nature and only took place in the presence of a very small number of people. Only the photographs could be exhibited to show the exchange. This form of dissemination was not yet widespread—the practitioners of Land Art did a lot to popularize it, starting with their first exhibitions, notably that at the Dwan Gallery (New York, October 1968). In the early 1960s, the artists who made use of photographic documentation to publicize their works, performances, and actions, were still proceeding by trial and error.

After having developed the protocol for the transfers, Klein exhibited the referenced zones of "immaterial pictorial sensibility" in various ways. Sometimes a simple mention in the exhibition catalog suggests their presence; in certain cases, this minimal indication was complemented by the presentation in the gallery or museum of a counterfoil book. The recording in the catalog ensured the promotion of the work and its inclusion in the annals of art history; the way it was exhibited, or more precisely the design of the signing, indicating the invisible presence of the work, was part of the necessary media coverage. The way of "showing" is even more important for the comprehension of the works as there is nothing to see. Thus, in Antwerp the artist's name was stenciled on the floor, opposite the space that was reserved for him. Afterwards, Klein removed any indications of this nature.[184] The absence of a name or label took on great significance.[185] The "immaterial pictorial sensibility" stabilized by Klein inhabited the space without occupying any particular spot. This paradox contributed to its ejection from rational mental categories. Here, one thinks of

what all the little Catholics heard, astounded, when they were taught in Sunday school that God is everywhere without, however, taking up any space.

In Leverkusen, during the exhibition organized by Udo Kultermann, *Monochrome Malerei* (Städtische Museum, March 1960), Klein showed an *IKB Blue Monochrome* (catalog no. 42), an *IKB Blue Relief* (catalog no. 43), a *Quivering Monogold* (catalog no. 44), and *Zone of Immaterial Pictorial Sensibility*, No. 1, Series No. 3 (catalog no. 45). The counterfoil book for Series No. 3 had been sent to Leverkusen, where it was probably displayed open so that the recipe for zone no. 1 was visible. This way of presenting the counterfoil books was reused at least once by the artist. Pierre Restany reported that on the occasion of the exhibition, for which he wrote his first manifesto of "Nouveau Réalisme," Klein "took part with his checkbook [counterfoil book] of immaterial pictorial zones"[186] (Galleria Apollinaire, Milan, May 1960). The brochure published on the occasion of this exhibition contained the "manifesto," but did not include the list of works exhibited. On the other hand, on the copy that was sent to Klein by his friends,[187] Restany wrote: "Still no check in circulation, but it will come. The immaterial is working, anthropologically speaking." Arman noted, not without humor: "Your immaterial zone is very impressive, it feels heavy and true."

Shortly beforehand, Klein had tried out a different strategy. For his first attempt at exhibiting precise "zones," he showed a *Quivering Monogold* (1959) at the exhibition *Antagonismes* (Musée des Arts Décoratifs, Paris, February 1960). Gold leaf, half-pasted to a leaf-gilded panel, quivered at the slightest breath of air. The list of works exhibited mentioned the presence of this *Quivering Monogold* and associated it with—providing no explanation—"zones of immaterial pictorial sensibility no. 1 and no. 2 of series no. 7 at 1,280 grams of fine gold."[188] The *Monogold*[189] was reproduced in the catalog, but the accompanying comment from Julien Alvard refers solely to the immaterial:

> The magical quality of painting has been spoken about for too long. Someone needed to isolate it from

its support. After all, what is it that distinguishes a real from a forged painting! A contested Watteau is worth ten times less than a Watteau vouched for by all the experts. A doubt changes everything. It is this whole that Yves Klein calls a zone of sensibility. It is immaterial, of course. Naturally, it has its price. It offers itself without a support, which is handy. Thus, you have everything without being hampered by anything. Having posed this pure question, Klein returned to the Rhine Gold.[190]

On this date, Klein did not yet have any photographs of any of the stages of a transfer. It was in early 1962 that the artist thought about having a visual evocation of his zones of "immaterial pictorial sensibility" appear in the catalog for the group exhibitions The Nouveaux Réalistes were supposed to show as a group at the Salon Comparaisons that year. François Dufrêne described the intentions and circumstances of a mise-en-scène in which he took part:

> In order to "materialize" in the Salon Comparaisons catalog Yves Klein's "Zone of Immaterial Pictorial Sensibility," Klein, aided by François Dufrêne, Villeglé, Niki de Saint Phalle, and Spoerri, had taken down the paintings in the room where the Nouveaux Réalistes were supposed to show three months later. Harry Shunk was in charge of the photography. The first page and the last page of the catalog would show, on the one hand, the hanging of the group's work and, on the other, the empty room with the mention of Yves Klein. The paintings were taken down, with the permission of the president of the Salon Violet, on January 26, 1962, at 8:30 p.m.[191]

The same day, Klein sold a "zone of immaterial pictorial sensibility" to Dino Buzzati. The same photographer—Harry Shunk—worked at

59. Taking down the paintings exhibited at the Salon Violet, Musée d'Art Moderne de la Ville de Paris, Paris, January 26, 1962 (from left to right: Jacques Villeglé, François Dufrêne, and Yves Klein).

the Salon Violet (**fig. 59**) in the morning, then, shortly afterward, on the banks of the Seine[192] (see **fig. 54**). Having learned a lesson from his recent experiences, Klein had perfectly understood the need to supply images to feed the scopic appetites of the art world. Even when there is nothing to see—the immaterial is always inaccessible to the eyes of the body—it has to be demonstrated that there is nothing visible, except the context and the gestures of a ceremonial. Able to be exhibited, the photographs bear witness: something took place. Complemented by narratives, essential assistants, they guide our imagination toward regions where sight is of no help to us.

The taking down of the works by Klein and his friends gave rise to evocations that, however positive they might have been, barely helped the reader understand what had happened and what was at stake. It was certainly not a "conceptual performance" as stated, somewhat

anachronistically, in the catalog of the major Yves Klein retrospective at the Centre Pompidou in 1983: "Removing Paintings from a Gallery to Make a Void, January 26, 1962; conceptual performance at the Musée d'Art Moderne de la Ville de Paris."[193]

To better understand the context in which the taking down of the paintings on January 26 took place better, one must recall that the Musée d'Art Moderne de la Ville de Paris regularly hosted Salons at the time. The sixteenth Salon Violet, organized by the fine arts section of the Association Nationale des Membres de l'Ordre des Palmes Académiques, was held there from January 12 to February 2, 1962. The rooms were supposed to be allocated to the Salon Comparaisons a little later. Once the "void" was produced, the works of the Nouveaux Réalistes were temporarily put up for long enough to take the photographs meant to appear in the catalog. It is possible that Klein seized an opportunity—to produce a promotional image[194] for Galerie J—but in such as way as to make it part of the rituals accompanying the presentification of his immaterial works. In a text written in collaboration, Klein and Restany observed: "Just as the transfer of the immaterial works sold for fine gold by Yves Klein, for five years already, has always been the object of a certain ritual ... the photograph showing the empty room of the Musée d'Art Moderne is, after all, only a ritual."[195]

The Salon Comparaisons catalog perpetuated the fruits of this appropriation **(fig. 60)**. A double-page spread in the middle of the brochure features, on the left, the room occupied by the works of Villeglé, Spoerri, Niki de Saint Phalle, Hains, Dufrêne, Raysse, Rotella, Tinguely, Anouj, and Arman. Occupying the entire facing page, a photograph taken from the same angle shows the same room, but absolutely empty, apparently, since the caption, followed by a text by Restany, states:

> Yves Klein—The Monochrome: a zone of immaterial pictorial sensibility. Zone no. 1, Series no. 5. Yves Klein's immaterial zone of pictorial sensibility exists in itself. Its "fantastic" constitutes the very essence of Nouveau Réalisme: neither the

VILLEGLE

Niki de SAINT-PHALLE

SPOERRI

HAINS

DUFRENE

RAYSSE

ROTELLA

TINGUELY

ANOUJ

ARMA

Yves KLEIN · Le Monochrome : une zone de sensibilité picturale immatérielle.
Zone nº 1, Série nº 5.

La zone de sensibilité picturale d'Yves Klein, immatérielle, extra dimensionnelle, existe en soi. Son « merveilleux » constitue
l'essence même du nouveau réalisme : ni les murs, ni les dimensions de la salle où elle se trouve exposée ne correspondent
à sa vraie réalité. Son intégrité est ailleurs, partout ; inutile d'en dire plus.
 P. R.

60. Catalog, Salon Comparaisons, 1962, pages 80–81: to the left, the Nouveaux Réalistes
room; to the right, view of the same room occupied by *Zone of Immaterial Pictorial Sensibility*,
No. 1, Series No. 5.

walls nor the dimensions of the room in which it is exhibited correspond to its true reality. Its integrity is elsewhere, everywhere; no need to say more.[196]

Could this piece of information offset the misunderstandings that had always accompanied the presentation of the "immaterial pictorial sensibility" in a precise location since the exhibition of the "Void"? It may be recalled that many critics had considered the wall of Galerie Iris Clert,[197] painted white, a monochrome, whereas, with his explanations, Klein unrelentingly tried to draw attention to the "pictorial climate" created by an impregnation that was sensible, invisible, but tangible, that inhabited the entire space.[198] Several times, Klein went back to the central importance of the radiance of the work, a radiance located beyond the visible, outside of any dimension. In his *Chelsea Hotel Manifesto*, he invoked the possibility of a direct comprehension of the "sensibility," which would live in the private memory of every individual:

> I think of those words that I was inspired to write one evening. "Wouldn't the future artist be he who expresses through silence, but eternally, an immense painting lacking any sense of dimension?"
> The gallery-goers—always the same, just as others— would carry this immense painting in their remembrance (a remembrance which does not derive at all from the past but alone is cognizant of the possibility of increasing infinitely the incommensurable within the scope of the indefinable sensitivity of man).[199]

Another document was particularly revealing of the characteristics of these immaterial works, the note provided by the organizers of the Salon Comparaisons, a note "to be kept by the exhibitor and presented during the depositing and collection of the work." Besides the expected administrative and regulatory information, the document comprised a box in which to specify the work concerned **(fig. 61)**. Klein filled it in as follows:

61. Salon Comparaisons, 1962, instructions for exhibitors given to Yves Klein for his *Zone of Immaterial Pictorial Sensibility*—Series No. 7, Zone No. 1, private collection.

• TYPE (painting) (sculpture): Pictorial Climate
• TITLE OF THE WORK: Zone of Immaterial
Pictorial Sensibility—Series No. 7, Zone No. 1
• SIZE: Beyond measurement
• PRICE: One thousand two hundred eighty grams
of fine gold.[200]

Klein never collected his work—it is possible to assume that it still inhabits the space that hosted it during a temporary exhibition at the Musée d'Art Moderne de la Ville de Paris, but it would be wiser, more coherent, to think that it is still alive, active in the minds of those who were aware of its existence. In his immaterial works, Klein was battling with a sort of double bind, the necessity to show nothing to remain faithful to the spirit of his project, and that of producing "images," albeit peripheral, to disseminate his project in the art world avid for visuality.

When Michael Blankfort learned that the photographs of the transfer which had enabled him to purchase Zone No. 1 of Series No. 4 had not only been taken, but also exhibited, he initially felt justifiably disappointed: "An 'immaterial,' I thought, should be altogether immaterial." For him, the photographs seemed to betray the initial project and were "a corruption of the artist's intent as well as of the sensation of purity which had possessed me at that time."[201] However, the evocative power of these images helps those looking at them to comprehend the emotion that emanated from the poetic works from the moment that several people agreed to take part in the transfer ritual. One must not tire of saying it: brought under control, the visible leads to the invisible, the image guides us toward the indefinable.

Another approach to the real presence of an invisible entity, the text enables what cannot be shown to be indicated. Klein gladly resorted to this and was tempted to deprive art lovers of the assistance of images, an untenable position for an artist, if only as an exception. He wrote a note asking that "this page written in [his] hand to show [that he was acting] in all good faith" be published:

As for my attempt at the immaterial—it's impossible to provide a photograph.[202]

The opposition between a logic of disappearance and the need to organize the traces—"ashes" of his art—led Klein to envisage another possibility, that of raising the immaterial from discourse, or more exactly from the silence that follows it. We can, therefore, as the artist himself invites us to, add to the collection of immaterial works known through an exhibition or a transfer one that he *would exhibit* in front of his audience by uttering, as he initially intended,[203] his *Chelsea Hotel Manifesto*. Here, the bipartite structure of his Monotone-Silence Symphony served as both a demonstrative example and a pragmatic matrix. This time, the creation of the immaterial work belonged to the performative model: *saying is doing*. More accurately, the artist gave another turn of the screw to this founding procedure. At the time when J. L. Austin was taking an interest in speech acts,[204] Klein drew attention to a postscript: doing so took place in the silence of a voice keeping quiet. It suffices to read or, better still, hear the text for, against a backdrop of silence, the work—no image of which will come to betray its purity—to then suddenly appear:

> Just as I created a "monotone-silence-symphony" in 1947, composed in two parts—one broad continuous sound followed by an equally broad and extended silence, endowed with a limitless dimension—in the same way, I shall attempt to put before you a written painting of the short history of my art, to be followed naturally at the end of my expose by a pure and affective silence.
>
> My expose will close with the creation of a compelling "a posteriori" silence whose existence in our communal space, which is, after all, the space of a single being, is immune to the destructive qualities of physical noise.
>
> Much depends upon the success of my written painting in its initial technical and audible phase.

Only then will the extraordinary "a posteriori" silence, in the midst of noise as well as in the cell of physical silence, generate a new and unique zone of pictorial immaterial sensitivity.[205]

Thus, to "specialize" the invisible pictorial sensibility, speech and the silence that it engenders, suffice. In the past, when only the learned had access to the text, its substance, images—the Bible of the poor—were intended for the illiterate. In the age of the "imaginary museum," the photographs that present the work to us in absentia play the role of mediators between art and its always growing public. This function seemed so important that André Malraux could state: "For the last hundred years (if we except the activities of specialists) art history has been the history of *that which can be photographed*."[206] Klein, in search of the most apt turn of phrase—nowhere to be found—used photographic images to translate, for the eyes of the common herd, the invisible reality of the immaterial, but he was not unaware of the fact that the most well-informed art lovers would be grateful to him for having attempted to do without representations.

The Flesh, the Incarnation

After the ritual for the transfers of "immaterial pictorial sensibility" were finalized and after having sold a few zones, Klein refined his use of his models' bodies. During the party at Robert Godet's, the young woman had crawled over the support sufficiently to produce a monochrome: therefore, every trace of a corporeal presence had disappeared. The pictorial process might have been known, but it did not appear at all, even to the most attentive, most perceptive eye. It was not by chance that Klein felt the need, driven by some whim or other, to affirm in the eyes of everyone the return of the body at the very moment that he was becoming involved in a spectacular manner with the invisible. He suggested, moreover, a causal relationship:

> Whatever directed me towards anthropometry? The
> answer can be found in my work during the years
> 1956 to 1957, when I was taking part in the adventure
> of creating the pictorial immaterial sensitivity.[207]

On February 23, 1960, Klein invited Pierre Restany to his studio to witness a new way of using the model. It was no longer a question of crawling over the support to produce a monochrome, but of leaving an identifiable trace on it. Udo Kultermann, the director of the Städtische Museum in Leverkusen, was also present. The bust, belly, and thighs of a model, Jacqueline, were covered with blue paint. She repeatedly pressed her body against the paper laid out on the floor or stapled to the wall, leaving a colorful trace of her passing. Restany was enthusiastic and, in his own words, exclaimed: "These are the anthropometries of the blue period."[208] They had the great advantage, in comparison with the corporeal monochromes, of evoking a real presence, that of the "living paintbrushes."

Later, as the public began to understand the method, the artist produced all sorts of variations. Sometimes, especially with the dynamic impressions, the shape of the body was difficult or impossible to recognize. But the effectiveness of the overall process stood surety for the fleshly nature of the anthropometries. This nature conferred the sensuality of contact on the virginal blue. The photographic metaphor can be called upon once again. The monochrome executed during the soiree organized by Robert Godet was not, of course, a representation. The same is true of the indicial traces of the anthropometries, but they invite us to think about the articulation between the absence of representation and the presence of an *acheiropoieton*—image "not made by human hands." With the return of the image, the links between the flesh and the color, forged over the centuries, gave way to another association, just as old but even more crucial. The matter of the flesh is at the heart of the fundamental Christian mystery, the Incarnation.

One recalls that Klein furtively disclosed the use of the body just as he was dazzlingly presenting the immaterialization of blue in 1958. In 1960, the situation introduced was symmetrical. The sales of "zones of immaterial pictorial sensibility" were made without a fuss when

the artist decided to cause a stir with the Anthropometries. Klein, therefore, meticulously organized the soiree intended to publicize them.

After having convinced the Comte d'Arquian to host a public demonstration of anthropometries in the Galerie Internationale d'Art Contemporain, Paris, of which he was the director, Klein had a dress rehearsal in the space, brought together musicians, and called on photographers and a cameraman. About a hundred people were invited to this ceremony, scheduled for the evening of March 9, 1960. At 10:00 p.m., the artist, wearing a black tuxedo and white bowtie, with a Maltese cross of the Knights of the Order of Saint Sebastian around his neck and his hands protected by immaculate gloves, appeared in front of the public, followed by three naked young women holding cans of paint. While they began to coat their breasts, torsos, bellies, and thighs with paint, Klein, signaled with his hand for the three violinists, three singers, and three cellists to start his Monotone-Silence Symphony—the performance of this bipartite symphony was not just aural decoration: the articulation of its fundamental structure was a reminder of the necessity to comprehend what was happening here in relation to the artist's other creations, IKB blue, and its immaterialization.

The young women, striking in their garments of paint, then bustled about as instructed by the artist **(fig. 62)**. They produced various anthropometries, on the sheets of paper placed on the floor and stuck to the walls, facing the audience quietly sitting on chairs placed in front of the "stage." After the pictorial work was completed, the models left, taking the cans of paint with them, and the scheduled debate took place. It was during an exchange with Georges Mathieu that Klein made the famous retort: "Art is health!" The success of this soiree is perceptible and nearly palpable in the grain of photographs taken that evening and widely disseminated since then.

This "action-performance"[209] merits a long analysis but what is essential to illustrate our point is the articulation that brings together two states of painting, less contrasting than it might seem. Its incarnation corresponds to its invisibilization. The return of the body comes to remind us of the two complementary topics of the Christic

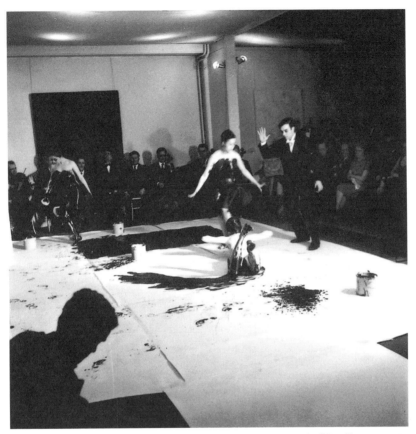

62. Yves Klein, *Anthropométries de l'époque bleue*, Galerie Internationale d'Art Contemporain, Paris, March 9, 1960.

Incarnation. The entire theology of the icon, and then the entire Catholic tradition of images, is based on the double nature of the son of God become man and, as such, representable. The presumed reality of the Christic hierophany was a determining argument for those who pleaded for the licitness of images, and particularly two-dimensional pictorial images—less suspect than sculpture, more linked to pagan practices and idolatry.

63. Yves Klein, sketch for *Blue Monochrome Stations of the Cross* (1958) for the chapel of Saint-Martin-de-France, Pontoise, private collection.

Saint John of Damascus wrote several discourses to refute Iconoclast arguments and, at the same time, lift the Old Testament interdiction of representation for good. It was based on one of the dogmas of the faith—the Word was made flesh, the two natures of Christ, fully man and fully God, existing in a single hypostasis—to develop his main thesis:

If we made an image of the invisible God, we should in truth do wrong. For it is impossible to make a statue of one who is without body, invisible, boundless, and formless. Again, if we made statues of men, and held them to be gods, worshipping them as such, we should be most impious. But we do neither. For in making the image of God, who became incarnate and visible on earth, a man amongst men through His unspeakable goodness, taking upon Him shape and form and flesh, we are not misled.[210]

In his texts, Klein rarely tackled religious themes head-on. His well-known devotion to Saint Rita remained strictly private. On the other hand, he offered to paint *Blue Monochrome Stations of the Cross* **(fig. 63)** for the chapel of Saint-Martin in Pontoise in 1958. The drawing made to clarify his intentions comprises a sketched plan. One wonders what the priests thought when the project was submitted to them: it only comprised twelve stations, which led one to assume a very approximate knowledge of Biblical history and of its artistic formalization for purposes of worship. Klein's religious references, deep-rooted but always intuitive, were rarely explicit. Occasionally, however, an allusion to the Christian faith appeared in his writings. His pictorial oeuvre, visible and invisible, does not directly treat the Incarnation. This dogma, an object of faith as wall as a cultural fact, should not be considered, strictly speaking, a subject or referent treated head-on by the artist. It remains, however, the major conceptual horizon in which his work is located. This founding horizon enables us to understand the system of binary articulations that he used to help us grasp the logic of the sequential links of an adventure that expressed its coherence in this way. It states and deepens the antagonism between the flesh and the spirit, the sensible and the spiritual.

Substituting de facto the immaterial and the flesh for the couple blue/immaterial, Klein modified and clarified his aims. Monochromy remained an essentially artistic affair when the flesh, linked to color, of course, also referred to a religious culture. Neither a puritan nor

64. Yves Klein, *Untitled Anthropometry*, 1962, private collection.

65. Yves Klein, *The Flesh*, 1960, private collection.

impervious to the charms of the "flesh," Klein knew what temptations it was subject to, as well as what hopes of redemption it represented. To evoke "the block of the human body, which is to say, the trunk and a part of the thighs that fascinated [him]" **(fig. 64)**, he used the term "the flesh," notably in the article "Truth becomes reality," which he wrote for the magazine *Zero*:

> The shape of the body, its curves, its colors between life and death, are not of interest to me. The affective atmosphere of the flesh itself is what I value.
> The flesh . . . !!!
> For all that, I took a look at the model now and then. . .
> As I continued to paint in monochrome, I reached the state of disembodiment almost automatically. This made me realize that I really was an Occidental, a proper Christian, believing with reason in the "resurrection of the body and in the resurrection of the flesh."[211]

Produced shortly before the writing of these reflections, one of his anthropometries was in fact entitled *The Flesh* (1960, 42 ¾ x 29 ¾ in., **fig. 65)**. This blue dynamic anthropometry was exhibited in Krefeld (*Monochrome und Feuer*, Museum Haus Lange, 1961). The return to the flesh, or the return of the flesh, scotomized by the application of the ritual transfer rules, has a prophylactic function. It is a question of guarding against the dangers of a disincarnation: how to inhabit the world when we keep throwing ourselves into the ether, from the other side of the sky, where Paradise is located, if we are to believe the image painted by Giotto in the Cappella degli Scrovegni, Padua —two angels roll up the sky, in this way revealing the Celestial City in front of which blue acted as a screen **(fig. 66)**. Klein thought it was vital not to shut oneself "inside the excessively spiritual regions of artistic creation," not to break with "the plain common sense that the presence of flesh in the studio would benefit *[our] incarnate condition*."[212] That is why he engaged naked models although he only painted monochromes:

The presence of this flesh in the studio steadied me during the enlightenment brought on by the execution of my monochromes. It preserved in me the spirit of health, the health that lets us partici-pate, carefree and yet responsible, in the order of the universe. Strong, tough, powerful, and yet fragile, like dreaming animals waking in the perceptual world, like things vegetable and mineral entranced in this world of ephemeral perception . . . [213]

Klein transfigured this reassuring force using color, which alone remained on the support after the flesh withdrew. The animality of the headless body resplendent in the radiance of blue irresistibly makes one think of the spiritualization of the body cut out of colored paper by Matisse in 1952. In this manner, he produced four *Blue Nudes* **(fig. 67),** which inspired Isabelle Monod-Fontaine to make the following comment:

Cut out of "the idea of absolute blue" [the phrase is Matisse's own], the four *Blue Nudes* of 1952 also echo the *Blue Nude: Memory of Biskra* of 1906, itself reworked in the *Pink Nude* of 1935. They are the ultimate inversion of the Matissian figure: the sensual vividness of the pink, a celebration of flushed flesh, is transposed to the color the most charged with spirituality, the color of Christianity. . . . The *Blue Nudes*, of all the figures painted by Matisse, are perhaps those that best express, at the very end, "the religious sentiment, so to speak" of life that he possessed.[214]

Klein possessed this "religious sentiment" to the highest degree although he had the good grace not to encumber his oeuvre with overdone references or allusions, which would, in fact, be invalidating in his artistic context. This sentiment nevertheless drove his entire quest and a few rare texts display it unabashedly, but in a provocative

66. Giotto, an angel rolling up the sky, detail of *The Last Judgment*, 1303–04, fresco, Cappella degli Scrovegni, Padua.

mode that contributed to lessening its impact. Thus, for example, we can read in his writings the following declaration, which could pass for impious:

> The painter, like Christ, says mass while painting and gives his body of the soul as food to other men; he performs in miniature the miracle of the Last Supper in every painting.[215]

67. Henri Matisse, *Blue Nude* (IV), 1952, cut-out gouache
and charcoal on paper, Musée Matisse, Nice.

The Last Supper, which established the Eucharist, is absolutely
liturgical in the sense that it is turned toward the future. It anticipated
a "memory of the future." The mystery of Transubstantiation suggests
the reality of a genuine, invisible presence under the auspices of the
matter offered to the incorporation of believers, as well as to the gaze
of the devout. This articulation is at the center of Klein's oeuvre as long
as it is considered on the basis of the hermeneutic model proposed
by the structure of his Monotone-Silence Symphony, that is, that we
agree to turn our aesthetes' eyes toward the significative relationships

between his various "expressions," in other words, toward the interstice (the "void") that separates and connects them, as well as toward each of them considered separately.

The Immaterial, After Klein

A few months after Klein's death, Pierre Restany based himself on a logic that called for the presence of the artist, or was in line with the context of the commemoration, when he stated that he had "concluded the ritual" in 1974: "In late 1961, Yves had expressed the wish to do a exhibition in Japan. . . . His wish was to be granted only after his death, in July 1962. The event was organized at the Tokyo Gallery par Shinichi Segi. During my stay in Tokyo, in October 1962, we—Shinichi Segi, Yoshiaki Tono, and myself—organized an evening in homage to Klein during which I carried out a *symbolic* transfer of the immaterial, in exchange for a gram of fine gold, thrown into the sea. *This farewell concluded the ritual.*"[216] This "homage" to Klein followed a promise that his premature death did not allow him to keep: that of carrying out a transfer of the immaterial with Shinichi Segi. A photograph of the "ritual" performed by the critic accompanied by Shinichi Segi and a few others **(fig. 68)**, was published with this surprising caption: "Pierre Restany throws a gold ingot into Tokyo Bay. Posthumous conceptual work by the International Klein Bureau."[217] Anachronisms of this type are common. The contamination of the past by the present on this occasion poses questions that allow us to define better the ambiguities of the status of the "zones of immaterial pictorial sensibility." As regards the zones, Klein never said or suggested that he might have subscribed to Lawrence Weiner's famous *Declaration of Intent*, published in 1969:

1. The artist may construct the piece.
2. The piece may be fabricated.
3. The piece need not be built.

68. "Symbolic transfer of the imma-
terial," organized by Pierre Restany,
Shinichi Segi, and Yoshiaki Tono in
homage to Yves Klein, Tokyo, October
1962.

Klein always officiated in person during the transfer rituals. Through his presence, attested by his autograph signature, he stood surety for both the reality and the specific quality of the zones inaccessible to the eyes of the body, which were authenticated, moreover, by one or more witnesses.

On account of their exceptional nature, the status of these works remains difficult to define. They are open to misunderstandings, sometimes fruitful. Even a connoisseur as well-informed as Pierre Restany, a party to Klein's artworks from the beginning, seems to have been destabilized by them. It might seem strange, but he was not present at any transfer, either as a witness or as a simple spectator or friend. This also means that he was never given one of these works, even as a gift. Even stranger, the critic made mistakes at least twice when he described the "ritual," which, however, had been set out in detail by the artist. In 1974, in his first monograph dedicated to Klein,

Restany wrote that the buyer who wished to appropriate the zone of immateriality that he had just acquired permanently had to "pay twice the amount of gold indicated on the receipt."[218] Seven years later, Restany gave a slightly different version of the transaction, which was just as inaccurate: "If the buyer agreed to destroy the check, i.e., his title of ownership, by burning it immediately, all the gold was restored to the cosmos by being thrown into the Seine. In the opposite case only a part of the gold was so disposed of: the rest came to Klein for the time being, he having only a temporary and conditional title to it."[219]

These imprecisions, linked to a conceptual vagueness or to being underinformed, led Restany, who believed he had "concluded the ritual" in 1962, to adopt another position a few years later: "The ritual can, however, be resumed because before his death Klein had transferred to his godson Yves Arman-Fernandez [Arman's son] his checks for the immaterial by leaving him the free disposal of the remaining receipts: he only had to conform to the terms of the transfer if potential buyers came forward."[220] Klein had in fact stated that the counterfoil books would go to his godson. After the artist's premature death, Yves Arman received the counterfoil books, which have been found.[221] He was thus able to use "zones of immaterial pictorial sensibility" that were still available. In 1975 he transferred zone no. 7 of series no. 1 to Karl Heinrich Müller, after having filled out the receipt and stub (fig. 69). Given such a continuation of activities post mortem, it is difficult not to think of Christ's declaration, which instituted the Eucharist, during the Last Supper: "This do in remembrance of me." The analogy is, however, misleading. To transfer a zone, that zone, according to the logic put in place by the artist, had to exist. Had Klein "specialized" the "immaterial pictorial sensibility" when the receipts were printed, or were the receipts just empty receptacles, ready to be invested with a substantial content during the ritual? Could one continue to print counterfoil books while respecting the protocol of geometric progression? These questions remind us that we are in the presence of a *fiction*, a fiction that takes shape and delivers its effects only if one pretends to forget—but is that not the name of the game—what it is, a work of art, an intellectual work.

69. Receipt book stub for the posthumous transfer of *Zone of Immaterial Pictorial Sensibility*, No. 7, Series No. 1, to Karl Heinrich Müller on May 16, 1975.

These questions remain unanswered, but Klein had thought about—without having resolved all the problems posed—the continuation of his work after his death. The patents that he registered with the Institut National de la Propriété Industrielle in France have long since fallen into the public domain. But if a coffee table is manufactured according to his plans and directions, which would be lawful, it could not be sold as a *work* by Klein because patents only apply to industrial objects. On the other hand, the logic of copyright that prevails in the art world protects works for unauthorized reproduction: the world of patents must be abandoned for that of copyright. Furthermore, the artist had made use of another strategy, delegation. In May 1960, Klein founded the International Klein Bureau, which allowed each of its members (besides Klein, Pierre Restany, Claude Pascal, Jean-Pierre Mirouze, and Arman) to produce and sign with his own name IKB blue monochromes. What would the status of a superb blue mono-chrome painted with a roller by Arman or Restany be? If one refers to

the theory of sensibilization and the example of the forgery discussed by Klein for illustrative purposes, it is evident that they would not be works likely to circulate under his name or label without, however, being considered mere plagiarism, and even less so for the forgeries. At the very beginning of the 1960s, the interest of artists in these questions and processes spread, but satisfactory solutions had not yet been found.[222]

More realistic, in the context of the period, or more mundane, Iris Clert wanted to guarantee the authenticity of the receipts for the transfers. She put it in plain language: "To avoid counterfeits, there will also be the stamp of my gallery and my signature."[223] Indeed, the stamps accompanied by the gallery owner's autograph signature appeared on the preserved receipts, which were all exchanged before the artist left her gallery—the transfers with the ritual of gold and fire had all been carried out when Klein obtained a contract with Jean Larcade.[224] Like the sale, the production of the forgery or even its possibility, indicates that the work considered is well and truly a part of the art market and that it is thus really a work of art—little does its aesthetic value matter here.

In the late 1950s, the mode of existence of conceptual works and that of "works with scores" had still not been elucidated by the development of artistic practices that, shortly afterward, we would have recourse to, in full knowledge of the facts. Paradoxically, whereas Marcel Duchamp ceaselessly produced multiple remakes of his works,[225] it was the signing by the artist of the replicas brought out by the Galleria Schwarz in 1964 that drew attention—outside the circle of specialists—to the desacralization of the concept of the original, in embryonic form, in the very concept of the ready-made.

Despite his few late and sporadic attempts at delegating his powers, Klein was part of an entirely different logic. In 1959 the real presence of the artist devoted to the invisible still seemed essential. Only he could *consecrate* his immaterial works. Such a concept was still reliant on those that prevailed for "traditional" painters, who were supposed to wield paintbrushes and not to confide them to their assistants. That is why Klein had to "specialize" himself, through his "affective presence" (and effective presence), the indeterminate space—the

"zone"—hosting the invisible sensibility. In this version of events, presented by Klein in various forms, with many slight differences and variants, the operation could not be delegated. It required the creative force of the artist in person.

In actual fact, this version of events whose efficacy no one, not even the artist, could prove, was based on another mechanism. Klein elaborated a "narrative" that with the passing episodes constructed a founding epic. It took shape in the creations, deeds, and words of the hero, a genuine epic poem that recounted a singular story, that of the artist and that of his work indistinctly mingled. His quest for the immaterial did not adopt the Christic model. It founded no religion and we cannot worship in its memory. As for the saints, this is a testimony, an "exemplary life" dedicated to the revelation of the truth, a truth located "beyond the problematic of art," that is, referred to art. An artist, Klein left us paintings, sculptures, relics, and questions.

The room of the "Void" in Krefeld is invaluable, whereas the same room rebuilt today would be nothing more than a cultural tourist trap. That is why we cannot recreate the ritual of the transfers or the anthropometries without sliding into an artificiality deprived of an aura or parody, which, when intentional, can have its own charms. The case of Yves Arman is exceptional, as we have seen, since Klein had bequeathed him his counterfoil books with the permission to use them. This translated the artist's wish—a recurrent wish in the twentieth century—to evade the law of a personification of the artwork. But the fact that a single transfer of this type had taken place also revealed the embarrassment of various individuals faced with creations that did not lend themselves to a logic of disappropriation. Therefore, Klein's works are not conceptual works or "works with scores." The fact that we constantly talk about the "checkbook" is also telling: do we picture signing valid checks from a dead man's checkbook? If we take up the now famous typology put forward by Nelson Goodman, let us note that the check itself is allographic, but that an authorized autograph signature is essential for it to acquire value.

As for avowed or obvious parodies, we are aware of at least two. In 1985 Mike Bidlo organized *Recreating Yves Klein's Anthropometries* **(fig. 70)**, a carnavalized remake at the Palladium in New York of the

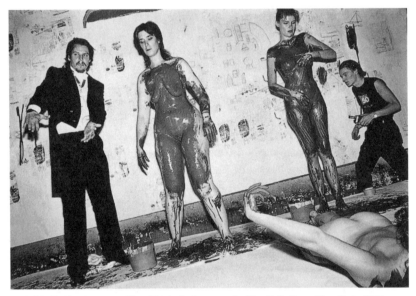

70. Mike Bidlo, *Recreating Yves Klein's Anthropometries*, The Palladium, New York, 1985.

session of March 9, 1960. Two decades earlier, the provocative charm of the ritual for the transfer of "zones of immaterial pictorial sensibility" had not escaped Marcel Duchamp. By way of an illustration—reproduced on the cover of the trade edition—for Arturo Schwarz's book, *Il Reale Assoluto* (Milan, 1964), he had the following text printed:

> We, Marcel Duchamp,
> declare for whatever purpose it may serve that the bearer of the present
> INALIENABLE AND NON-TRANSFERABLE CERTIFICATE
> is an accredited and incorporated reader of the collection of poems by
> ARTURO SCHWARZ
> entitled

IL REALE ASSOLUTO
The bearer of this *Inalienable and Non-Transferable Certificate* is sole holder of the *Droit de Libre Lecture* of said collection and has paid the sum of one thousand Italian lire to enjoy this privilege.
One hundred copies were numbered and signed at our permanent residence in New York on February 29 of the leap year 1964.[226]

Through their differences, such creations demonstrate how much the ceremonies and rituals practiced by Klein were charged with "magic" that owes nothing to run-of-the-mill occultism or sham alchemy. One can, of course, poke fun at them but, if one wants to do them justice, it would be difficult to present them today in a mode other than that of the dreamy evocation delivered by the documents and relics, or that of the narrative. Most of the time, these two registers complement one another to combine their effects and specific virtues. In the context of the 1960s, a few years after Klein's death, Edward Kienholz had put an "immaterial work" by the French artist in a group exhibition. This commemorative presentification remains a model of its kind.

Kienholz was a convert—they are often the best propagandists of the faith. He knew Klein by reputation before meeting him, on the occasion of his exhibition at the Dwan Gallery in California (1961), and still had mixed feelings about the somewhat "theatrical" aspect of his oeuvre. For their meeting, he produced "a working-travelling kit" **(fig. 71)**—a small suitcase containing a can of IKB pigment, a doll, cans of spray paint, a few sheets of paper—that he presented, not without irony ("rather tongue in cheek"[227]), to Klein. Quickly won over by his work, he received in exchange, as we have seen, a *Zone of Immaterial Pictorial Sensibility*.

Invited to take part in the exhibition organized by Harald Szeemann at the Kunsthalle Bern, *Live in Your Head* (1969), Kienholz decided to present dissimilar works even, in addition to his own work, the immaterial work in his possession. Klein thus participated in the exhibition in his own right. The same amount of space was allocated to him in the catalog as to the other artists. The first of the two pages

71. Edward Kienholz, *Traveling Art Show Kit*, 1961, suitcase and objects, private collection.

dedicated to him contains a strict minimum of factual information. It features a portrait of the artist, in extreme close-up, and notes: "Yves Klein is represented in this exhibition with an 'Immaterial,' 'written' for this catalogue by Edward Kienholz." On the second page **(fig. 72)**, in addition to an atypical photograph of the "Leap into the Void," the facsimile of a typescript by Kienholz contains all the necessary information. After mentioning his encounter with Klein, he states: "An Immaterial is a very difficult work. In its final distilled aspect, it is probably pure art because nothing physical exists." After this warning and statement of his views, Kienholz succinctly describes the rules for the transfers of the immaterial and mentions his immaterial work.

Kienholz did not say if he exhibited the "zone of immaterial pictorial sensibility" that belonged to him in Bern. Nothing suggests otherwise, and this would comply with a certain logic: he could have loaned his work for the duration of an exhibition, as collectors and institutions often do. In any event, Kienholz draws the legitimacy of his gesture from his status. Far from presenting, under cover of impunity, what he does not have—as mentioned, there was nothing to see, no concrete objet to furnish as proof of his loan—the American artist offered what he possessed, what we know he possessed since he mentions it in the catalog. To verify if all this was true, one must be able to consult the receipt stub. Kienholz had the good grace not to furnish this proof: he thus expressed his confidence in the intrinsic strength of the "epic poem" elaborated by his friend, an oeuvre that created its own truth more then it based itself on attested facts. In any case, no document will ever be able to tell us if the "immaterial pictorial sensibility" is fiction or not. Far from imposing itself with "proofs" (definitely nowhere to be found, like the proofs of the existence of God), it leaves us absolutely free.

The fact that the intercessor between the immaterial work and the Kunsthalle public was an artist was not insignificant. Kienholz's own work was perfectly well-known and he had no need to lean on the work of another. His disinterested complicity with Klein gave rise to an act of pure generosity—needless to say, there was no commercial consideration here. That being the case, nothing got in the way of the work he presented. This is one of the reasons that make this

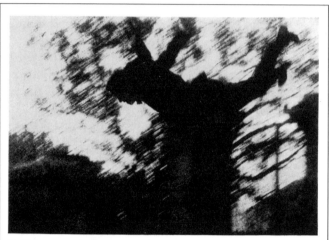

Yves Klein, Saut dans le vide, Paris 1980

I first met Yves Klein in 1962 when he came to this country (America) for an exhibition at Dwan Gallery in Westwood, California. Knowing him only by reputation and being somewhat in awe of the theatrical production aspects of his work, I made a small suitcase containing toy dolls, press releases and a jar of International Klein Blue (sort of a working-travelling kit), which I presented him (rather tongue in cheek) on his arrival. A warm friendship ensued and one day he gave me an Immaterial.

An Immaterial is a very difficult work. In its final distilled aspect, it is probably pure art because nothing physical exists. It works this way: The buyer-collector of an Immaterial would give Yves money; in fact, quite a bit of money for the ownership of the Immaterial. Yves would then issue a receipt for the money which was printed on very special paper, the stub of which I believe was filed somewhere by someone for record purposes. Yves would then divest himself of the money by "throwing the gold", which meant actually scattering the money in the mountains from a plane or dropping it in the ocean from a boat, etc. The buyer-collector then completed the gesture by burning the receipt so that artist and owner each had nothing but the art experience.

In my particular case, Yves' untimely death prevented his "throwing the gold". However, at a later date, his wife, Rotraut, and Arman cast gold leaf from a boat on the waters of the Mediterranean in his name, symbolically completing my Immaterial.

72. Back of the page dedicated to Yves Klein, exhibition catalog, *Live in Your Head: When Attitudes Become Form: Works, Concepts, Processes, Situations, Information*, Kunsthalle, Bern, 1969, n. p. (Yves Klein, *The Leap into the Void*, and Kienholz's text).

exemplary reactivation difficult to reproduce. Moreover, the historical context in which the Bern exhibition was organized was particularly favorable to its inclusion in a strictly verbal form. Conceptual art had just appeared. Its freshness and novelty attracted attention. In Bern, Robert Barry presented an invisible work. The catalog signals its presence and invites us to think that it was indeed real. The caption of a photograph of the top of the Kunsthalle informs the reader that the roof of the building was "being occupied by the radiation from 'Uranyl Nitrate (UO2(NO3)2).'"[228] It goes without saying that Klein's immaterial works manifested, in anticipation, affinities with those of Barry. Their differences are, nevertheless, more significant.

The photograph produced by Barry proves nothing and the fact is now unverifiable, but it could have been checked on the spot during the exhibition. The right measuring device was all that was needed to see if the radiation existed or not. A work of this nature could be perfectly recreated, and presented exactly as it had been. On the other hand, the "zones of immaterial pictorial sensibility" could only be *evoked* because they had no concrete existence. The artist did, however, manage to implement the conditions of their apparition, to create the forms of their presentification, and to organize the possibility of reactivating the memory of them. Klein bequeathed to us explanations, documents, relics, and the memory of an endeavor so exceptional that it could leave no one indifferent. In doing so, he expressed his faith in our capacity to take up their challenge: to find the means to perpetuate all their brilliance.

NOTES

Foreword

1. August Wilhelm Schlegel, "Die Gemählde: Ein Gespräch," *Athenäum* 2 (1799).

2. Yves Klein, "La verité sur le Nouveau Réalisme," *Le Dépassement de la problématique de l'art et autres écrits*, Marie-Anne Sichère and Didier Semin, eds. (Paris: École nationale supérieure des Beaux-Arts, 2003), 273.

3. Shortly before his death, Klein had plans to collect and have translated into English several of his texts in order to put together what he called "the epic book of the century" (*Le Dépassement de la problématique de l'art et autres écrits*, 420).

Visibility and Presence

4. Yves Klein, "Quelques extraits de mon journal en 1957," *Le Dépassement de la problématique de l'art et autres écrits*, 44.

5. Eugène Delacroix, *The Journal of Eugène Delacroix*, trans. Lucy Norton, 3rd ed. (London: Phaidon, 1995), 7. My italics.

6. In the foreword he wrote for *L'Aventure monochrome* (project for a collection of texts conceived in 1958; unfinished, several states of it exist), Klein reminds us in his own way that he writes as an artist: "I know that all these notes and thoughts are confused, badly worded, pompous, unsophisticated, often naive no doubt because they were written day to day. I know that this will be considered by many as nonsense in bad taste. But I don't mind; I am neither a literary type nor a distinguished man. I am an artist, and I love my freedom, which is neither vanity nor foolish candor, even if I verge on stupidity from time to time." *Le Dépassement de la problématique de l'art et autres écrits*, 223.

7. Klein was de facto the opposite of his contemporary Clement Greenberg, whose idea of modernism implied that each of the arts, painting, sculpture, poetry, or music, would undertake a "process of self-purification" in order to eliminate "*expendable* conventions" ("American-Type Painting," reprinted in *Art and Culture*

[Boston: Beacon Press, 1961), 208]; Greenberg's italics). It is piquant to note that, to develop his concept of an art in search of its essence, Greenberg referred to the painting of Jackson Pollock in particular because Allan Kaprow drew diametrically opposed conclusions. Examining "The Legacy of Jackson Pollock" in 1958, Kaprow detected in Pollock's paintings an invitation to pursue his work outside the specificity of painting (in *Essays of the Blurring of Art and Life* [Berkeley: University of California Press, 1993], 1–9). Kaprow was one of the first to advocate, in opposition to the specificity of the arts, a widespread decompartmentalization: "Young artists of today need no longer say, 'I am a painter' or 'a poet' or 'a dancer.' They are simply 'artists.' All of life will be open to them" (ibid., 9). During the same period, Klein thought of his activity in this mode. But the artists who, like Kaprow, refused to confine themselves to a specific art had abandoned painting or sculpture. This perhaps explains the setback experienced by Klein in New York when he presented his paintings: they seemed too reliant on a modernism to whose development, in 1961, they added nothing and, for lack of contextualization, they could scarcely be received as elements of an altogether different adventure—which they are, however, as demonstrated by the immaterialization of blue, if one agrees to consider it a hermeneutic contribution to the interpretation of his monochromes.

8. Consistent, Klein adopted an unusual way of presenting his career to the audience at the Sorbonne during his lecture of June 3, 1959 ("L'évolution de l'art vers l'immatériel"—"The Evolution of Art toward the Immaterial"): instead of mentioning his early days, then moving on to each of the main stages of his development one by one to end up in the present, he went back in time, beginning with his most recent activity (his participation in the exhibition *Vision in Motion—Motion in Vision*, Hessenhuis, Antwerp, March 1959). Logically, the chronology can in fact only be established retrospectively. This lecture was recorded and released as a vinyl album after the artist's death. The transcription of this lecture has been published in a bilingual book: *Vers l'immatériel / Towards the Immaterial*, trans. Charles Penwarden (Paris: Éditions Dilecta, 2006). This book also contains a CD featuring a reproduction of the vinyl recording.

9. Yves Klein, "Le dépassement de la problématique de l'art", *Vers l'immatériel / Towards the Immaterial*, 87. On the debate organized in the Galerie Colette Allendy, see Bernadette Allain, "Propositions monochromes d'Yves Klein," *Couleurs* 15 (May–June 1956): 25–27.

10. Yves Klein, "L'Aventure monochrome," part 1, "Le vrai devient réalité ou Pourquoi pas," *Le Dépassement de la problématique de l'art et autres écrits*, 233. This brilliant idea certainly appeared a short time later as the explanatory crowning achievement of an intention that sought to take shape. While the eleven identical paintings had really been displayed with different prices, it is unlikely that this spectacular fact would have escaped the attention of an observer as keen as Dino Buzzati. After having described them and having indicated that nothing allowed

their profound differences to be recognized—"Ma si riconosce in qualche modo nei dipendi questa diversità di stato d'animo creativo? No assolutamente no."—the writer states that they are all displayed with the same price: "A proposito, il prezzo. E modestissimo: 25.000 lire al quadro" (Dino Buzatti, "Blu, blu, blu. Un fenomeno a la galleria Apollinaire," *Corriere d'informazione* [January 9, 1957]).

11. Yves Klein, "L'Aventure monochrome," *Le Dépassement de la problématique de l'art et autres écrits*, 243.

12. Ibid., 235.

13. Jorge Luis Borges, "Pierre Menard, Author of the *Quixote*," in *Fictions*, trans. Andrew Hurley (London: Penguin, 2000).

14. Borges notably gives this example, to conclude his short story, to convince us of the importance of information extrinsic to the work itself: "Attributing the *Imitatio Christi* to Louis-Ferdinand Céline or James Joyce—is that not sufficient renovation of those faint spiritual admonitions?"

15. Arthur C. Danto, *The Transfiguration of the Commonplace* (Cambridge, MA: Harvard University Press, 1981), 138.

16. Otto Pächt, for example, underlines this in a section of *The Practice of Art History: Reflections on Method* entitled "Knowing Eyes." He observed: "The modern psychology of perception shows that even in daily life there is no such thing as seeing without prior knowledge: there is, as it were, no innocent eye." The historian adds: "If, therefore, in the normal daily exercise of our organs of sight, we see with knowing eyes (whatever the source of that knowledge), it follows that in aesthetic perception this factor must be more important still" (*The Practice of Art History: Reflections on Method*, trans. David Britt (London: Harvey Miller Publishers, 1999), 78 and 79 respectively.

17. Arthur C. Danto, *The Transfiguration of the Commonplace*, 31.

18. Ibid.

19. Ibid., 42. My italics.

20. Arthur Danto (ibid., 42 ff.) discusses the analyses of Nelson Goodman who, from the example of the forged painting, demonstrates that no one can claim that no perceptive difference will ever appear between two objects that seem identical to us today. However, the two philosophers agree on one point: the "theoretical problem raised" by profoundly dissimilar works even though they are perceptually indiscernible is one of great interest for aesthetics.

21. Yves Klein, "L'Aventure monochrome," *Le Dépassement de la problématique de l'art et autres écrits*, 246.

22. A satire of art criticism (drawing by Rembrandt in the Metropolitan Museum of Art, New York) depicts, beside the painting that occupies the center of the sketch, a defecating figure, possibly an allusion to the ignoble character of the subjects that were all too plentiful in his own works (see Svetlana Alpers, *Rembrandt's Enterprise: The Studio and the Market* [Chicago: University of Chicago Press, 1988]). Gérard de Lairesse's comments reinforce this hypothesis (cf. *Groot Schilderboek* [1740], 324, quoted by Alpers, *Rembrandt's Enterprise*, 153, n. 51).

23. Yves Klein, "L'Aventure monochrome," *Le Dépassement de la problématique de l'art et autres écrits*, 246–47. My italics.

24. Eugène Delacroix, "Réalisme et idéalisme," *Oeuvres littéraires*, vol. 1 (Paris: Éditions G. Crès, 1923), 63.

25. As Michel Pastoureau reminds us, "color is not so much a natural phenomenon as a complex cultural construct." Inviting us to distinguish perception, an essentially neurobiological phenomenon, from vision, largely a cultural construct, he demonstrates in all his works as a historian dedicated to color that it is not in the least a "transcultural truth" (see, in particular, *Le Bleu, Histoire d'une couleur* [Paris: Seuil, 2000]).

26. Of course, I am thinking of the readers of the artist's writings. But Klein often used the term *lecteur* (reader) when he evoked the art lovers looking at his paintings when one would expect *regardeur* (viewer), for example: "I contented myself with staying in the classic format, rectangular, so as not to shock psychologically the *reader* who in this way was presented with a colored surface" ("L'aventure monochrome," *Le Dépassement de la problématique de l'art et autres écrits*, 245. My italics.) We could give many more occurrences of this idiosyncratic usage which allows emphasis to be placed on the links between the texts—to read—and the paintings—to look at; in other words, to avoid a purely retinal contemplation. This weaving of legible and visible is part of a tradition, that of *ut pictura poesis*. Thus, Nicolas Poussin discussing his painting *The Gathering of Manna* in a letter to Jacques Stella (c. 1637), wrote: "I have found a certain distribution for Monsieur de Chantelou's painting, and certain natural attitudes, which show the misery and hunger to which the Jewish people had been reduced, and also the joy and happiness that came over them; the astonishment that had struck them, and the respect and veneration that they felt for their lawgiver, with a mixture of women, children, and men of different ages and temperaments; things that, I believe, will not displease those who know how to *read* them" (Nicolas Poussin, *Lettres et propos sur l'art*, Anthony Blunt, ed. [Paris: Hermann, 1989], 37; my italics).

27. It goes without saying that I have chosen—from the dense mass of the artist's writings—passages that I have arranged with heuristics in mind.

28. Jules Janin, "Le Daguerotype [*sic*]," *L'Artiste* (April 1839).

29. Jean-Marie Schaeffer drew attention to this experimental procedure, which he commented on in *L'Image précaire. Du dispositif photographique* (Paris: Seuil, 1987), 21 ff.

30. In these attempts to photograph the invisible, see in particular: Georges Didi-Huberman, *Invention de l'hystérie. Charcot et l'iconographie photographique de la Salpêtrière* (Paris: Macula, 1982), 84 ff; Philippe Dubois, *L'Acte photographique et autres essais* (Paris: Nathan, 1990), 205 ff; Clément Chéroux, "Ein Alphabet unsichtbarer Strahlen. Fluidaltfotografie am Ausgang des 19. Jahrhunderts," *Im Reich der Phantome. Fotografie des Unsichtbaren*, exh. cat. (Cantz, 1997), 11 ff; Clément Chéroux, "La photographie des fluides ou les lapsus du révélateur," *Vision machine*, exh. cat. (Paris: Somogy, 2000), 9 ff; Daniel Grojnowski, *Photographie et langage* (Paris: José Corti, 2002), 245 ff.

31. Hippolyte Baraduc, "Conférence prononcée à Bar-le-Duc," October 25, 1895, cited by Daniel Grojnowski, *Photographie et langage*, 281. Dr. Baraduc was keen on dissociating his research from spirit photography, the recording of an apparition raised by a medium: "I can say that I never saw anything of what was happening on the plate, whereas those experimenters saw the apparition they were photographing. I thus confine myself to the domain of the *Iconography of the Invisible*" (*L'Âme humaine, ses mouvements, ses lumières, et l'iconographie de l'invisible fluidique* [Paris: Georges Carré Éditeur, 1896], 34)—this book was republished in a popularized edition with the same title [Paris: G. A. Mann Éditeur, 1911], itself translated into English as *The Human Soul, its Movements, its Lights* [Paris: G. A. Mann Éditeur, 1913]).

32. August Strindberg, "Notes scientifiques et philosophiques" (1896), extracts reproduced in Clément Chéroux, *L'Expérience photographique d'August Strindberg* (Arles: Actes Sud, 1994), 91; for illustrations of Strindberg's photographs, see *Strindberg, peintre et photographe*, exh. cat. (Paris: Réunion des Musées Nationaux, 2001).

33. This phrase was soon used for photographs produced thanks to X-rays (see, for example, Georges Vitoux, *Les Rayons X et la photographie de l'invisible* [Paris: Chamuel, 1896]).

34. Charles Richet, *Revue métapsychique* (May–June 1927), cited by Daniel Grojnowski, *Photographie et langage*, 262 (the Institut Métapsychique International, a state-approved private foundation since 1919, still exists: it claims to take a scientific approach to the phenomena that fall within the province of parapsychology).

35. On Bragaglia, his photographic experiments, and their rejection by the Futurists, cf. Marta Braun's article, "Fantasmes des vivants et des morts. Anton Giulio Bragaglia et la figuration de l'invisible," *Études photographiques* 1 (November 1996): 41 ff.

36. The success of scientific books, illustrated or not, dedicated to the invisible has not waned. Recent publications include: Jean Audouze, Michel Cassé, and Jean-Claude Carrière, *Conversations sur l'invisible* (Paris: Plon, 1996); Patrice Lanoy, *Invisibles. Images de l'inaccessible* (Paris: Somogy / Cité des Sciences et de l'Industrie, 1998); Katherine Roucoux and David Malin, *Heaven and Earth: Unseen by the Naked Eye* (London: Phaidon, 2002); France Bourély, *Mondes invisibles. Éloge de la beauté cachée* (Paris: La Martinière, 2002).

37. Odilon Redon, *À soi-même. Journal (1867-1915). Notes sur la vie, l'art et les artistes* (Paris: José Corti, 1985), 28.

38. Paul Klee, *The Thinking Eye*, trans. Ralph Mannheim, Charlotte Weidler, and Joyce Wittenborn (London: Lund Humphries; New York: George Wittenborn, 1961), 76.

39. A distinction should be made, as Dr. Baraduc invited us to do, between spirit photographs that record an apparition that those who took part in the séance well and truly saw, or believed they saw, and the actual photographs of the invisible, those which fix on a photosensitive plate a trace or a presence—that of an aura, for example—which foils any direct attempt to capture it. This second category of "images" is much richer in terms of lessons about the nature of the photographic process because the photographs obtained are neither representations, in the pictorial sense of the term, nor fanciful projections (the painter can give form to that which he does not see). Of course, they attest less to the presence of a referent than to a chemico-physical phenomenon; there is no change of state without cause—and the plate is altered. Finally, let us state that the sincerity of the device or deliberate cheating do not in any way change the demonstration. Whether one believes in the intervention of the supernatural or not, it must be noted that photography produces a non-mimetic image even though it may appear lifelike.

40. The realist only draws or paints what he sees. Courbet said: "Show me goddesses, if you can, and I'll paint them for you" (remarks cited by Félicien Champsaur in "Édouard Manet," *Les Contemporains* 29 [June 16, 1881]); in the same spirit, Courbet teased one of his colleagues who showed him a painting of the Holy Family: "That's lovely, that is. So you knew these people—you painted their portrait!" (remarks cited by Guy de Maupassant, "La vie d'un paysagiste," *Gil Blas* [April 28, 1886]).

41. Charles S. Peirce, *Collected Papers of Charles Sanders Peirce*, 8 vols. (Cambridge, MA: Harvard University Press), 2.248.

42. Ibid., 2.305.

43. Ibid., 2.281.

44. Ibid.

45. Yves Klein, "L'Aventure monochrome," *Le Dépassement de la problématique de l'art et autres écrits*, 230.

46. From a different standpoint, Walter Benjamin had spotted a comparable phenomenon: "No matter how artful the photographer, no matter how carefully posed his subject, the beholder feels an irresistible urge to search such a picture [the portrait of a man with his fiancée, who would later commit suicide] for the tiny spark of contingency, of the here and now, with which reality has (so to speak) seared the subject" ("Little History of Photography," in *Selected Writings, Vol. 2, Part 2, 1931–1934* [Cambridge, MA: Harvard University Press, 1999], 510).

47. Odilon Redon, *À soi-même*, 124. More radical, Klein had replied to a question put to him by Georges Mathieu—"For you, what is art?"—during the debate that followed the public session of *Anthropometries* organized at the Galerie Internationale d'Art Contemporain on March 9, 1960: "Art is health" (see Pierre Restany, *Yves Klein le monochrome* [Paris: Hachette, 1974], 103).

48. Odilon Redon, *À soi-même*, 125. Making use of his own experience, Klein made a similar statement: "It's when I have no inspiration, when I am empty and demoralized, morbid or psychically weakened, that I really work each painting, the matter; I keep starting over, I fail, I go back over old things. Whereas, when everything is going well, when I'm on form, the good paintings are executed very quickly, without hesitation, directly and I am happy. I get tired but it's a good tiredness" ("L'Aventure monochrome," *Le Dépassement de la problématique de l'art et autres écrits*, 241).

49. Yves Klein, "L'Aventure monochrome," *Le Dépassement de la problématique de l'art et autres écrits*, 235.

50. Ibid., 252–53.

51. Ibid., 240–41.

52. Ibid., 246.

53. Ibid., 248. The notion of impregnation, crucial for Klein, is exemplified by his sponges saturated with color, presented as sculptures or integrated into his monochromes. They not only referred to the artist's general practice, but also mimicked and illustrated the process of a successful reception. Klein observed: "Thanks to the sponges, raw living matter, I was going to be able to make portraits of the viewers of my monochromes, who, after having seen, after having traveled in the blue of my paintings, return totally impregnated in sensibility, like sponges" ("Remarques sur quelques oeuvres exposées chez Colette Allendy," *Le Dépassement de la problématique de l'art et autres écrits*, 54).

54. Yves Klein, "L'Aventure monochrome," *Le Dépassement de la problématique de l'art et autres écrits*, 235.

55. Ibid., 233.

56. Plotinus, [I 6]. Cited in Pierre Hadot's remarkable book *Plotinus, or The Simplicity of Vision*, trans. Michael Chase (Chicago: University of Chicago Press, 1993), 30.

57. Roland Barthes, *Camera Lucida: Reflections on Photography*, trans. Richard Howard (New York: Hill and Wang, 1981), 27. Barthes's italics.

58. Ibid., 55.

59. Ibid., 53. In support of his thinking, Barthes quoted Kafka: "'The necessary condition for an image is sight,' Janouch told Kafka; and Kafka smiled and replied: 'We photograph things in order to drive them out of our minds. My stories are a way of shutting my eyes.'"

60. Ibid., 55.

61. Eugène Delacroix, *The Journal of Eugène Delacroix*, 444 (June 22, 1863).

62. Ibid., 7 (October 8, 1822). Delacroix's italics.

63. Yves Klein cites, for example, this passage borrowed from Delacroix: "Woe betide the painting that shows nothing beyond the finite; the merit of a painting is the "indefinable," it is precisely what escapes precision. . . . It is what the soul has added to the colors and the lines to reach the soul" (Yves Klein, "L'Aventure monochrome," *Le Dépassement de la problématique de l'art et autres écrits*, 234—Klein's quotation is approximate.

64. Eugène Delacroix, *Journal 1822-1863* (Paris: Plon, 1981), 850–51. Thus, Delacroix himself invoked a possible relationship between painting and "the immaterial." My italics.

65. Plato, *The Republic*, VII–533d. *Plato in Twelve Volumes*, vols. 5 and 6 translated by Paul Shorey. (Cambridge, MA: Harvard University Press, 1969). Roland Barthes attests to the durability of this hierarchy when he notes that "what is hidden is for us Westerners more 'true' than what is visible" (*Camera Lucida*, 100).

66. Maximus Confessor, *Selected Writings*, trans. George C. Berthold (Mahwah, NJ: Paulist Press, 1985), 189.

67. André Grabar, *Les Origines de l'esthétique médiévale* (Paris: Macula, 1992), 114–15.

68. Yves Klein, "L'Aventure monochrome," *Le Dépassement de la problématique de l'art et autres écrits*, 234.

69. Yves Klein, "Comment et pourquoi en 1957 …," *Le Dépassement de la problématique de l'art et autres écrits*, 388.

70. Yves Klein, "L'Aventure monochrome," *Le Dépassement de la problématique de l'art et autres écrits*, 235–36.

71. In "Remarques sur quelques oeuvres exposées chez Colette Allendy," Klein explains the desire to immerse art lovers in the blue, in the pictorial sensibility, embodied here: "The screens enabled the envelopment in blue. One could arrange them in a semicircle so as to be able to position oneself as a reader of the work in the center of the diameter" (*Le Dépassement de la problématique de l'art et autres écrits*, 53).

72. Here, the artist invites us to think of "a transposition of the famous veil of the Temple, which was torn at Christ's death," a veil of which he says: "That is why I think that the Studio in general was a closed temple, and the mind is still closed for many today but must become an open temple. So the torn veil of this temple of the Studio may be used as a shroud" (letter to John Anthony Twaites, December 28, 1960, *Le Dépassement de la problématique de l'art et autres écrits*, 414).

73. Pierre Fontanier, *Figures du discours* (Paris: Flammarion, 1977), 305.

74. Yves Klein, "L'Aventure monochrome," *Le Dépassement de la problématique de l'art et autres écrits*, 237–38.

75. Oil on canvas, 1933, 28 ¾ x 26 in. (73 x 66 cm), Russian Museum, Saint Petersburg.

76. The expression is Georges Didi-Huberman's, who mentions in his book *Le Cube et le visage. Autour d'une sculpture d'Alberto Giacometti* (Paris: Macula, 1993), 63, the analysis of *The Invisible Object* by Yves Bonnefoy (*Alberto Giacometti: A Biography of His Work*, trans. Jean Stewart [Paris: Flammarion, 2001]). Reminding us of Giacometti's admiration for Cimabue's *The Madonna and Child in Majesty Surrounded by Angels* (Louvre, Paris), Yves Bonnefoy wrote: "The twentieth century sculptor's figure recalls the Madonnas of the Italian *trecento*, and really we only have to imagine an infant between those hands, which do not reveal what they are holding—so carefully, up to the breasts which seem full and soft—to be before a version, nude indeed but still virginal, of the medieval Virgin and Child" (*Alberto Giacometti*, 230). The author then mentions the other title of the work, *Hands Holding the Void*, to note that it "does not allow one to ascribe any positive value to the content of those two raised hands." He then develops the idea that "this Virgin from the depths of night is seated on a tomb." So, what could one find "more natural to place between her hands than the *Cubist Head*, that skull which Giacometti had recently sculpted." If this image is that of death, this "Virgin" anticipates the Pièta—the dead Christ is latent in the newborn. Finally, faced with "those hands which are at the centre of the work, those hands to which the visible touches the invisible" (ibid., 232), the author remembers "Giacometti himself in his studio, his hands raised towards the lump of damp clay or plaster from which he was going to make a figure" (ibid., 232). Thus, "the invisible object is, all things considered, not so much the child reduced to his shadow as the inaccessible and yet real work he is going to

produce: starting afresh to fashion it with his own exile, as those two silent hands in the statue bid him do" (ibid., 234).

77. Sidra Stich, *Yves Klein* (Stuttgart: Cantz Verlag, 1994), 96, book published on the occasion of the exhibition *Yves Klein: Leap into the Void*, which traveled to Cologne, Düsseldorf, London, and Madrid in 1994. Stich's book, mostly remarkably well documented, does not specify the source of this piece of information, which is difficult to verify.

78. Pierre Restany, *Yves Klein le monochrome*, 46.

79. Pierre Restany, *Yves Klein. Le feu au coeur du vide* (Paris: La Différence, 1990), 18. A little later in the book, Restany described Klein's attitude in these terms: "After having overcome a moment of irritation due to the presence of a bulky radiator that disrupted the volumetric of the small room, his facial features hardened: he was pale and tense, and betrayed a profound emotion made up of a solemn joy and of a kind of diffuse apprehension. A mixture of joy and fear, analogous to the 'terror of God' of Christian mystics" (ibid., 19).

80. Yves Klein, "Comment et pourquoi en 1957 …," *Le Dépassement de la problématique de l'art et autres écrits*, 393.

81. In his "Remarques sur quelques oeuvres exposées chez Colette Allendy" (*Le Dépassement de la problématique de l'art et autres écrits*, 54), Klein wrote, about his tactile sculptures: "They were not exhibited. I don't know why, especially as I had talked about them a lot. They were boxes pierced with holes equipped with muffs. The idea was to be able to insert one's arms up to the elbows through the muffs and touch, feel the sculpture inside the box without being able to see it. I now think that I didn't exhibit these boxes because I had so quickly attained a point of perfection for these tactile sculptures that I thought it would be a good idea to wait a little. This point was quite simply the fact of placing inside the boxes living sculptures such as beautiful naked models, with very curvy figures, of course. It was a little premature at the time. I would have had the police on my back immediately." Henri-Pierre Roché mentioned Brancusi's *Sculpture for the Blind*, a work "in marble enclosed in a silk bag, with a rubberized opening to put one's hand through." It was to have been shown at the Society of Independent Artists exhibition in New York in 1917. He also reports that Brancusi had produced a 'base' for his *Beginning of the World*, an intimate work, but he preferred it 'placed on a cushion or a divan—and above all placed on the knees, touched by the hands, eyes closed" (Henri-Pierre Roché, *Écrits sur l'art* [Marseille: André Dimanche Éditeur, 1998], 175 and 129 respectively). This sculpture is often confused with *Sculpture for the Blind*, two versions of which—executed in the 1920s—exist. The abundance of variants produced by Brancusi and the question of their title is too complex to explore here. On the other hand, it should be pointed out that Marinetti was enthusiastic about "Tactilism, or the Art of Touch." His *Manifesto of Tactilism* (1921) created a polemic: Picabia

thought that "tactile art" was invented in New York. He referred to the photograph of a sculpture by Miss Clifford Williams published in the magazine *Rongwrong* (July 1917). She features in the magazine, accompanied by the caption, "Plaster for touching at De Zayas'."

82. It is, notably, what Pierre Restany asserted.

83. Yves Klein, "Comment et pourquoi en 1957 ...," *Le Dépassement de la problématique de l'art et autres écrits*, 388.

84. Iris Clert's account is worth quoting in full: "Yves Klein had triumphed in Milan. What can be done to outdo this success in Paris? How can one attract the attention of Parisians to this young unknown? I wanted to make a poetic gesture, to launch bunches of blue balloons into the Paris sky. Despite my destitution, I went in search of these balloons. I managed to order a thousand of them. A man was supposed to take care of blowing them up one by one with helium in front of the gallery on the day of the vernissage. I had kept it a secret to surprise Yves, but I couldn't resist and let the cat out of the bag a few hours before the vernissage. Yves was very excited about it.

From the beginning, this gesture, so benign and poetic in itself, had given rise to great protests, including by Claude Rivière:

—It's disgraceful. It's commercial advertising.

—Not at all, Claude. It's a disinterested gesture as there is no inscription on the balloons. And, anyway, apart from a few guests, no one would know what it was about. Needless to say, not stupid, I invited the news crew to film us. As all the justification of Klein's oeuvre is done afterward, he called my balloon launch his 'pneumatic period'" (*Iris-Time [l'Artventure]*[Paris: Denoël, 1978], 137). Clert achieved her aim: the Actualités Gaumont news crew did film this event.

85. All commentators agree that this name was retrospective. As for the number of balloons, various documents attest that Klein has not decided on it right away and that the figure 1,001 appeared after June 1957 (see Sidra Stich, *Yves Klein*, 261, note 41).

86. In only one article—by J. A. (Julien Alvard)—was the connection between the blue of the works, the "first phase," and what followed, upstairs, noticed: "the spell" by which, in "a light-filled room with no paintings," was revealed "the presence of blue with no support." The author adds: "Yves' experiment proves the extraordinary power of persuasion. Nothing is there, everything is there" ("Yves," *Cimaise* [July–August 1957]: 34).

87. Yves Klein, "My position in the battle between line and color," (Otto Piene, Heinz Mack and Laurence Alloway. *Zero*. [Cambridge, MA: MIT Press 1973], 10–11).

88. For this reason, it is one of the exhibitions included in the book *Die Kunst der Ausstellung. Eine Dokumentation dreißig exemplarischer Kunstausstellungen dieses Jahrhunderts*, Bernd Klüser and Katharina Hegewisch, eds. Frankfurt: Insel, 1991; French edition: *L'Art de l'exposition. Une Documentation sur trente expositions exemplaires du XX^e siècle* (Paris: Éditions du Regard, 1998).

Celestial Eclipse

89. Yves Klein, *Chelsea Hotel Manifesto*, New York, 1961, (this text was originally written in English by the artist in collaboration with Neil Levine and John Archambault); Klein clarified his explanations: "Painting no longer appeared to me to be functionally related to the eye when in my blue monochrome period of 1957 I became acquainted with what I have termed the pictorial sensitivity. This pictorial sensitivity exists beyond our being and yet belongs in our sphere", *Le Dépassement de la problématique de l'art et autres écrits*, 298. During the writing of his *Chelsea Hotel Manifesto*, Klein and his friends chose the term "sensitivity" to form the phrase "pictorial immaterial sensitivity." We have opted for "immaterial pictorial sensibility," a phrase that is widely used in English and which better translates the expression devised by the artist in French ("Sensibilité picturale immatérielle").

90. Yves Klein, "Le dépassement de la problématique de l'art", *Vers l'immatériel / Towards the Immaterial*, 87.

91. Ibid., 88.

92. Yves Klein thus named his April 1958 exhibition during the lecture he gave at the Sorbonne on June 3, 1959 ("L'évolution de l'art vers l'immatériel," *Vers l'immatériel / Towards the Immaterial*, 125). In his book, *Le Dépassement de la problématique de l'art*, published a few months later, he proposed a slightly different formulation: *The Specialization of Sensibility in Raw Material State into Stabilized Pictorial Sensibility* ("Le dépassement de la problématique de l'art", *Vers l'immatériel / Towards the Immaterial*, 88).

93. Iris Clert perhaps remembered this wording when she stated, when she mentioned the preparation of the "exhibition of the void," that the artist, with his monochromes, had attained "the exasperation of color" (*Iris-Time*, 159).

94. Yves Klein, "Le dépassement de la problématique de l'art", *Vers l'immatériel / Towards the Immaterial*, 92.

95. Ibid., 92.

96. This illumination of the place de la Concorde obelisk in blue took place in 1983 on the occasion of the vernissage of the Yves Klein retrospective at the Centre Pompidou, then on the occasion of a exhibition of sculptures on the Champs-Élysées, *Les Champs de la sculpture*, Paris, April 11–June 9, 1996, and again during

the *Nuit blanche* of October 9, 2006, when a second Yves Klein retrospective was being held at the Centre Pompidou.

97. Yves Klein, "Le dépassement de la problématique de l'art", *Vers l'immatériel / Towards the Immaterial*, 92.

98. Later commenting on this project, Yves Klein wrote: "This time, at Iris's, I had left the visible and physical blue at the door, outside, in the street. . . . Inside, it was the true blue, the blue of the blue depths of space" ("Comment et pourquoi en 1957 . . .," *Le Dépassement de la problématique de l'art et autres écrits*, 393).

99. Yves Klein, "L'évolution de l'art vers l'immatériel," *Vers l'immatériel / Towards the Immaterial*, 125–26.

100. Yves Klein, "Comment et pourquoi en 1957 . . .," *Le Dépassement de la problématique de l'art et autres écrits*, 392–93. Several times, the artist insisted on this conception of the painting. One of his most cutting turns of phrase, in this respect, is the following: "I realized [after having presented the blue period] that the paintings are but the ashes of my art. The authentic quality of the painting, its very 'Being,' once created, lies beyond what is visible, in the raw material state of pictorial sensibility" ("Le dépassement de la problématique de l'art", *Vers l'immatériel / Towards the Immaterial*, 87).

101. Yves Klein, letter to John Anthony Twaites, *Le Dépassement de la problématique de l'art et autres écrits*, 414.

102. Yves Klein, "Le dépassement de la problématique de l'art", *Vers l'immatériel / Towards the Immaterial*, 91.

103. Most commentators who reviewed the exhibition drew attention to the white walls. André Arnaud, interviewing the artist on radio station Europe 1 on April 29, 1958, asked him if he was establishing a "link between the house painter and the artist." Klein answered: "No, not at all. I don't apply color to the walls. It's an illusion—and one of the last ones—because in fact what I want to present here tonight is not at all the walls of this gallery but the atmosphere of the gallery. I painted the walls of this gallery myself simply in order to see clearly in my own atmosphere." The transcription of this interview was published in *Yves Klein*, exh. cat. (Paris: Centre Pompidou, Musée National d'Art Moderne, 1983), 197.

104. Yves Klein, "Comment et pourquoi en 1957 . . .," *Le Dépassement de la problématique de l'art et autres écrits*, 386. In this passage, Klein contrasted the "technical, artisanal, and visually apparent quality" of the painting with "its real quality of immaterial pictorial radiance."

105. Yves Klein, "L'évolution de l'art vers l'immatériel," *Vers l'immatériel / Towards the Immaterial*, 126. Italics mine.

106. Here, I invert the proposition expressed in these terms by Yves Klein: "Blue is the invisible becoming visible" ("Discours à la Commission du théâtre de Gelsenkirchen," *Le Dépassement de la problématique de l'art et autres écrits*, 341).

107. Yves Klein, "Comment et pourquoi en 1957 ...," *Le Dépassement de la problématique de l'art et autres écrits*, 388.

108. Yves Klein, "Vitesse pure et stabilité monochrome," review of the exhibition in collaboration with Jean Tinguely at Iris Clert's (November 1958), *Le Dépassement de la problématique de l'art et autres écrits*, 64.

109. Jean Grenier, *Essais sur la peinture contemporaine* (Paris: Gallimard, 1959), 159–60 (Grenier's italics). In this book, Grenier wrote about Braque, Chagall, Rouault, de Staël, Vieira da Silva, Borès, and a few others, but did not mention Klein.

110. Pierre Restany, communiqué inserted into a tin can filled with garbage and sent out as invitations to Arman's exhibition. the text was published in the exhibition catalog *1960. Les Nouveaux Réalistes* (Paris: Musée d'Art Moderne de la Ville de Paris, 1986), 75.

111. Yves Klein, "Truth becomes reality," in *Zero*, 94.

112. André Grabar, *Les Origines de l'esthétique médiévale*, 21.

113. Frantisek Kupka, *La Création dans les arts plastiques* (Paris: Éditions Cercle d'Art, 1989), 229.

114. Andy Warhol, *The Philosophy of Andy Warhol: From A to B and Back Again* (London: Penguin, 2007), 143. Warhol's italics.

115. Ibid., 144.

116. Robert Barry began producing invisible, or nearly invisible, works when he declared at a conference organized by Seth Siegelaub at Bradford Junior College in February 1968: "There is something about void and emptiness which I am personally very concerned with. I guess I can't get it out of my system. Just emptiness. *Nothing* seems to me the most potent thing in the world" (transcription published by Lucy R. Lippard in her book, *Six Years: the Dematerialization of the Art Object from 1966 to 1972* [Berkeley: University of California Press, 1997], 40). The following year, Barry looked back over the evolution of his art: "I started using thin transparent nylon monofilament. Eventually the wire became so thin that it was virtually invisible. . . . It was at this point that I discarded the idea that art is necessarily something to look at" (ibid., 71–72).

117. Yves Klein, "L'évolution de l'art vers l'immatériel", *Vers l'immatériel / Towards the Immaterial*, 127; it should be noted that an article by C. R. (Claude Rivière) titled "Manifestation d'avant-garde à la galerie Iris Clert" published in the newspaper *Combat* (May 5, 1958: 7), finished with this remark: "The public reacted in a rather

surprising way and we can affirm that 40 percent of the visitors were there, filled with the magic of the color, asking themselves with interest what adventure could occur after the daring of this lively new beginning."

118. Jean-Philippe Domecq, "Buren : de l'autopublicité pure, Dubuffet : du brut snob, et la suite," *Esprit* 179 (February 1992): 25–26.

119. "Courrier des arts. À travers les galeries," *Le Monde* (May 23, 1958). Note the use of the word "tabernacle" here, an interesting Catholic reference that the journalist uses without thinking of drawing out the religious metaphor.

120. The villa was built between 1927 and 1930 for Hermann Lange, who bequeathed it to his son Ulrich in the late 1930s. In 1954 Ulrich Lange put it at the disposal of the Kaiser Wilhelm Museum to house exhibitions of contemporary art, then, in 1966, he donated it to the city. It is still used for this purpose today (I owe this information to Julian Heynen's extremely well-documented book, *A Place That Thinks: Haus Lange and Haus Ester by Ludwig Mies van der Rohe, Modern Architecture and Contemporary Art* (Krefeld: Krefelder Kunstmuseen, 2000).

121. Yves Klein, letter of February 26, 1960, addressed to Paul Wember, reproduced in facsimile in the book *Yves Klein: Monochrome und Feuer, Krefeld 1961* (Krefeld: Krefelder Kunstmuseen, 1994), 4, 6, and 7; this letter is quoted and commented on by Jean-Marc Poinsot is his book *Quand l'oeuvre a lieu. L'art exposé et ses récits autorisés* (Geneva: Mamco; Villeurbanne, Institut d'art contemporain & Art édition, 1999); chapter 2, "Deux expositions d'Yves Klein," 59 ff.

122. This plan is reproduced by Jean-Marc Poinsot, ibid., 62.

123. See Julian Heynen, *A Place That Thinks*, 25.

124. Nan Rosenthal, "Assisted Levitation: The Art of Yves Klein," in *Yves Klein 1928–1962: A Retrospective*, exh. cat. (Houston: Institute for the Arts, Rice University; New York: The Arts Publisher, 1982), 126. This exhibition was held at the Institute for the Arts, Rice University, Houston; the Museum of Contemporary Art, Chicago; the Solomon R. Guggenheim Museum, New York; and the Centre Pompidou, Paris; the French version of the catalog is significantly different from that of the original American catalog. Furthermore, Nan Rosenthal observes that the two photographs differ on a point of detail, crucial for the analysis of the fictional register adopted by the artist: in the first version, a cyclist rides away, while the street in empty in the second version, published in Krefeld. Thus, Klein intentionally supplied clues about the process used—photomontage—a process that he claimed, moreover, he wanted to keep absolutely secret (ibid., 127–28).

125. Yves Klein, "Le peintre de l'espace se jette dans le vide !", *Dimanche. Le journal d'un seul jour* (November 27, 1960): 1 (cf. "Dimanche", *Le Dépassement de la problématique de l'art et autres écrits*, 182).

126. An even more unsettling fact—and perhaps even more significant is a desire for discretion to the point of secrecy—Julian Heynen's book includes a plan of Haus Lange indicating the functions of the various spaces. The location of the "Void" room is perfectly recognizable, with its entry door and sealed-up door, but no caption or indication makes clear what it is (see Julian Heynen, *A Place That Thinks*, 95). While the attentive reader of Heynen's text can understand where this room was located, nothing indicates that it may still be visited today. Note, too, the linguistic imprecision that characterizes its current designation: while Paul Wember called it the "Immaterieller Raum" in his catalogue raisonné of the artist's works (*Yves Klein* [Cologne: DuMont Schauberg, 1969]), it is now known at the museum as the "Raum der Leere" or "White Room."

127. On this question, see Jean-Pierre Vernant's article, "De la présentification de l'invisible à l'imitation de l'apparence," in *Images et significations* (Paris: La Documentation française, 1983), 25 ff. and, more generally, *Corps des dieux*, Charles Malamoud and Jean-Pierre Vernant, eds. (Paris: Gallimard, 2003).

128. I obtained this information from the curators at the Kaiser Wilhelm Museum (letter of August 16, 2002, from Cora Spycher—I would like to thank her for the information she communicated to me).

129. Yves Klein, "L'Aventure monochrome," *Le Dépassement de la problématique de l'art et autres écrits*, 79. My italics.

130. This term was used by Jean-Marc Poinsot, and it is consistent with his interpretation, which is not that of the "official version" elaborated by the artist (ibid., 73).

131. Yves Klein, "Viens avec moi dans le vide," *Dimanche*, 2 (cf. "Dimanche", *Le Dépassement de la problématique de l'art et autres écrits*, 192).

132. Ibid.

133. This *Untitled Blue Monochrome (IKB Godet)*, 59 x 78 in., pure pigment and synthetic resin on mounted paper, is on display at the Musée d'Art Moderne et d'Art Contemporain de Nice (the work is part of a private collection that agreed to a long-term loan to the museum).

134. Charles Le Brun, "Sentiments sur le discours du mérite de la couleur par M. Blanchard," lecture given on January 9, 1672, reprinted in *Les Conférences de l'Académie royale de peinture et de sculpture au XVIIᵉ siècle*, Alain Mérot, ed. (Paris: École nationale supérieure des Beaux-Arts, 1996), 221.

135. Denis Diderot, *Essais sur la peinture* (1766), chapter II "Mes petites idées sur la couleur"; reprinted in Denis Diderot, *Oeuvres esthétiques* (Paris: Dunod, 1994), 677.

136. Charles Blanc, *Grammaire des arts du dessin*, 5th ed. (Paris: Librairie Renouard, 1883), 21.

137. Ibid., 22.

138. Saint John of Damascus, *Three Treatises on the Divine Images*, trans. Andrew Louth (Crestwood, NY: St. Vladimir's Seminary Press, 2003), 93.

139. Yves Klein, "Le dépassement de la problématique de l'art", *Vers l'immatériel / Towards the Immaterial,* 89. The price was given in "old" francs; one old franc was worth 15 "new" francs; in 2010, this amount is equivalent to 30 US dollars.

140. Ibid., 96. Klein added: "Believe me, one is not robbed when one purchases such paintings."

141. Ibid., 89.

142. Ibid., 90.

143. Ibid.

144. Yves Klein, "L'évolution de l'art vers l'immatériel," *Vers l'immatériel / Towards the Immaterial*, 118.

145. This adjective echoes the noun used by Arthur Danto in his book, *The Transfiguration of the Commonplace.*

146. Yves Klein, "L'évolution de l'art vers l'immatériel," *Vers l'immatériel / Towards the Immaterial*, 119.

Beyond the Sky, Eden

147. Yves Klein, "La guerre," *Dimanche*, 3 (cf. "Dimanche", *Le Dépassement de la problématique de l'art et autres écrits*, 206).

148. Georges Friedmann, *La Puissance et la sagesse* (Paris: Gallimard, 1970), 359.

149. Plato, *Phaedrus*, 247 c–d. *Plato in Twelve Volumes*. Vol. 9 translated by Harold N. Fowler (Cambridge, MA: Harvard University Press; London: William Heinemann Ltd., 1925). While all these souls are eager to rise up, not all of them are able to remain in these heights. Those who do not succeed are condemned to pass "down again within the heaven." The balloons launched in place Saint-Germain-des-Prés proposed a naive—but effective—metaphor for the souls described by Socrates. That is why it mattered so much to Klein that his *Aerostatic Sculpture* freed itself for good from gravity: "The forms freed by me on the occasion of the Vernissage of my Blue Period rose in the air, in our atmosphere, then gradually disappeared from our sight. They never came back; they didn't want the slavery of gravity, under whose yoke we live, to start again for them" (note on "Les sculptures libérées de leurs socles," *Le Dépassement de la problématique de l'art et autres écrits*, 368). We have mentioned

that (see chapter I) Klein had made the comparison between his *Aerostatic Sculpture* and his *Leap into the Void*: it can be said that he had a real anagogical impulse, which reached its acme with this "leap," an attempt to reach heaven without getting rid of the body. This is an "Imitation of Christ," since only Jesus managed such a feat during his Ascension, but after his death, after his Resurrection, after his Transfiguration, then.

150. Yves Klein, "Chelsea Hotel Manifesto," *Le Dépassement de la problématique de l'art et autres écrits*, 299; my italics. While the artist signed the underside of the blue of the sky, as he did later with his monochromes, so as not to spoil their perfection, he still thought that in this narrative the obverse, the blue, constituted his work. To go beyond the problematic of art, one must go beyond the visible, that is, be on the other side of the sky, in the kingdom of the immaterial.

151. Iris Clert wrote to Palazzoli: "Yves Klein is delighted that <u>you were the first to buy a zone of sensibility!!!</u> We are working on the receipt and as soon as it is ready, we will send it to you. You'll see, it will be great" (letter of September 20, 1959, photocopy kept in the Yves Klein Archives). The content of this document put a stop to the speculation, kept alive by several statements by Klein, about the sales of "immaterial pictorial sensibility" before September 1959.

152. Klein sometimes expressed a taste for rare or specialist terms. We have already discussed his use of the term "pneumatic"; it might be useful to point out that the adjective "synallagmatic," also from Greek, is used for a contract "imposing recip-rocal obligations upon the parties" (*Webster's Revised Unabridged Dictionary*)—thus, a sale is a synallagmatic contract). As for the order in which these projects were executed, there is every reason to believe that the model of the receipt was produced before that of the counterfoil book as a whole, which is more elaborate and closer to the final work.

153. This wording is used on the two models in the Musée National d'Art Moderne, Paris.

154. Iris Clert, letter to Peppino Palazzoli, November 18, 1959 (there is a photocopy of this letter in the Yves Klein Archives—the punctuation is transcribed as is here). On the back of Palazzoli's receipt, Klein wrote: "Zone transferred to Monsieur Peppino Palazzoli of Milan. Nov 18, 1959 Yves Klein." In light of the dates and modes of sending "receipts," it seems obvious that this very first sale was not the object of a ritual transfer with the exchange for gold in the presence of witnesses, a ritual whose terms had not yet been finalized when Palazzoli offered to buy a "zone of immaterial pictorial sensibility." In her memoirs, Clert gave her version of events, which confirms this chronology (cf. *Iris-Time*, 185 and 192). In August 1959, on a visit to Milan, she spoke with Palazzoli: "'Well,' he said, 'I'll buy an immaterial painting from you! On one condition—that you send me a receipt signed by Yves. That will be the only proof of the existence of the painting.'" Clert continued her

account: "As soon as I got back to Paris, I phoned Yves and casually announced: 'Yves, your idea is absolutely fantastic, I've found the solution.'

'What idea?'

'Why, the invisible paintings, of course! I even sold one to Palazzoli.'

Yves was speechless.

'How much did you sell it for?'

'Ten thousand lire for number one, but now we have to come up with an absolutely fantastic receipt.' (The word 'fantastic' was an integral part of discussions.)"

155. The seal of guarantee states, in the centre: "iris clert / paris" and, on the edges: "the most advanced art gallery in the world."

156. The receipt book for Series No. 6, long thought lost, reappeared in 2006, but nothing confirms that the receipt book for Series No. 7—for "zones of immaterial pictorial sensibility" exchangeable for 1,280 grams of fine gold—was ever produced.

157. The receipt books for series nos. 0, 1, 2, 4, 5, and 6 now belong to private collectors.

158. Several runs on the printing press were required to produce the receipts and their stubs. It is likely that Series No. 0 came from a batch of sheets for which the printing process was not completed. It is possible to conjecture that Klein had got the unfinished sheets back, and that the idea for a "Series No. 0" came later: it was just a matter, then, of printing the numeral "0" or "Series No. 0," which was done, during a separate operation, to print the other numbers, those of the successive series, printed batch by batch.

159. Yves Klein, English version of the text, typescript reproduced in *Yves Klein USA* (Paris: Éditions Dilecta, 2009), 175— "Sensitivity": see note 89, p. 166.

160. Iris Clert claims that she persuaded these buyers during one of her cocktail parties (see *Iris-Time*, 192).

161. Peppino Palazzoli's receipt was shown at the exhibitions *Yves Klein le Monochrome*, Galleria Blu, Milan, 1969, and *Conceptual Art—Arte Povera—Land Art*, Galleria Civica d'Arte Moderna, Turin, 1970. Paride Accetti's receipt was shown at the retrospective, *Yves Klein. La Vie, la vie elle-même qui est l'art absolu*, Musée d'Art Moderne et d'Art Contemporain de Nice, 2000. Alain Lemée's receipt was shown at the exhibitions *Yves Klein*, Museet for Samtidskunst, Oslo, 1997, and *Yves Klein*, Sara Hildén Art Museum, Tampere. Jacques Kugel's was shown in the following exhibitions: *Coup d'envoi ou l'art à la lettre*, Musée de la Poste, Paris, 1989; *Pierre Restany, le coeur et la raison*, Musée des Jacobins, Morlaix, 1991; *Les Couleurs de l'argent*, Musée de la Poste, Paris, 1991; *Azur*, Fondation Cartier,

Jouy-en-Josas, 1993; *Yves Klein*, Museum Ludwig, Cologne, and Kunstsammlung Nordrhein-Westfalen, Düsseldorf, 1994; and *Yves Klein. Corps, couleur, immatériel*, Centre Pompidou, Paris, 2006.

162. For a particularly clear summary of these variants over the centuries, see Jean Wirth, "Faut-il adorer les images ? La théorie du culte des images jusqu'au concile de Trente," in *Iconoclasme. Vie et mort de l'image médiévale*, exh. cat. (Paris: Somogy, 2001), 28 ff.

163. An amusing detail: the writer had surreptitiously slipped into his pocket the tiny unburned remains of the receipt that he held between his fingers (this anecdote, recounted by Dino Buzzati in his article "Sortilegio a Notre-Dame," *Corriere della Sera* [February 4, 1962], was repeated by Pierre Restany, who wrote in *Yves Klein le monochrome*, 68: "Buzzati could not stop himself from keeping a half-charred fragment of it in his pocket with the idea of either keeping it as a poetic talisman or burning it at a date of his choice, for himself.").

164. This album, known as the "Spiral Notebook," is kept in the Yves Klein Archives.

165. This photograph is reproduced, with no particular comment, at the end of the sequence dedicated to the Blankfort transfer in *Yves Klein*, exh. cat. (Centre Pompidou, 1983), 392 (which does not make it easier to understand since for this last transfer, ingots, not gold leaf, were used).

166. Most of the pages dedicated to the Blankfort transfer in this album are reproduced, oddly, in a different order, in ibid., 382 ff. In this publication, three pages were omitted: in one of them, Klein specified that twenty grams of fine gold—two ingots—were "given to the museum director (Commission for the Museum that Authenticated the Immaterial Work)"; this page is not reproduced in *Yves Klein USA*, 176–80, either (reproduction of eight of the eleven pages dedicated by the artist to this transfer in his "Spiral Notebook."), but it appears in the exhibition catalog *Yves Klein 1928–1962*, 209 (this features, in a more satisfactory, but still somewhat chaotic order, seven of the nine photographs related to this transfer in Klein's "Spiral Notebook," as well as the portrait of the artist that opens this photo report).

167. François Mathey, walking back up the embankment after the transfer, gave his two small gold ingots to the tramps who found themselves there. Pierre Descargues gave an account of the episode in an article published shortly afterward, but Klein contested its veracity: according to the critic, he probably did not want an unforeseen initiative to disturb the course of the ritual he had planned in such minute detail. See Pierre Descargues, *Yves Klein, comme s'il n'était pas mort* (Paris: Galerie 1900–2000, 1995), unpaginated.

168. *Arts* (February 21–27, 1962); *La Tribune de Lausanne* (February 18, 1962); *Il Giorno* (March 21, 1962).

169. The portrait of the artist pasted in his album before the series of photographs dedicated to the Blankfort transfer features in the background a partial view of Notre-Dame Cathedral (the composition used makes it difficult to identify for those unfamiliar with the cathedral; this document is reproduced in *Yves Klein*, exh. cat. (Centre Pompidou, 383) and in *Yves Klein 1928–1962*, 209.

170. The idea of the notary came spontaneously to Pierre Restany when he described, in his own way, the ritual for the transfers (see note 218 below).

171. Pierre Descargues described the end of the transfer he witnessed: "Everything was carried out. Mr. Blankfort decided not to have his check framed as evidence. What remained of the sixteen ingots of fine gold that he gave would be a souvenir of the ritual transfer. The lesson is that nothing is worth more or is more durable than the immaterial, which has its headquarters in the mind and the memory. Yves Klein told me that the seven remaining ingots would pay for the lunch. There was no photo taken of the lunch" (Pierre Descargues, *Yves Klein, comme s'il n'était pas mort*).

172. Klein wrote: "In no way do I consider myself an avant-garde artist. I want to make it clear that on the contrary I think and believe myself to be a classic, perhaps even one of the rare classics of this century" ("Le dépassement de la problématique de l'art", *Vers l'immatériel / Towards the Immaterial*, 111).

173. Poussin's words reported by Bonaventure d'Argonne, published in Nicolas Poussin, *Lettres et propos sur l'art*, 199.

174. We have already mentioned this article, pasted by Klein into his album, after the photographs of the Blankfort transfer. The anonymous author reported an interview with the artist and wrote: "To express the immaterial, Yves Klein went to the banks of the Seine, near Notre-Dame. He was accompanied by a representative of the Musées de France and a few supporters, the collar of his overcoat upturned. He then gave the first buyer of a zone of pictorial sensibility, the American writer Blankford [*sic*], delighted with the windfall, a receipt for the equivalent of an ingot of fine gold, symbol of the work created in the artist's thoughts, but nonexistent for the uninitiated" *Arts* (February 21–27, 1962). The journalist ended the article with this question: "What comes of the wind in the void?"

175. I am borrowing this argument from Joseph Kosuth, who observed in his essay "Art after Philosophy" (*Studio International*, 1969): "When someone 'buys' a Flavin he isn't buying a light show, for if he was he could just go to a hardware store and get the goods for considerably less. He isn't 'buying' anything. He is subsidizing Flavin's activity as an artist" (text reprinted in Joseph Kosuth, *Art after Philosophy*

and After: Collected Writings, 1966–1990, ed. Gabriele Guercio [Cambridge, MA: MIT Press, London, 1991], 32, n. 17).

176. Since then, other artists have associated buyers to their work. Hence, the agency "Les ready-mades appartiennent à tout le monde®." Jean-Hubert Martin described how the Musée National d'Art Moderne bought *Souvenir-Écran* (1988), a work attributed to Christophe Durand-Ruel (a collector) that entered the French public collections under this artist's name—a success for the agency that, according to Michel Bourel, "is not afraid to write in its advertisements aimed at collectors, that it would open the doors of the best galleries and museums to them for them to be listed as artists" (Michel Bourel, interview with Jean-Hubert Martin, "Respect de l'étiquette, intérêt du cartel," *Feux pâles*, exh. cat. (CAPC Musée d'Art Contemporain de Bordeaux, 1990), 19 ff.

177. Yves Klein, "Le dépassement de la problématique de l'art", *Vers l'immatériel / Towards the Immaterial*, 96.

178. Edward Kienholz gives an account in a note written for the catalog for the exhibition *Live in Your Head: When Attitudes Become Form* (1969, unpaginated). After mentioning the rules for the "integration" of the work by its buyer, Kienholz wrote: "In my particular case, Yves' untimely death prevented his 'throwing the gold.' However, at a later date, his wife, Rotraut, and Arman cast gold leaf from a boat on the waters of the Mediterranean in his name, symbolically completing my Immaterial."

179. Yves Klein, *Chelsea Hotel Manifesto* manuscript, in *Le Dépassement de la problématique de l'art et autres écrits*, 420.

180. Yves Klein, handwritten note given to Alfred Schmela, published in the catalog of the exhibition *Yves Klein, peintures de feu* (Düsseldorf: Galerie Schmela, 1964); cf. Sidra Stich, *Yves Klein*, 205.

181. Yves Klein, "Le réalisme authentique d'aujourd'hui," (written in 1959), *Le Dépassement de la problématique de l'art et autres écrits*, 154.

182. Iris Clert wrote "During a cocktail party at my place on avenue Paul-Doumer, I managed to sell three [zones of immaterial pictorial sensibility] for 10,000 francs apiece" (Iris Clert, *Iris-Time*, 192). They were probably the zones sold to Kugel, Accetti, and Lemée. As mentioned, the first zone was sold to Palazzoli for 20,000 lire (see the photocopied letter in the Yves Klein Archives sent by Iris Clert to Palazzoli, dated November 18, 1959, in which she wrote: "These twenty grams of gold are worth 20,000 lire I think / In principle and for it to be fully valid, you need to pay another 10,000 lire!!!").

183. Iris Clert, *Iris-Time*, 201.

184. Yves Klein had already acted in a similar fashion in 1955. The organizing committee of the Salon des Réalités Nouvelles refused to show his monochrome if he did not add at least a dot or a line to the orange "ground." He refused, of course. But the work, *Expression of the Color Minium Orange* (1955), was still signed with a monogram, and dated, in black in the right-hand corner. Later, his monochromes were all perfectly immaculate; the signature and sometimes other indications were placed on the back of the painting.

185. As mentioned, Andy Warhol adopted a different strategy for his *Invisible Sculpture*, produced in a New York nightclub in 1985: the label on the wall drew attention to an absence, assigning it a space.

186. Pierre Restany, *Yves Klein le monochrome*, 70 (this information was confirmed in a Restany/Klein interview taped on December 15, 1961, typed and annotated by the artist, kept in the Archives de la Critique d'Art, Châteaugiron). Restany talked about the Milan exhibition in these terms: "You had participated in the thing [the exhibition] through the immaterial in a completely immaterial manner by using the famous check [receipt], let's call it a check of immaterial sensibility." Restany also wrote that the exhibition *Yves Klein le Monochrome*, at Jean Larcade's, Galerie Rive Droite (October 11–November 13, 1960) "include a special-edition zone of pictorial sensibility" (*Yves Klein le monochrome*, 71): the catalog for the *Yves Klein le Monochrome* exhibition mentions the work at the end of the list under number 15.

187. This copy, in the Yves Klein Archives, also features a comment and the signature of Guido Le Noci, the owner of the Galleria Apollinaire where this group exhibition (Arman, Hains, Dufrêne, Yves le Monochrome, Villeglé, and Tinguely) was held in May 1960.

188. *Antagonismes*, exh. cat. (Paris: Musée des Arts Décoratifs, 1960), 97. The text of the entire catalog was written by Julien Alvard (see page 4 of the catalog).

189. This *Monogold* is most like the one currently in the Städtische Museum, Mönchengladbach. One of the characteristics of this work is that the back of it is painted blue. Thus, the immaterial and the blue are secretly combined with gold.

190. *Antagonismes*, 68.

191. François Dufrêne, account published in *François Dufrêne*, exh. cat. (Les Sables d'Olonne: Musée de l'Abbaye Sainte-Croix, 1988), unpaginated.

192. As far as I know, the transfer to Buzzati was the first to be photographed.

193. Text introducing the photographs of this "performance" published in *Yves Klein 1928–1962*, 212.

194. Cf. Harry Shunk cited by Sidra Stich, *Yves Klein*, 268, n. 89: "Harry Schunk . . . stated that initially the images were made as potential illustrations for an advertisement for the Galerie J. Only later did Klein decide to use the picture of the

completed void space for the *Comparaisons* exhibition, and ultimately the Galerie J decided not to use the void image for advertising purposes."

195. Pierre Restany (in collaboration with Yves Klein), "Yves Klein : Le Monochrome : UNE ZONE DE SENSIBILITÉ PICTURALE IMMATÉRIELLE — Zone 1, Série n° 5," typescript, Yves Klein Archives.

196. Besides this caption typeset underneath the photograph, the title of the work with which Klein took part in the exhibition appears in the catalog, in the place attributed to him by alphabetical order between "Kito, Akira" and "Knopp, Guitou": "KLEIN, THE MONOCHROME, Yves 14, rue Campagne-Première. Paris. MED. 02-77. *254. Zone of Immaterial Pictorial Sensibility, Series No. 7, Zone No. 1*" (72). Thus Klein would suggest that he had introduced two immaterial works into the salon, one from series no. 7, the other from series no. 5. Although only the first was duly listed, the second, documented by a photograph, was very lucky to have been noticed.

197. The photograph published in the Salon Comparaisons catalog in 1962 is, moreover, reminiscent of those of his exhibition of the "Void" (Iris Clert, 1958), disseminated later.

198. Yves Klein wrote this unpublished statement: "For a long time I have shouted, despite all the concepts. For me, it is therefore a question of showing this space for work and creation in the volume of the gallery and *absolutely not the walls painted white*" (typescript in the Yves Klein Archives; my italics).

199. Yves Klein, "Chelsea Hotel Manifesto," *Le Dépassement de la problématique de l'art et autres écrits*, 292–93.

200. Klein had entrusted this document to the "organizer of the group," Villeglé, who still has it. There is a photocopy of it in the Yves Klein Archives.

201. Michael Blankfort gave an account of his dismay when an art critic friend told him that he had seen large photographs of the transfer in which he had taken part at a retrospective of Klein's work in Tokyo: "This was the first time I knew that Klein had arranged to have a photographer nearby. I confess I felt let down. An 'immaterial,' I thought, should be altogether immaterial. The making of a film record seemed to be a corruption of the artist's intent as well as of the sensation of purity which had possessed me at that time." Blankfort added, nevertheless, with winning honesty: "But later vanity came to the surface to appease me" ("Confessions of an Art Eater," in *The Michael and Dorothy Blankfort Collection*, exh. cat [Los Angeles: Los Angeles Country Museum of Art, 1982], 14). Blankfort was no doubt perfectly sincere, but it is surprising that he had forgotten the presence of photographers when, in one of the photographs taken that day, we can see him conspicuously presenting his "receipt" to the camera lens.

202. Yves Klein, text handwritten on a sheet of paper kept in the Yves Klein Archives (*Le Dépassement de la problématique de l'art et autres écrits*, 319).

203. The tone adopted by Klein as well as various changes in the definitive wording (for example, "written painting" replaced "oral painting") indicate that the artist had initially intended to read his manifesto in front of an audience (on this point, see *Le Dépassement de la problématique de l'art et autres écrits*, 418).

204. Austin delivered his William James Lectures at Harvard University in 1955. See J. L. Austin, *How to Do Things with Words* (Cambridge, MA: Harvard University Press, 1962).

205. Yves Klein, "Chelsea Hotel Manifesto" (*Le Dépassement de la problématique de l'art et autres écrits*, 293—"Sensitivity": see note 89, p. 166). In a preparatory manuscript for the manifesto, written in French, the artist writes: "In the midst of the physical silence that will follow my paper will be *a new zone of immaterial pictorial sensitivity added to the collection of those that already exist!*" (Yves Klein Archives; my italics).

206. André Malraux, "Museum Without Walls," in *The Voices of Silence: Man and His Art*, trans. Stuart Gilbert (New York: Doubleday, 1953), 30; Malraux's italics.

207. Yves Klein, "Chelsea Hotel Manifesto" (*Le Dépassement de la problématique de l'art et autres écrits*, 296).

208. Pierre Restany, *Yves Klein le monochrome*, 95.

209. A notion forged later by Pierre Restany, who defined it thus: "The action is a 'job,' its result is a 'work.' Unlike the happening, the [Nouveau Réaliste] action did not wear out its meaning as it progressed. At the end of the performance, a tangible trace remained. The collective expression had been creative" (Pierre Restany, *Le Nouveau Réalisme* [Paris: Union Générale d'Édition, 1978], 217–18).

210. Saint John of Damascus, "Apologia Against Those Who Decry Holy Images," in *On Holy Images*, trans. Mary H. Allies (London: Thomas Baker, 1898).

211. Yves Klein, "Truth becomes reality," in *Zero*, 92.

212. Ibid.; my italics. Few commentators drew attention to a double topic in the artist's oeuvre. One of them, Pierre Descargues, nevertheless wrote: "The body remained very present in the work of this artist of the immaterial. It was the constant touchstone of his attempted experiments. In his work, there was—and that is no doubt why his oeuvre contains such emotion—a to-and-fro between the ideal and the weight of the flesh" (Pierre Descargues, *Yves Klein, comme s'il n'était pas mort*). The reading of this declaration, to which I fully subscribe, greatly helped me become more confident about my own intuitions.

213. Yves Klein, "Truth becomes reality," in *Zero*, 92.

214. Isabelle Monod-Fontaine, *Matisse,* Le Rêve *ou les belles endormies* (Paris: Adam Biro, 1989), 18.

215. Yves Klein, "La guerre," *Dimanche. Le journal d'un seul jour,* 4 (cf. "Dimanche", *Le Dépassement de la problématique de l'art et autres écrits,* 213).

216. Pierre Restany, *Yves Klein le monochrome,* 72. My italics.

217. See *Yves Klein,* exh. cat. (Centre Pompidou, 1983), 82.

218. It is worth citing the entire passage: "The act of accepting a receipt in return for gold materializes the immaterial, so to speak, the work being indentified with the receipt. To reply to this objection, Yves Klein wanted to completely separate the letter from the spirit of the operation. If the buyer wants to take control of not the letter (receipt for the zone), but the spirit (that is, of the zone in itself), he must burn the receipt in public, after his name, address, and the date of purchase were written on the checkbook stub. If the buyer wants to witness his own impregnation by the immaterial, he must pay twice the amount of gold indicated on the receipt: Yves Klein, in the presence of a notary or, failing that, of two witnesses, will throw half the gold in the sea or in the waters of a river, or in a nature spot from which it would be impossible to remove. From that moment on, the zone of immaterial pictorial sensibility becomes the exclusive property of its purchaser" (Pierre Restany, *Yves Klein le monochrome,* 67–68).

219. Pierre Restany, *Yves Klein e la mistica di Santa Rita da Cascia* (Milan: Domus, 1981), 15; text reprinted in *Yves Klein 1928–1962,* 255.

220. Pierre Restany, *Yves Klein* (Paris: Chêne / Hachette, 1982), 57, n. 2.

221. Yves Arman is thought to have received five or six counterfoil books: they are now in various private collections.

222. It is not, moreover, certain that the question is any clearer today; on this subject, see the shrewd analyses of Didier Semin in his book, *Le Peintre et son modèle déposé* (Geneva: Mamco, 2000).

223. Iris Clert, *Iris-Time,* 192.

224. Yves Klein's first exhibition at the Galerie Rive Droite opened on October 11, 1960. Later, Jean Larcade, the gallery owner, signed a contract with him that the artist would denounce on May 14, 1962.

225. See Francis M. Naumann's brilliantly documented book, *Marcel Duchamp: The Art of Making Art in the Age of Mechanical Reproduction* (Ghent: Ludion Press; New York: Distributed by Harry N. Abrams, 1999).

226. Marcel Duchamp, no doubt amused by the distant memories of his father's notarial office, made this homage in parody form two years after the death of Klein, whom he had known and supported in New York in 1961 (this "inalienable certifi-

cate" was reprinted in Francis M. Naumann, *Marcel Duchamp*, 216, and there is a transcription of its text in Marcel Duchamp, *Duchamp du signe. Écrits*, with an introduction by Michel Sanouillet [Cambridge, MA: Da Capo Press, 1989], 276; Didier Semin had already made this connection in *Le Peintre et son modèle déposé*, 36–37).

227. This expression appears in Kienholz's text for the catalog of the exhibition *Live in Your Head: When Attitudes Become Form* (Bern: Kunstalle Bern, 1969), which freely inspired my description of his meeting with Klein.

228. *Live in Your Head: When Attitudes Become Form*, n. p.

CHRONOLOGY

Yves Klein
April 28, 1928–June 6, 1962

This brief chronology presents the main exhibitions, works, and information relating to the artist's career or life in the left-hand column, while the right-hand column features the events and publications directly linked to the immaterial and the body.

1947

After failing the entrance exam for the École de la Marine Marchande (1946), Klein helps out in the book department of his Aunt Rose's store in Nice.

While lying on the beach in Nice, signs his name on the underside of the sky "during a fantastic, 'realistico-imaginary' journey."

September: Joins the police judo club where he meets Claude Pascal and Armand Fernandez (who later changes his name to Arman).

1948

Discovers Max Heindel's book, *La Cosmogonie des Rose-Croix* (*The Rosicrucian Cosmo-Conception*).

Studies, along with Claude Pascal, the Rosicrucian doctrine with Louis Cadeaux.

June: The two friends become members of the Rosicrucian Society of Oceanside, California.

November: Goes to Germany to do his military service.

1949

October 28: Returns to Nice after the end
of his military service.

November: Goes to London with Claude
Pascal to improve his English.

1950

April–August: Stays at a riding club in
Ireland with Claude Pascal to prepare for
their journey to Japan on horseback.

December: Returns to Nice.

1951

February: Leaves for Madrid, where he
studies Spanish, and gives French and judo
lessons.

Fall: Moves to Paris, near his parents, both
painters.

Begins preparations for his trip to Japan.

1952

Gives up Rosicrucian teaching.

August: Sails for Japan.

October: Settles in Tokyo to study judo at
the prestigious Kodokan Institute.

1953

Obtains black belt, first dan, at the
Kodokan Institute.

Breaks with the Rosicrucian Society of
Oceanside.

1954

February: Returns to Paris after obtaining black belt, fourth dan; clash with the management of the Fédération Française de Judo, which refuses to recognize his Japanese title.

May: Goes to Madrid, where he is invited to teach judo; publishes, with the help of a printer friend, two books of monochromes in various colors, *Yves Peintures* and *Haguenault Peintures*.

November: Returns to France, where his book *Les Fondements du judo* is published by Grasset.

1955

February: Begins teaching judo at the American Center.

July: His monochrome *Expression of the Color Minium Orange* was rejected by the organizing committee of the Salon des Réalités Nouvelles.

September: Opens a judo school on boulevard de Clichy in Paris.

October: Organizes an exhibition of his monochromes, *Yves Peintures*, at the Club des Solitaires in the private salons of Éditions Lacoste.

Meets Pierre Restany on this occasion.

1956

February 21–March 7: *Yves, propositions monochromes* exhibition at Galerie Colette Allendy, Paris. Introduction to catalog, "La minute de vérité," by Pierre Restany.

March 11: Made a Knight of the Order of Archers of Saint Sebastian (church of Saint-Nicolas-des-Champs, Paris).

Meets Iris Clert.

1957

January 2–12: *Yves Klein: Proposte monocrome, epoca blu* exhibition, Galleria Apollinaire, Milan.

May 10–25: *Propositions monochromes* exhibition, Galerie Iris Clert, Paris.

May 14–23: *Propositions monochromes* exhibition, Galerie Colette Allendy, Paris.

May 31–June 23: *Yves, Propositions monochromes*, Galerie Schmela, Düsseldorf.

June 24–July 13: *Monochrome Propositions of Yves Klein*, Gallery One, London.

Releases 1,001 blue balloons into the sky at Place Saint-Germain-des-Prés, Paris (gesture later referred to as *Aerostatic Sculpture*).

On the second floor of the Galerie Colette Allendy, presents *Surfaces and Blocks of Pictorial Sensibility: Pictorial Intentions*.

1958

January: Is commissioned to produce the mural decorations for the Musiktheater im Revier, Gelsenkirchen (architect: Werner Ruhnau).

April: First pilgrimage to the sanctuary of Saint Rita, Cascia.

May 20: Writes to President Eisenhower to ask him to support *The Blue Revolution* project.

September: Another pilgrimage to Cascia, where the artist leaves a small blue monochrome at the sanctuary of Saint Rita.

October: Works in Gelsenkirchen, assisted by Rotraut Uecker.

November 17: Vernissage of the exhibition *Vitesse pure et stabilité monochrome*, in collaboration with Jean Tinguely, Galerie Iris Clert.

April 28: Vernissage of the exhibition later known as that of the "Void", Galerie Iris Clert, Paris.

June 5: First presentation of a "living brush" producing a blue monochrome in front of a select audience at Robert Godet's apartment.

Plans for a *Blue Monochrome Stations of the Cross*.

1959

March 17: Invited to take part in the *Vision in Motion–Motion in Vision* exhibition, Hessenhuis, Antwerp.

June 15–30: *Bas-reliefs dans une forêt d'éponges* exhibition, Galerie Iris Clert.

October 2–25: Shows a large blue mono-chrome at the first *Biennale des Jeunes* in Paris.

October 20–November 7: Takes part in the group exhibition *Works in Three Dimensions*, Leo Castelli Gallery, New York.

December 15: Attends the inaugura-tion of the Musiktheater im Revier, Gelsenkirchen.

June 3: "L'Évolution de l'art vers l'immatériel" ("The Evolution of Art toward the Immaterial") lecture at the Sorbonne.

September–November: Elaborates and prints the counterfoil books for the transfers of *Zones of Immaterial Pictorial Sensibility*.

November 18: First sale of a *Zone of Immaterial Pictorial Sensibility*; Peppino Palazzoli acquires Zone 1, Series 1.

December 7: Sale to Jacques Kugel of *Zone of Immaterial Pictorial Sensibility*, No. 2, Series 1, and *Zone of Immaterial Pictorial Sensibility*, No. 3, Series 1, to Paride Accetti.

December 8: Sale of *Zone of Immaterial Pictorial Sensibility*, No. 4, Series 1, to Alain Lemée.

December: Publication of a book by the artist that examines his evolution toward the immaterial and presents his projects, *Le Dépassement de la problématique de l'art* (La Louvière, Éditions de Montbliart).

1960

February: Takes part in the exhibition *Antagonismes*, Musée des Arts Décoratifs, Paris.

March 18–May 8: Invited to take part in the group exhibition *Monochrome Malerei*, Städtische Museum, Leverkusen.

The catalog for the exhibition *Antagonismes* features *Quivering Monogold*, presented on the picture rails, and *Zone of Immaterial Pictorial Sensibility*, No. 1 and *Zone of Immaterial Pictorial Sensibility*, No. 2 of Series No. 7 with 1,280 grams of fine gold.

February 23: Pierre Restany called the impressions of bodies that he sees produced under the artist's direction "Anthropometries."

March 9: Party for the *Anthropométries de l'époque bleue* exhibition, Galerie Internationale d'Art Contemporain, Paris.

April: Takes part in the exhibition *Les Nouveaux Réalistes*, Galleria Apollinaire, Milan.

April 23: Founds the Association pour le Dépassement de l'Art Moderne (A.D.A.M.).

May 19: Registers the formula for his blue at the Institut National de la Propriété Industrielle (Soleau envelope no. 63471) and founds the International Klein Bureau: each of the five members could use this blue in his name.

October 11–November 13: *Yves Klein le Monochrome* exhibition, Galerie Rive Droite (Jean Larcade), Paris.

October 27: Nouveaux Réalistes group founded in the artist's home.

November 18: Inauguration of the second Festival d'Art d'Avant-Garde, Palais des Expositions, Paris; a few days later, two of Klein's works are vandalized by persons unknown.

Among his works shown at the Städtische Museum (Leverkusen), the catalog mentions the *Zone of Immaterial Pictorial Sensibility*, No. 1, Series No. 3 (no. 45).

A counterfoil book for the transfers of *Zones of Immaterial Pictorial Sensibility* was most probably shown at the Galleria Apollinaire.

The catalog for this exhibition mentions the presence of a special-edition *Zone of Immaterial Pictorial Sensibility*, numbered 15.

October 19: *Leap Into the Void*, photographed in Fontenay-aux-Roses by Harry Shunk and John Kender.

November 27: On the occasion of the Festival d'Art d'Avant-Garde, publishes the newspaper *Dimanche. Le journal d'un seul jour*.

1961

January 14–February 26: *Yves Klein: Monochrome und Feuer* exhibition, Museum Haus Lange, Krefeld.

March: Produces a first series of "fire paintings" at the Centre d'Essais du Gaz de France, La Plaine Saint-Denis, outside Paris.

At the end of March: Arrives in New York and stays at the Chelsea Hotel.

April 11–19: *Yves Klein le Monochrome* exhibition, Leo Castelli Gallery.

April: Writes *The Chelsea Hotel Manifesto*.

May 17–June 10: Takes part in the exhibition organized by Pierre Restany, *À quarante degrés au-dessus de Dada, les Nouveaux Réalistes*, Galerie J, Paris.

In this exhibition, an "empty room" is reserved for the "Immaterial Pictorial Sensibility."

February: Makes a pilgrimage to Cascia once again; the artist leaves an ex-voto that he has designed and made in homage to Saint Rita.

February 28: Transfer to the Museum Haus Lange, represented by its director, Paul Wember, of *Zone of Immaterial Pictorial Sensibility*, No. 1, Series No. 0.

The uttering of this manifesto is said to have generated a "new and unique zone of pictorial sensitivity of the immaterial."

May: Arrives in Los Angeles.

May 29–June 24: *Yves Klein le Monochrome* exhibition, Dwan Gallery, Los Angeles.

July 13–September 13: Participates in the first festival of Nouveau Réalisme in Nice.

July 17–18: Paolo Cavara films sequences of anthropometries for Gualtiero Jacopetti's *Mondo Cane.*

October 8: Klein, Raymond Hains, and Martial Raysse disavow Restany's text, "À quarante degrés au-dessus de Dada"; they dissolve the Nouveaux Réalistes group.

November 1: Signs an exclusive contract with Jean Larcade (Galerie Rive Droite).

November 21: Vernissage of the exhibition *Yves Klein le Monochrome: il Nuovo Realismo del Colore*, Galleria Apollinaire, Milan.

June 14: Transfer to Edward Kienholz of *Zone of Immaterial Pictorial Sensibility*, No. 2, Series No. 0.

July 18–19: Produced "fire paintings" and impressions of bodies (Centre d'Essais du Gaz de France).

1962

January 21: Marries Rotraut Uecker (church of Saint-Nicolas-des-Champs).

March: Takes part in the group exhibition *Antagonismes II : l'objet*, Musée des Arts Décoratifs, Paris.

May 12: Cannes Film Festival, projection of *Mondo Cane.*

June 6: Dies of a heart attack.

August 6: Birth of his son, Yves.

January 26: Taking down of the works in a room of the Salon Violet, Paris, in order to photograph the space dedicated to his work, *Zone of Immaterial Pictorial Sensibility*, No. 1, Series No. 5, for the Salon Comparaisons catalog.

January 26: Transfer to Dino Buzzati of *Zone of Immaterial Pictorial Sensibility*, No. 5, Series No. 1, Pont-au-Double, Paris.

February 4: Transfer to Claude Pascal of *Zone of Immaterial Pictorial Sensibility*, No. 6, Series No. 1, Pont-au-Double, Paris.

February 10: Transfer to Michael Blankfort of *Zone of Immaterial Pictorial Sensibility*, No. 1, Series No. 4, Pont-au-Double, Paris.

March 12–April 2: The artist's participation in the Salon Comparaisons is recorded in the catalog with the photograph of the empty room reserved for the Nouveaux Réalistes (*Zone of Immaterial Pictorial Sensibility*, No. 1, Series No. 5), and the mention at entry 254 of *Zone of Immaterial Pictorial Sensibility*, No. 1, Series No. 7.

A BRIEF BIBLIOGRAPHY
AND FILMOGRAPHY

This brief bibliography, based on the main books and films cited in this essay, is divided into four sections:

– The texts published by Yves Klein himself and the main catalogs of the exhibitions, in which he took part with immaterial works. This section also features the book containing all the artist's writings, made public either by Klein or after his death, as well as a CD of the recording of his lecture at the Sorbonne (June 1959).

– The filmography of his exhibitions and "action-performances."

– Various articles, books, and exhibition catalogs dedicated to him, at least partially.

– Other works used and cited.

YVES KLEIN AND THE IMMATERIAL

Antagonismes.

> Exh. cat. Paris: Musée des Arts Décoratifs, 1960.

Comparaisons.

> Exh. cat. Paris: Musée d'Art Moderne de la Ville de Paris, 1962.

Klein, Yves

> *Le Dépassement de la problématique de l'art.* La Louvière: Éditions Montbliart, 1959.

> *Dimanche. Le journal d'un seul jour* (November 27, 1960).

> *Le Dépassement de la problématique de l'art et autres écrits.* Marie-Anne Sichère and Didier Semin, eds. Paris: École nationale supérieure des Beaux-Arts, 2003.

> *Vers l'immatériel / Towards the Immaterial.* Bilingual text with a CD recording of the Sorbonne lecture. With a preface by Denys Riout. Translated by Charles Penwarden. Paris: Éditions Dilecta, 2006.

Monochrome Malerei.

> Exh cat. Leverkusen: Städtische Museum, 1960.

Yves Klein le Monochrome.
> Exh cat. Paris: Galerie Rive Droite, 1960.

Yves Klein: Monochrome und Feuer.
> Exh. cat. Krefeld: Museum Haus Lange, 1961.

Yves le Monochrome
> "Le vrai devient réalité." *Zero* 3 (July 1961).

FILMOGRAPHY

These films, shot on 16-mm or 35-mm stock between 1953 and 1962, were restored by the Centre Pompidou in Paris in 1999. They relate to the immaterial works and the anthropometries, as well as other events or subjects.

1957 *Propositions monochromes,* two simultaneous exhibitions, Galerie Colette Allendy and Galerie Iris Clert, Paris (color).

1958 *La Spécialisation de la sensibilité picturale à l'état matière première en sensibilité picturale stabilisée,* Galerie Iris Clert, Paris, April 28–May 12 (color).

1961 *Monochrome und Feuer,* Museum Haus Lange, Krefeld, January 14–February 26 (color).

1960 *Anthropométries de l'époque bleue,* Galerie Internationale d'Art Contemporain, Paris, evening of March 9 (black and white).

1961 The artist overseeing an anthropometries session (film made in Düsseldorf by Peter Morley; black and white).

1961 *Peintures de feu,* fire paintings and the production of anthropometries, Centre d'Essais du Gaz de France, La Plaine-Saint-Denis (black and white, then color, with "living brushes").

1953 *Scènes de judo,* filmed in Japan (randori for foreigners and kata of the five principles; black and white).

1956–57 *Yves Klein* (demonstration of monochrome painting, color).

1958–59 *Gelsenkirchen* (execution of large paintings—with sponges—commissioned from the artist for the Musiktheater; black and white).

1959 Bas-reliefs in a forest of sponges, Galerie Iris Clert, June 15 (color).

1959 *Gelsenkirchen* (inauguration of the Musiktheater, December 15 (color).

1960 *Dimanche 27 novembre 1960* (distribution and presentation of the newspaper: street scenes and Galerie Rive Droite; black and white).

1961 *Essai de toit d'air,* rue Campagne-Première, Paris (black and white).

1962 *Mariage de Rotraut Uecker avec Yves Klein*, January 21, church of Saint-Nicolas-des-Champs, Paris (color).

1962 *Antagonismes 2, l'objet*, Musée des Arts Décoratifs, Paris (black and white).

1962 *Appartement d'Yves Klein*, rue Campagne-Première, Paris (color).

OTHER

Actualités Gaumont

> Report on the launch on blue balloons during the vernissage of the exhibition *Yves Klein: Propositions monochromes*, Galerie Iris Clert, May 10, 1957.

Jacopetti, Gualtiero

> *Mondo cane* (color; a—calamitous—sequence of this feature-length film is dedicated to the Anthropometries), 1962.

ON YVES KLEIN (ARTICLES, BOOKS, AND EXHIBITION CATALOGS)

Allain, Bernadette

> "Propositions monochromes d'Yves Klein." *Couleurs* 15 (May–June 1956): 25–27.

Buzzati, Dino

> "Blu, blu, blu. Un fenomeno a la galleria Apollinaire." *Corriere d'informazione* (January 9, 1957).

> "Sortilego a Notre-Dame." *Corriere della Sera* (February 4, 1962).

Restany, Pierre

> *Yves Klein le monochrome.* Paris: Hachette, 1974.

> *Yves Klein e la mistica di Santa Rita da Cascia.* Milan: Domus, 1981.

> *Yves Klein.* Paris: Chêne / Hachette, 1982.

> *Yves Klein. Le feu au coeur du vide.* Paris: La Différence, 1990.

Stich, Sidra

> *Yves Klein.* Stuttgart: Cantz Verlag, 1994.

Yves Klein 1928–1962: A Retrospective.

> Exh. cat. Houston: Institute for the Arts, Rice University; New York: The Arts Publisher, 1982.

Yves Klein.

> Exh. cat. Paris: Centre Pompidou, Musée National d'Art Moderne, 1983.

Yves Klein: Long live the Immaterial!

Exh. cat. New York: Delano Greenidge Editions, 2000.

Yves Klein.

Exh. cat. Ostfildern: Cantz, 2004.

Yves Klein. Corps, couleur, immatériel.

Exh. cat. Paris: Centre Pompidou, 2006. (A different version was published when the show moved to the Museum Moderner Kunst Stiftung Ludwig Wien: Yves Klein. Die blaue Revolution. Exh. cat. Vienna: Springer, 2007.)

Yves Klein USA.

Featuring a text by Robert Pincus-Witten and an interview with Rotraut Klein-Moquay. Paris: Éditions Dilecta, 2009.

Yves Klein: With the Void, Full Powers.

Exh. cat. Washington: Hirshhorn Museum and Sculpture Garden; Minneapolis: Walker Art Center, 2010.

OTHER WORKS

1960. Les Nouveaux Réalistes.

Paris: Musée d'Art Moderne de la Ville de Paris, 1986.

Alpers, Svetlana

Rembrandt's Enterprise: The Studio and the Market. Chicago: University of Chicago Press, 1988.

Audouze, Jean, Michel Cassé, and Jean-Claude Carrière

Conversations sur l'invisible. Paris: Plon, 1996.

Austin, J. L.

How to Do Things with Words. Cambridge, MA: Harvard University Press, 1962.

Bachelard, Gaston

L'Air et les songes. Essai sur l'imagination du mouvement. Paris: José Corti, 1943.

Baraduc, Hippolyte

L'Âme humaine, ses mouvements, ses lumières, et l'iconographie de l'invisible fluidique. Paris: Georges Carré Éditeur, 1896.

L'Âme humaine [...], réédition vulgarisée. Paris: G. A. Mann Éditeur, 1911; English translation: *The Human Soul, its Movements, its Lights.* Paris: G. A. Mann Éditeur, 1913.

Barthes, Roland

Camera Lucida: Reflections on Photography. Translated by Richard Howard. New York: Hill and Wang, 1981.

Benjamin, Walter

"Little History of Photography." In *Selected Writings, Vol. 2, Part 2, 1931–1934.* Cambridge, MA: Harvard University Press, 1999.

Blanc, Charles

Grammaire des arts du dessin. Fifth edition. Paris: Librairie Renouard, 1883.

Blankfort, Michael

"Confessions of an Art Eater." In *The Michael and Dorothy Blankfort Collection.* Exh. cat. Los Angeles: Los Angeles Country Museum of Art, 1982.

Bonnefoy, Yves

Alberto Giacometti: A Biography of His Work. Translated by Jean Stewart. Paris: Flammarion, 2001.

Borges, Jorge Luis

"Pierre Menard, Author of the *Quixote.*" In *Fictions.* Translated by Andrew Hurley. London: Penguin, 2000.

Bourély, France

Mondes invisibles. Éloge de la beauté cachée. Paris: La Martinière, 2002.

Braun, Marta

"Fantasmes des vivants et des morts. Anton Giulio Bragaglia et la figuration de l'invisible." *Études photographiques* 1 (November 1996).

Chéroux, Clément

L'Expérience photographique d'August Strindberg. Arles: Actes Sud, 1994.

"Ein Alphabet unsichtbarer Strahlen. Fluidaltfotografie am Ausgang des 19. Jahrhunderts." *Im Reich der Phantome. Fotografie des Unsichtbaren.* Exh. cat. Ostfildern: Cantz, 1997.

"La photographie des fluides ou les lapsus du révélateur," *Vision machine.* Exh. cat. Paris: Somogy, 2000.

Clert, Iris

Iris-Time (l'Artventure). Paris: Denöel, 1978.

Les Conférences de l'Académie royale de peinture et de sculpture au XVIIᵉ siècle.

Edited by Alain Merot. Paris: École nationale supérieure des Beaux-Arts, 1996.

Corps des dieux.

Edited by Charles Malamoud and Jean-Pierre Vernant. Paris: Gallimard, 2003.

Danto, Arthur C.

The Transfiguration of the Commonplace. Cambridge, MA: Harvard University Press, 1981.

Delacroix, Eugène

"Réalisme et idéalisme." *Oeuvres littéraires*. Vol. 1. Paris: Éditions G. Crès, 1923.

Journal 1822-1863. Paris: Plon, 1981.

The Journal of Eugène Delacroix. Translated by Lucy Norton. Third edition. London: Phaidon, 1995.

Descargues, Pierre

Yves Klein, comme s'il n'était pas mort. Paris: Galerie 1900–2000, 1995.

Diderot, Denis

Oeuvres esthétiques. Paris: Dunod, 1994.

Didi-Huberman, Georges

Invention de l'hystérie. Charcot et l'iconographie photographique de la Salpêtrière. Paris: Macula, 1982.

Dubois, Philippe

L'Acte photographique et autres essais. Paris: Nathan, 1990.

Duchamp, Marcel

The Writings of Marcel Duchamp. Edited by Michel Sanouillet and Elmer Peterson. Cambridge, MA: Da Capo Press, 1989.

Dufour-Kowalska, Gabrielle

L'Art et la sensibilité de Kant à Michel Henri. Paris: Vrin, 1996.

Fontanier, Pierre

Figures du discours. Paris: Flammarion, 1977.

François Dufrêne.

Exh. cat. Les Sables d'Olonne: Musée de l'Abbaye Sainte-Croix, 1988.

Friedmann, Georges

La puissance et la sagesse. Paris: Gallimard, 1970.

Grabar, André

Les Origines de l'esthétique médiévale. Paris: Macula, 1992.

Greenberg, Clement

Art and Culture: Critical Essays. Boston: Beacon Press, 1961.

Grenier, Jean

> *Essais sur la peinture contemporaine*. Paris: Gallimard, 1959.

Grojnowski, Daniel

> *Photographie et langage*. Paris: José Corti, 2002.

Hadot, Pierre

> *Plotinus, or The Simplicity of Vision*. Translated by Michael Chase. Chicago: University of Chicago Press, 1993.

Heynen, Julian

> *A Place That Thinks: Haus Lange and Haus Ester by Ludwig Mies van der Rohe, Modern Architecture and Contemporary Art.* Krefeld: Krefelder Kunstmuseen, 2000.

Iconoclasme. Vie et mort de l'image médiévale.

> Exh. cat. Paris: Somogy, 2001.

Janin, Jules

> "Le Daguerotype [*sic*]." *L'Artiste* (April 1839).

John of Damascus, Saint

> *On Holy Images*. Translated by Mary H. Allies. London: Thomas Baker, 1898.
>
> *Three Treatises on the Divine Images*. Translated by Andrew Louth. Crestwood, NY: St. Vladimir's Seminary Press, 2003.

Kaprow, Allan

> *Essays of the Blurring of Art and Life*. Berkeley: University of California Press, 1993.

Klee, Paul

> *The Thinking Eye*. Translated by Ralph Mannheim, Charlotte Weidler, and Joyce Wittenborn. London: Lund Humphries; New York: George Wittenborn, 1961.

Kosuth, Joseph

> *Art after Philosophy and After: Collected Writings, 1966–1990*. Edited by Gabriele Guercio. Cambridge, MA: MIT Press, London, 1991.

Kupka, Frantisek

> *La Création dans les arts plastiques*. Paris: Éditions Cercle d'Art, 1989.

Lanoy, Patrice

> *Invisibles. Images de l'inaccessible*. Paris: Somogy / Cité des Sciences et de l'Industrie, 1998.

Lippard, Lucy R.

Six Years: the Dematerialization of the Art Object from 1966 to 1972. Berkeley: University of California Press, 1997.

Live in Your Head. When Attitudes Become Form: Works, Concepts, Processes, Situations, Information.

Exh cat. Bern: Kunstalle Bern, 1969.

Malraux, André

The Voices of Silence: Man and His Art. Translated by Stuart Gilbert. New York: Doubleday, 1953.

Maximus Confessor

Selected Writings. Translated by George C. Berthold. Mahwah, NJ: Paulist Press, 1985.

Monod-Fontaine, Isabelle

Matisse, Le Rêve ou les belles endormies. Paris: Adam Biro, 1989.

Naumann, Francis M.

Marcel Duchamp: The Art of Making Art in the Age of Mechanical Reproduction. New York: Harry N. Abrams, 1999.

Pächt, Otto

The Practice of Art History: Reflections on Method. Translated by David Britt. London: Harvey Miller Publishers, 1999.

Pastoureau, Michel

Le Bleu, Histoire d'une couleur. Paris: Seuil, 2000.

Peirce, Charles S.

Collected Papers of Charles Sanders Peirce. Vol. 2: Elements of Logic. Edited by Charles Hartshorne and Paul Weiss. Cambridge, MA: Harvard University Press.

Plato

Phaedrus. Plato in Twelve Volumes. Vol. 9. Translated by Harold N. Fowler. Cambridge, MA: Harvard University Press; London: William Heinemann Ltd., 1925.

The Republic. Plato in Twelve Volumes. Vols. 5 and 6. Translated by Paul Shorey. Cambridge, MA: Harvard University Press, 1969.

Poinsot, Jean-Marc

Quand l'oeuvre a lieu. L'art exposé et ses récits autorisés. Geneva: Mamco; Villeurbanne, Institut d'art contemporain & Art édition, 1999.

Poussin, Nicolas

> *Lettres et propos sur l'art.* Anthony Blunt, ed. Paris: Hermann, 1989.

Prichard, Joseph

> *Images de l'invisible. Vingt siècles d'art chrétien.* Tournai / Paris: Casterman, 1958.

Redon, Odilon

> *À soi-même. Journal (1867-1915). Notes sur la vie, l'art et les artistes.* Paris: José Corti, 1985.

Restany, Pierre

> *Le Nouveau Réalisme.* Paris: Union Générale d'Édition, 1978.

Roché, Henri-Pierre

> *Écrits sur l'art.* Marseille: André Dimanche Éditeur, 1998.

Roucoux, Katherine, and David Malin

> *Heaven and Earth: Unseen by the Naked Eye.* London: Phaidon, 2002.

Santini, E.-N.

> *La photographie à travers les corps opaques par les rayons électriques, cathodiques et de Röntgen avec une etude sur les images photofulgurales.* Illustrated with sixteen engravings. Paris: Charles Mendel, 1896.

Schaeffer, Jean-Marie

> *L'Image précaire. Du dispositif photographique.* Paris: Seuil, 1987.

Schlegel, August Wilhelm

> "Die Gemählde: Ein Gespräch." *Athenäum* 2 (1799).

Semin, Didier

> *Le Peintre et son modèle déposé.* Geneva: Mamco, 2000.

Strindberg, peintre et photographe.

> Exh. cat. Paris: Réunion des Musées Nationaux, 2001.

Vernant, Jean-Pierre

> "De la présentification de l'invisible à l'imitation de l'apparence." In *Images et significations.* Paris: La Documentation française, 1983.

Vitoux, Georges

> *Les Rayons X et la photographie de l'invisible.* Paris: Chamuel, 1896.

Voids: A Retrospective.

> Exh. cat. Paris: Centre Pompidou; Bern: Kunsthalle; Zurich: JRP-Ringier, 2009.

Warhol, Andy

The Philosophy of Andy Warhol: From A to B and Back Again. London: Penguin, 2007.

Wember, Paul

Yves Klein. Catalogue raisonné. Cologne: DuMont Schauberg, 1969.

Yves Klein: Monochrome und Feuer, Krefeld 1961.

Ein Dokument des Avantgarde. Edited by Julian Heynen. Krefeld: Krefelder Kunstmuseen, 1994.

Zero.

Translated by Howard Beckman. With an introduction by Lawrence Alloway and Otto Piene. Cambridge, MA: MIT Press, 1973.

INDEX

LIST OF ILLUSTRATIONS
AND PHOTOGRAPHIC CREDITS

LIST OF ILLUSTRATIONS AND PHOTOGRAPHIC CREDITS

1. Yves Klein, *Untitled Blue Monochrome* (IKB Godet), 59 x 78 in., pigment and synthetic on paper glued to canvas, private collection, on loan to the Musée d'Art Moderne et d'Art Contemporain de Nice. Courtesy Musée d'Art Moderne et d'Art Contemporain de Nice.

2. Albert Camus, "With the void, full powers," 1958, sheet of *NRF* letterhead (Nouvelle Revue française, Éditions Gallimard). Yves Klein Archives.

3. View of the exhibition *Yves Peintures*, Club des Solitaires, Paris, October 1955. Yves Klein Archives.

4. Yves Klein at his exhibition *Proposte monocrome, epoca blu*, Galleria Apollinaire, Milan, January 1957. Yves Klein Archives.

5. Anonymous, formerly attributed to Rembrandt, *The Man in the Golden Helmet*, oil on canvas, 26¼ x 19¾ in., Gemäldegalerie, Berlin. Photo Bridgeman-Giraudon.

6. Rembrandt, *The Polish Rider*, c. 1655, oil on canvas, Frick Collection, New York. Photo AKG-images.

7. Hippolyte-Ferdinand Baraduc, "Psychicones" produced by Dr. Maurice Adam, *The Human Soul: Its Movements, Its Lights and the Iconography of the Fluidic Invisible* (Paris: G.-A. Mann, 1913), pl. XXIII; Bibliothèque Nationale de France, Paris.

8. August Strindberg, *Celestograph*, 1893–94, modern print, 4¾ x 3¼ in., Nationalmuseum, Stockholm, after an original in the Kungliga Biblioteket, Stockholm.

9. "Surfaces and Blocks of Pictorial Sensibility. Pictorial Intentions," poster displayed opposite the stairs, Galerie Colette Allendy, Paris, May 1957. Stills from the film devoted to Klein's double exhibition at the galleries of Iris Clert and Colette Allendy, *Monochrome Propositions*. Yves Klein Archives.

10. Yves Klein presenting a "pictorial intention" in the room reserved for "surfaces and blocks of pictorial sensibility," Galerie Colette Allendy, Paris, May 1957. Stills from the film devoted to Klein's double exhibition at the galleries of Iris Clert and Colette Allendy, *Monochrome Propositions*. Yves Klein Archives.

11. Yves Klein presenting an orange monochrome painting, photograph illustrating an article by Pierre Restany, "La minute de vérité," *Couleurs* 18 (December 1956): 10. Bibliothèque Nationale de France, Paris.

12. Kazimir Malevich, *The Woman Worker*, 1933, oil on canvas, 28 x 23½ in., Russian Museum, Saint Petersburg. Photo AKG-images.

13. Alberto Giacometti, *The Invisible Object*, 1934, bronze, 60½ x 12½ x 11½ in., Fondation Maeght, Saint-Paul-de-Vence. Photo AKG-images.

14. Yves Klein, *Tactile Sculpture* (S22), undated, wooden box, pedestal and base painted white, various materials on the inside, 56¼ x 19¾ x 19¾ in., private collection. Yves Klein Archives.

15. Yves Klein, score of The *Monotone-Silence Symphony*, short version, for choir and orchestra, 1961. Yves Klein Archives.

16. The blue balloons of the *Aerostatic Sculpture* in front of the Galerie Iris Clert on May 10, 1957, the evening of the vernissage of Yves Klein's exhibition, before they were brought to the church of Saint-Germain-des-Prés and launched into the sky. Yves Klein Archives.

17. Yves Klein, *The Leap into the Void*, 5, rue Gentil-Bernard, Fontenay-aux-Roses, October 1960. Another version of this photograph (with a cyclist in the background) was published by Klein on the front page of his newspaper *Dimanche* (November 27, 1960) with the headline: "Un homme dans l'espace! Le peintre de l'espace se jette dans le vide!". Artistic action by Yves Klein. Photo Harry Shunk-John Kender. © Yves Klein, ADAGP, Paris (for the work). Photograph Shunk-Kender © Roy Lichtenstein Foundation.

18. This article, "Yves", by J. A. (Julien Alvard), *Cimaise* (July–August 1957): 34, features on a page in one of Yves Klein's press books.

19. Invitation to the vernissage of the exhibition, later known as that of the "Void", on April 28, 1958, Galerie Iris Clert, Paris. Yves Klein Archives.

20. Yves Klein, *Exasperations 1958*, project for an envelope written and drawn in blue pencil. 3¼ x 7 in. Private collection.

21. Advertisement for Yves Klein's exhibition at the Galerie Iris Clert, published in *L'Oeil* (May 1958).

22. Advertisement for the exhibition *Yves le monochrome* at the Galerie Iris Clert, published in *Art international* (May–June 1958).

23. Envelope with blue stamp containing the invitation to the vernissage of the exhibition later known as that of the "Void", on April 28, 1958 (Galerie Iris Clert, Paris), addressed to Yves Klein by himself (4½ x 7 in.). Yves Klein Archives.

24. View of the Galerie Iris Clert, window painted blue, and the entrance to the building, draped in blue, for Yves Klein's exhibition, April 28–May 12, 1958. Film stills put together to give an idea of the exhibition. Yves Klein Archives.

25. Yves Klein, illumination in blue of the obelisk in place de la Concorde, Paris, "Conceptual work produced by the Musée National d'Art Moderne in association with the City of Paris on March 1, 1983, to mark the inauguration of the retrospective exhibition of the artist's work at the Centre Pompidou," postcard published by the Amis du Musée d'Art Moderne de la Ville de Paris. Photograph Adam Rzepka.

26. Interior view of the Galerie Iris Clert, bare walls, empty display case, and entrance draped in white, during Yves Klein's exhibition, April 28–May 12, 1958. Film stills put together to give an idea of the exhibition. Yves Klein Archives.

27. Invitation to the lecture given at the Sorbonne by Yves Klein on June 3, 1959: "L'évolution de l'art vers l'immatériel" ("The Evolution of Art toward the Immaterial"). Yves Klein Archives.

28. Arman preparing his exhibition *Le Plein*, Galerie Iris Clert, Paris, October 1960.

29. Yves Klein, *Dimanche. Le journal d'un seul jour*, November 27, 1960, front page, 21¾ x 15 in.

30. Andy Warhol in front of the label for his *Invisible Sculpture*, The Area, New York, 1985.

31. This article, "Manifestation d'avant-garde à la Galerie Iris Clert," by C. R. (Claude Rivière), *Combat* (May 5, 1958), features on a page in one of Yves Klein's press books.

32. Yves Klein, plan produced in 1960 for his exhibition *Monochrome und Feuer* (1961) at the Museum Haus Lange, Krefeld, blue and red ballpoint pen on tracing paper glued to canvas, 13½ x 19½ in., private collection.

33. Recent interior view of the "empty" room dedicated to the "immaterial pictorial sensibility," Museum Haus Lange, Krefeld, 173¼ x 63 x 114¼ in.

34. Yves Klein in the "empty" room dedicated to the "immaterial pictorial sensibility," Museum Haus Lange, Krefeld, during his exhibition *Monochrome und Feuer*, January 14–February 26, 1961.

35. Yves Klein in the "empty" room dedicated to the "immaterial pictorial sensibility," Museum Haus Lange, Krefeld, during his exhibition *Monochrome und Feuer*, January 14–February 26, 1961.

36. Exterior view of the door to the "empty" room dedicated to the "immaterial pictorial sensibility," Museum Haus Lange, Krefeld (summer 2002).

37. Yves Klein painting the space of the "empty" room white for his exhibition *Monochrome und Feuer*, Museum Haus Lange, Krefeld, January 1961.

38. First public presentation of a "living brush" in action, at Robert Godet's, Paris, June 5, 1958.

39. Yves Klein, "Ticket good for free admission," included with the invitation card to the vernissage of his exhibition at the Galerie Iris Clert on April 28, 1958 (2 x 3½ in). Paris, Centre Pompidou, Bibliothèque Kandinsky, Fonds Iris Clert.

40. Yves Klein in front of the space reserved for him during the vernissage of the exhibition *Vision in Motion—Motion in Vision*, Hessenhuis, Antwerp, March 17, 1959. Photograph by Charles Wilp, 9½ x 11¾ in., with a caption by the artist on the back: "Yves Klein presents the immaterial."

41. Yves Klein, draft of a "certificate" for the "synallagmatic relinquishment of a transferable zone of immaterial pictorial sensibility," 1959, pink ink and gold paint on paper mounted on a blue background, 3½ x 10¼ in., private collection.

42. Yves Klein, draft of a "certificate" for the "relinquishment of a transferable zone of immaterial pictorial sensibility," 1959, ink and gold paint on paper mounted on a

blue background, 6 x 14½ in., Musée National d'Art Moderne, Centre Pompidou, Paris. Photo CNAC/MNAM Dist. RMN.

43. Yves Klein, model for a counterfoil book for the relinquishments of volumes of "transferable immaterial pictorial sensibility," 1959, back of the receipt, ink, ballpoint pen, and gold paint on paper, blue paper (dimensions of the receipt: 3¾ x 11¾ in.), Musée National d'Art Moderne, Centre Pompidou, Paris. Photo CNAC/ MNAM Dist. RMN.

44. Yves Klein, model for a counterfoil book for the relinquishments of volumes of "transferable immaterial pictorial sensibility," 1959, front of the receipt, ink and gold paint on paper, blue paper (dimensions of the counterfoil book: 4 x 12¾ in.), Musée National d'Art Moderne, Centre Pompidou, Paris. Photo CNAC/MNAM Dist. RMN.

45. Receipt book for the *Zones of Immaterial Pictorial Sensibility*, Series No. 5, 1959, printed paper, 3¼ x 11¾ cm, private collection.

46. Receipt book for the *Zones of Immaterial Pictorial Sensibility*, Series No. 0, 1959, printed paper, 3¼ x 11¾ cm, private collection (the visible counterfoil attests to the agreed transfer to the Museum Haus Lange).

47. Receipt book for the *Zones of Immaterial Pictorial Sensibility*, Series No. 1, 1959, printed paper, 3¼ x 11¾ cm, private collection (the visible counterfoil attests to the sale to Peppino Palazzoli of Zone No. 1).

48. Receipt book stub for the sale to Jacques Kugel of the *Zone of Immaterial Pictorial Sensibility*, No. 2, Series No. 1, on December 7, 1959.

49. Receipt book stub for the sale to Paride Accetti of the *Zone of Immaterial Pictorial Sensibility*, No. 3, Series No. 1, on December 7, 1959.

50. Receipt book stub for the sale to Alain Lemée of the *Zone of Immaterial Pictorial Sensibility*, No. 4, Series No. 1, on December 8, 1959.

51. Yves Klein, receipt given to Paride Accetti for the purchase of *Zone of Immaterial Pictorial Sensibility*, No. 3, Series No. 1 (December 7, 1959), private collection.

52. Yves Klein, receipt given to Alain Lemée for the purchase of *Zone of Immaterial Pictorial Sensibility*, No. 4, Series No. 1 (December 8, 1959), private collection.

53. Yves Klein, receipt given to Jacques Kugel for the purchase of *Zone of Immaterial Pictorial Sensibility*, No. 2, Series No. 1, mounted on a gold background (December 7, 1959), private collection.

54. Yves Klein, transfer to Dino Buzzati of *Zone of Immaterial Pictorial Sensibility*, No. 5, Series No. 1, Pont-au-Double, January 26, 1962. Photographs Shunk-Kender © Roy Lichtenstein Foundation.

55. Yves Klein, transfer to Claude Pascal of *Zone of Immaterial Pictorial Sensibility*, No. 6, Series No. 1, Pont-au-Double, February 4, 1962. Photograph Gian Carlo Botti.

56. Yves Klein, transfer to Michael Blankfort of the *Zone of Immaterial Pictorial Sensibility*, No. 1, Series No. 4, Pont-au-Double, February 10, 1962, page from the "Spiral Notebook" put together by the artist (authentication of the zone transferred by François Mathey). Yves Klein Archives.

57. Receipt book stub for the transfer of a *Zone of Immaterial Pictorial Sensibility*, Series No. 0, to Edward Kienholz, June 14, 1961.

58. Yves Klein, *Ex-Voto Dedicated to Saint Rita*, 1961, pure pigments, gold leaf, gold ingots, and manuscript in a Plexiglas box, 8¼ x 5½ x 1¼ cm, collection of the Monastero di Santa Rita, Cascia, Italy.

59. Taking down the paintings exhibited at the Salon Violet, Musée d'Art Moderne de la Ville de Paris, Paris, January 26, 1962 (from left to right: Jacques Villeglé, François Dufrêne, and Yves Klein). Photographs Shunk-Kender © Roy Lichtenstein Foundation.

60. Catalog, Salon Comparaisons, 1962, pages 80–81: to the left, the Nouveaux Réalistes room; to the right, view of the same room occupied by *Zone of Immaterial Pictorial Sensibility*, No. 1, Series No. 5. Photographs Shunk-Kender © Roy Lichtenstein Foundation.

61. Salon Comparaisons, 1962, instructions for exhibitors given to Yves Klein for his *Zone of Immaterial Pictorial Sensibility*—Series No. 7, Zone No. 1, private collection.

62. Yves Klein, *Anthropométries de l'époque bleue*, Galerie Internationale d'Art Contemporain, Paris, March 9, 1960. Yves Klein Archives.

63. Yves Klein, sketch for *Blue Monochrome Stations of the Cross* (1958) for the chapel of Saint-Martin-de-France, Pontoise, pencil and ballpoint pen on paper, 11½ x 8¼ in.

64. Yves Klein, *Untitled Anthropometry* (ANT 7), 1962, pure pigment and synthetic resin on paper glued to canvas, 40¼ x 28¾ in., private collection.

65. Yves Klein, *The Flesh* (ANT 71), 1960, pure pigment and synthetic resin on paper, 42¾ x 29¾ in., private collection.

66. Giotto, an angel rolling up the sky, detail of *The Last Judgment*, 1303–04, fresco, Cappella degli Scrovegni, Padua.

67. Henri Matisse, *Blue Nude* (IV), 1952, cut-out gouache and charcoal on paper, 40½ x 29¼ in., Direction des Musées de France, gift of Jean Matisse, on loan to the Musée Matisse, Nice, 1978, Inv. D78.1.57, © 2004, Succession H. Matisse/photo Ville de Nice-service photographique.

68. "Symbolic transfer of the immaterial," organized by Pierre Restany, Shinichi Segi, and Yoshiaki Tono in homage to Yves Klein, Tokyo, October 1962.

69. Receipt book stub for the posthumous transfer of *Zone of Immaterial Pictorial Sensibility*, No. 7, Series No. 1, to Karl Heinrich Müller on May 16, 1975.

70. Mike Bidlo, *Recreating Yves Klein's Anthropometries*, The Palladium, New York, 1985.

71. Edward Kienholz, *Traveling Art Show Kit*, 1961, suitcase and objects, 8 x 14¼ x 10 in., private collection.

72. Back of the page dedicated to Yves Klein, exhibition catalog, *Live in Your Head: When Attitudes Become Form: Works, Concepts, Processes, Situations, Information*, Kunsthalle, Bern, 1969, unpaginated (Yves Klein, *The Leap into the Void*, and Kienholz's text).

© Yves Klein / Adagp 2010, Paris.

© Adagp 2010, Paris, for the works by Arman, Alberto Giacometti, and Andy Warhol.

All rights reserved.

ACKNOWLEDGMENTS

I am grateful to the organizers of conferences and lecture cycles for showing their confidence in me by inviting me to speak about various aspects of the oeuvre of Yves Klein. *Expressing the Immaterial* results in large part from these requests, which led me to pursue my research and clarify my hypotheses. That is why I would like to express my gratitude to Jacques Sato and Christophe Viart (Université de Rennes II, 1996), Daniel Soutif (Centre Pompidou, 1997), Michèle Brun and Gilbert Perlein (Musée d'Art Moderne and d'Art Contemporain de Nice, 2000), Michel Giroud (École des Beaux-Arts de Besançon, 2001), Richard Conte (Université de Paris I, 2001), and Marc Archambault (Centre Pompidou, 2001).

I would also like to take the opportunity to thank those who, each in his or her own way, facilitated the preparation of my essay and enabled the production of this book, particularly my wife Christine Regouby, as well as Cora Spycher (Museum Haus Lange), Macha Daniel (department of prints and drawings, Musée National d'Art Moderne), Laurence Le Poupon and Sylvie Mokhtari (Archives de la Critique d'Art), Marie-Anne Sichère, Didier Semin, Éric Vigne, Jean-Loup Champion, Laurence Peydro, Clotilde Chevalier, Amélie Airiau, and all those—too many to mention here—who answered my questions and supplied me with information.

Finally, this book could not have been published without the thoughtful support of Rotraut Klein-Moquay and Daniel Moquay, who encouraged me to focus my research on Klein's immaterial works and generously gave me access to the Yves Klein Archives where, for nearly three years, I sorely tested the patience of Philippe Siauve, in charge of these archives in Paris, whose competence was a great help to me: I would like to express my gratitude to them here.

Originally published in French as *Yves Klein : manifester l'immatériel*
© Gallimard, Paris, 2004

English-language edition
© Éditions Dilecta, Paris, 2010
4, rue de Capri – 75012 Paris – France
contact@editions-dilecta.com
www.editions-dilecta.com
ISBN 978-2-916275-74-1

Editorial direction: Grégoire Robinne
Editorial coordination: Marie-Clémentine Pierre
Translation: Chrisoula Petridis / Copy editing: Emer Lettow
Layout: Sophie Onillon / Cover design: Christian Bouyjou

Distribution:
– Europe:
Buchhandlung Walther König
Ehrenstrasse 4
D-50672 Köln
Germany
T + 49 (0) 221 205 96 53
F + 49 (0) 221 205 96 60

– UK & Eire:
Cornerhouse Publications
70 Oxford Street
GB-Manchester M1 5NH
UK
T +44 (0) 161 200 15 03
F +44 (0) 161 200 15 04
publications@cornerhouse.org

– Outside Europe:
D.A.P. / Distributed Art Publishers
155 Sixth Avenue, 2nd Floor
New York, N.Y. 10013
USA
T + 1 212 627 1999 205
F + 1 212 627 9484

Dépôt légal: October 2010
Printed in September 2010
by Grafiche Marini Villorba, Treviso, Italy.

Cover:
Yves Klein presenting a "Pictorial Intention" in the room dedicated to the "Surfaces and Blocks of Pictorial Sensibility," Galerie Colette Allendy, Paris, May 1957. © Yves Klein / Adagp 2004, Paris.